X Y

NICOLE ANGEMI'S

ANATOMY BOOK

A Catalog of Familiar, Rare, and Unusual Pathologies

This book is for anyone
who has ever been told no . . .

NICOLE ANGEMI'S

ANATOMY BOOK

A Catalog of Familiar, Rare, and Unusual Pathologies

CERNUNNOS

◇

INTRODUCTION

I'm no different than any other middle-aged, married mother of three. I drive my kids around to their soccer games and jiujitsu training, have movie nights with my family, cook dinner, and enjoy doing arts and crafts projects around my house. Oh, and I also dissect humans on the side!

Aside from being a wife and mother, I am a pathologists' assistant. A pathologists' assistant, or PA, is a trained medical professional that works in a hospital's pathology department. PAs specialize in human anatomy, abnormal anatomy, and disease. Some PAs work in a hospital's surgical pathology laboratory dissecting organs and body parts that are removed from live patients, while others work in hospital morgues performing autopsies.

Throughout the course of my career, I've dissected thousands of humans and human body parts using my specialized training and experience. By carefully looking at the anatomy, I'm able to determine what's normal and what causes a patient to have pathology both in life and in death.

Growing up, I never felt "normal" or like I fit in until I found pathology. Finally, I began to feel normal when I discovered the abnormal. This was my calling!

As a child, I wasn't an academic and hated school. Bored and rebellious, I often got myself into trouble. Detentions, suspensions, and frequent phone calls to my parents just touched the surface of the problems I dealt with growing up. My stubbornness and impulsivity eventually led me to a teen pregnancy at fourteen years old.

After months of anger and sadness, my parents and I decided the best thing for our family and our beliefs was to keep the baby. At fifteen years old, I gave birth to my daughter, Maria. Keeping her was the best decision I've ever made. In fact, she saved my life.

Being a teen mom was rough, both socially and academically. I struggled in school with friends, and dating. My life was so different from anyone I knew. The years following my pregnancy were difficult. I had a kid, yet was a kid myself, and trying to find my way. At sixteen, I dropped out of high school and hopped from job to job with no real direction.

A couple of years later, my parents were notified that my daughter and I would both no longer be covered under their health insurance. I was only nineteen and had to get a job with benefits quickly. Having no motivation or interest in anything, this was really a blessing in disguise. I was forced to get my shit together.

Remember how I said I hated school? I really did. The very thought of it made me want to take a nap. Suddenly, I found myself enrolling in my local community college in the summer of 1999 after deciding I would try to be a nurse.

Why did I choose nursing? It was not because I was compassionate, nurturing, and wanted to help people. I had a cousin who was an RN. It seemed like it was a solid, dependable, well-paying career she obtained in less than three years. At this time, being in school for the least amount of time possible was a huge motivating factor.

In 1999, there wasn't online registration for college courses. I had to pick my classes out of a catalog and stand in line for hours to register. Before picking my classes, I met with a counselor, telling her my intentions of being a nurse. She told me I had to start by taking four basic courses: math, English, psychology, and biology. I had no idea what to expect. After all, I barely went to high school!

The first day of biology, my professor discussed the material we would be learning throughout the semester. For a person who hated school, I quickly became very interested in what we'd be learning.

A few days into the class, we were introduced to the microscope. First, we looked at a newspaper clipping to learn how to adjust the objective lenses on the scope. Next, my teacher took a piece of skin from an onion and put it on a microscope slide for us. Under the microscope, I was able to see the inner workings of the onion: plant cells. That was the moment I fell in love with science.

As the weeks went on, I started looking forward to going to school, particularly biology class. Biology was very exciting to learn, and even more exciting that I understood it. Biology 101 is a class that almost every college student must take. My professor not only took notice of my interest but was excited to have a student who was interested in the material she was teaching.

One day we were talking after class and I jokingly said, "I wish there was a job I could get where I could look under the microscope all day and get paid." Her eyes lit up. She told me that was a possibility!

In addition to teaching, my professor worked as a medical technologist in the microbiology lab for a local hospital. She discussed her job with me, including her responsibilities of identifying bacteria that made people sick and helping doctors know which antibiotics to give the patients. She introduced me to a world I didn't know existed. Forget being a nurse, I wanted to be a scientist!

Being 1999, I could not run home and google all about the medical laboratory, because google wasn't really a thing yet! In the late nineties, my family did not have much of a connection to the internet at all. We had one computer in our house and the internet was connected through our phone line. On a perfect day, it would take about twenty minutes to get connected to the internet, and as soon as the phone rang, it would kick me off. All research for my future career had to be done the old-fashioned way—by talking to people!

My professor helped me network with other laboratory professionals, eventually landing me my first job working in a hospital microbiology lab. My job consisted of taking urine, sputum, blood, feces, nose swabs, etc. and putting them on agar plates. Agar plates (petri dishes) are plastic dishes filled with gel that help bacteria grow.

Many aspects of the lab piqued my interest. In 2001, the anthrax attacks after 9/11 initially got me interested in infectious diseases and bioterrorism. This all fueled my desire to learn more about cells under the microscope.

My perspective on life changed in such a short period of time. Only months prior, I was dreading the thought of having to go to college for two whole years. Now I was looking into universities to further my education. I wanted more.

After completing my prerequisites at the community college, I transferred to a university in Philadelphia. I switched jobs, now working at a larger lab at a university hospital and moved myself and my then-seven-year-old daughter to the city.

Since I had such a strong interest in cellular changes and the microscope, I majored in cytotechnology. Cytotechnology is a part of the anatomic pathology lab that studies changes in cells under the microscope, looking for signs of cancer, infections, and other pathology.

At twenty-three, I graduated with a Bachelor of Science and was even awarded an "Outstanding Academic Scholarship." Pretty good for a high school dropout who hated school! I was hired as a cytotechnologist at the hospital affiliated with my university, where I stayed employed for the next ten years of my life.

I worked as a cytotechnologist for the first couple of years at that hospital. It was basically an office job—well, maybe a morbid office job. I had my own cubicle and wore professional clothing; however, in my crisp white lab coat, I was analyzing samples from vaginas, bodily fluids, and semen under the microscope.

These first few years working in the hospital were great, and it never felt like I was going to "work." I was doing something I loved and hanging out with a great group of people who shared a common interest. For the first time in my life, I felt like I fit in.

Despite loving looking at diseased cells under the microscope, I began to get bored

with the repetitive nature of the job. No longer feeling challenged, I considered going back to school but was also at a loss for what I would even study. Epidemiology was high on my list because of my love for the study of infectious diseases. Then one day, it became clear what my calling in life would be.

One morning while sitting in my cubicle, I heard a commotion in the hallway. Everyone was horrified because of some awful smell that can only be described as trash filled with dead fish and rotten meat. The smell was so grotesque that it piqued my curiosity as to what it could be coming from. Then I heard the unforgettable words "The leg refrigerator is broke."

Excuse me? The *leg* refrigerator? I had so many questions.

Down the hall, around the corner, I entered a lab I hadn't seen before. There was a plaque on the wall labeled "The gross room." What was the gross room? I was intrigued!

Entering the lab, my nose led me to the leaking refrigerator. I couldn't believe my eyes. There was a large refrigerator with a glass door, like one you would see at a pizza place holding two-liter bottles of soda, but instead, this refrigerator was holding something a bit more macabre: human legs!

Through the glass doors of the fridge, I saw four or five red biohazard bags perfectly wrapped into the shape of a leg. I couldn't believe what I was looking at, and yet every-one in the room was just carrying on like nothing strange was going on.

When patients have pathology such as gangrene, or those who have a limb amputated due to trauma, their limb is sent to pathology to get examined. Before and after the legs are examined, they are stored in the refrigerator. The awful smell was a mixture of gangrene and human decomposition.

The most shocking part was that I was working in this hospital for two whole years on the other side of this wall and had no idea there was a fridge filled with human body parts behind me. In fact, I had no idea about anything that was going on in the gross room.

The gross room is a laboratory in surgical pathology that examines organs, body parts, and foreign bodies that are removed from patients. The word "gross" refers to the macroscopic examination, meaning what the tissues look like with our eyes instead of with a microscope.

I asked a resident to show me around, and she brought me further back into the lab, where I saw people sitting at benches with cutting boards and knives, only it wasn't a kitchen. They were cutting up human body parts! Huge ovaries, colons, appendixes, you name it! I never knew this world existed. I had an urge to put on a pair of gloves, grab a knife, and start dissecting. That was the day I decided I was going to change my career. I didn't know what it was called, if I had enough schooling to do it, or

◊

if I had to go back to college. All I knew is that I was going to work there, do whatever I needed to do to make it possible.

After talking with some of my coworkers, I learned that I didn't have to be a doctor, and my bachelor's degree was enough to get my foot in the door. With this information, I stepped into the pathology director's office and asked if I could switch departments. At first, he tried to convince me not to take the job. He argued that my current job was much easier and much cleaner, but I didn't care.

Shortly after, I found a program at a local university that offered a master's degree for a pathologists' assistant.

This degree would build my knowledge of pathology, give me the skills necessary for working in the pathology lab, and allow me to teach medical students and residents. Eventually I convinced the director, and he agreed to let me switch. We had an agreement that I would work as a technician in the gross room, keeping my cytotech salary, until I graduated from PA school and was eligible for a pay increase. Within a month, I was working in the gross room, and within a year, I began PA school.

During this period, I got to observe my first autopsy. It was a strange experience, with lots of mixed emotions. I was getting used to cutting up people's organs, but they did not have a face!

When I saw my first autopsy, the strangest part was that I was in the room with about five other people, yet I seemed to be the only one who was mind-blown that there was a dead guy lying there! No one was phased. I was trying to act cool but kept staring at this dead figure that was alive only a few hours prior. It was really something. Of course, I got over that quickly and was instantly intrigued over what I was seeing. At that time, I did not know I was going to love autopsy so much. This was all overwhelming at first, and not something I felt confident I would ever be able to do by myself.

As a PA student, we had to observe and perform many autopsies. Eventually, one of my mentors thought I was ready to do one alone. To this day, my first solo autopsy is one of the grossest I've ever done.

The deceased was green, bloated, decomposed, and covered with maggots. Disgusting, yet the perfect body for a student to learn from. This person would not be having a formal funeral viewing; therefore, it was okay if my incisions were not perfect. Despite maggots crawling up my arm and the smell of human decomposition stuck in my nose for an entire day, my first autopsy was a success.

The more I did, the more I preferred performing autopsies over the dissections involved with surgical pathology. The puzzle of an autopsy, having to use various findings to answer why a person died, was so fascinating to me.

While it was difficult attending school full time, working full time, and being a

single mom, within two years I was able to obtain my master's degree and pass my exam to become a certified pathologists' assistant. Finally, as per our agreement, my job promoted me to a full time PA. On the very first day of my new position, there was an autopsy. My supervisor said to me, "You're a PA now, go cut it."

She was right. I was done with my training and passed my certification exam, although still unsure about my capabilities. This was the first time I would be the one in charge, I had no mentor with me to hold my hand.

I went through the autopsy slowly and did everything I was trained to do. When I removed the ribs, I saw that the sac around his heart was big and purple. I hadn't seen this before, but I was pretty sure I knew what was going on. It was really exciting.

I called the pathologist who was on autopsy that week. Prior to this, I didn't have much more than a casual hi/bye relationship with him. I picked up the bloody phone in the morgue and told him I found something interesting and to come down and take a look.

He came down to the morgue and I showed him the patient's heart. He was so excited and said, "Do you know what this is?" I said I hadn't seen this before but thought it was a cardiac tamponade. He became even more excited when I answered his question right.

A cardiac tamponade is when blood exits either the aorta or the heart within the heart sac (pericardial sac) and fills the sac up with blood. Every time the heart beats, the sac fills up with more and more blood, eventually restricting the heart so it can no longer beat properly, and the patient dies.

The pathologist and I carefully opened the heart sac so we could identify where the blood was coming from. The patient had a ruptured aorta.

After that autopsy, I became more confident of my abilities, and I formed a strong bond with that pathologist. He was as excited about the gross findings as I was. I found myself showing him all the cool things I was seeing in surgical pathology and autopsies, even when he was not the doctor on call.

His enthusiasm was infectious and made me want to learn more. I picked his brain daily and soaked up his knowledge like a sponge. Soon he and I started to try to make big changes within the department to improve the education of the residents and the medical students.

While in PA school, two of my mentors held a "gross conference," where the PAs would lay out certain organs from each autopsy to show how they determined the cause of death. Residents from all over the hospital (pathology, surgery, radiology, etc.), med students, and physicians would discuss the gross changes seen in the organs and discuss why the patient died. I thought

this multidisciplinary approach was the best way for medical professionals to learn, and I wanted to bring that to my hospital.

We held our first gross conference, and it was a raving success (to most people). The gross conference was held in the morgue. I held organs aside from interesting cases in both surgical pathology and autopsy and placed them on trays I stole from the cafeteria (don't worry, I did not return them!). I put an invitation out to all the doctors and medical students in the hospital and was shocked to see how many attended. I was thinking maybe five to ten people would show up, but over fifty people were there! It was standing room only, and the morgue was so packed that we could not let some people in. I really felt like I was contributing to the education of doctors and better patient care.

Unfortunately, just like with anything in life, if you are doing something right, people are going to hate it. A couple of male pathologists had a problem with the gross conference, likely because it was not their idea. Afterall, a younger woman with less education was able to get other departments interested and enthusiastic about pathology, something they were not able to do after years of trying. Instead of joining us, they decided to sabotage us.

After only a few gross conferences, they were canceled by the department head because the morgue was "too dirty" for visitors. I was devastated. I did not know what was next for me. I loved pathology so much but wasn't sure how to get that energy out.

After work, I would find myself writing notes about interesting findings and comparing them to what I had learned in school. After a few weeks of doing this, I decided to organize my notes, turning them into a blog. Eventually, word got out about my blog, and doctors from all over the hospital were checking it out. My family and friends began taking interest too. Clearly, this was not something only medical professionals were interested in. The people around me were interested to learn about the human body, and I was eager to share my job with the world!

In 2013, my boyfriend (now husband) suggested I take these images and descriptions to Instagram. My first question to him was, "What *is* Instagram?" At that time I wasn't on social media and had no interest in it.

He showed me the app and overall concept, but I just didn't understand it. Luckily, I had an eighteen-year-old kid to show me how to navigate it.

At that time, Instagram was more organic (pre-algorithm) and easier to spread knowledge using hashtags. Eventually, I got the hang of it and could post regularly without my daughter's assistance. In only a couple of weeks, I had over two thousand followers. Not only were my peers interested in my work, but so many others were also interested in pathology.

At this time, my life was chaotic. I was working full time, newly married, had a college student, a toddler, and was pregnant for the third time. Posting to Instagram was easier than maintaining a blog and fueled my enthusiasm for my profession again after my gross conferences got shut down. Unfortunately, that excitement quickly ended when Instagram deleted my account. I handled it in a way that any strong woman would: I cried hopelessly on the corner of my couch.

Even though I felt like quitting, my husband encouraged me to keep trying. Each time I created a new account, it got more play, and then would be disabled by Instagram. I went through this roller coaster two more times until my current account, @mrs_angemi, finally stuck. Today, I have close to two million followers.

My journey with Instagram hasn't been easy, and although I'm mostly praised for my work, there are definitely a fair share of haters. Some people have been pushing for years to "cancel" me because they feel these images should be left to the professionals. I disagree. Everyone deserves and has the capability to learn about their bodies. Due to this constant censorship battle with Instagram, I have moved most of my material over to my private blog called "The Gross Room."

The most unexpected aspect of sharing my work has been connecting to people around the world who share a love for pathology. Over the years, I have received hundreds of messages and photographs from followers sharing their stories. The community from my Instagram helped me come up with the idea for this book.

Most people started following me because they were intrigued by the images, but like me, end up wanting to learn more. I wanted to make a book that was like a pathology textbook but written for everyone, not just people working in medicine and pathology. I also wanted to make it fun. Textbooks are boring! People want to learn about diseases, but they also want the juicy details that come with a person's experience! ◊

—NICOLE ANGEMI

ANGEMI ANATOMY CRASH COURSE

I went to college for six years to study biology, anatomy, and pathology so you don't have to! Before diving into the cases I present in this book, take a crash course in Angemi Anatomy!

HUMANS JUST BEING HUMANS

Humans are the most complex, intelligent animals living on planet Earth. Like it or not, we are animals. Take away our cars, phones, computers, and social media, and we are just like any other animal. Since we are animals, basic evolutionary and biological principles are essential for us to understand so our species can survive. That is the whole point, right?

In the scientific world, humans are classified as *Homo sapiens*. *Homo sapiens* are mammals who share the same characteristics with other mammals, like dogs and cats. Our bodies are covered in hair, we are warm-blooded, and our bodies are anatomically designed to give birth to live offspring and breastfeed our young. What also makes mammals different from all other animals are our highly complex brains. *Homo sapiens* have the most complex brains of any living creature.

Humans, like all other animals, have a purpose: we want to survive. We have instincts like other animals, but we can also have critical thought, and with that comes choices. We don't make all of our choices based on instincts; we make them based on emotions as well. We differ from the remainder of the animal kingdom because we can go against our biology. *Homo sapiens* are biologically born omnivores (meat- and plant-eaters), but we can make the choice to be vegan and go against our biology. We were also anatomically designed to create offspring, but we can make the choice not to have children. The choices we make every day are a balance between doing the right thing to stay healthy, taking risks to enjoy ourselves, and happiness.

Since we humans want to survive and enjoy our lives, advancements have been made in medicine to not only improve our longevity, but also to improve our quality of life. Fertility treatments, medications, cosmetic surgery, gender reassignment, and weight-loss surgeries are a few advancements specific to humans that are changing our evolution as a species. It will be interesting to see how we evolve as a species over the next hundreds of years.

The twenty-first century has made huge advancements in medicine, but we have nowhere near perfected it yet. Although it

appears medicine is modern and sophisticated, much of it is still an experiment. Doctors, health professionals, and researchers are some of the highest respected people in the world, but they have yet to master medicine. Just like each and every one of us, they are just humans being humans. They use their experience and education along with critical thought to save lives and further advancements in medicine, but they have bad days and make mistakes too.

MORTUI VIVOS DOCENT
"THE DEAD TEACH THE LIVING"

One of the coolest parts of doing a modern-day autopsy is that I am looking at the same exact anatomy that was studied by physicians and anatomists thousands of years before me. There were no textbooks or highly sophisticated CT scanners back then, just knives and dead bodies.

For thousands of years, dead bodies have been dissected, and the findings have been documented. What has been clear since the beginning of time is that most humans share the same anatomy. Medical books from the 1800s show the same dissections as modern-day medical illustrations.

Since most of us share the same anatomy, "normals" were created in medicine. This means that most humans fall within these parameters. Normals are useful, so we can identify when something is not right with the body. For example, the normal weight of a female heart is 250-300 grams. Some

will have a 220-gram heart, some will have a 310-gram heart; still, these are within normal range. At autopsy, however, if the heart is 700 grams, that indicates a problem.

There are around seven billion humans currently living on the planet, and there is not even one who exactly fits the textbook image or description of a normal human. Some have slight anatomic differences, while others have severe, debilitating defects. Humans are all unique and all different; that is what makes the world so exciting. If everyone was the same, life would be so boring!

Anatomy has not changed much over thousands of years, but what has changed is pathology. Pathology is the study of disease and abnormalities in anatomy. In 1821, the average life expectancy (if you lived past childbirth) was around twenty-nine years old. Many of the autopsies back then would have revealed causes of death from infections. Many of these infections are eradicated today because of autopsies and advancements in medicine. Now, in the twenty-first century, the average life expectancy is about seventy-eight years old. We are living almost fifty years longer than our ancestors! An example of a common finding at autopsy today that was not seen two hundred years ago are deaths related to obesity.

It is important for anyone in medicine to understand the parameters of normal anatomy (how things look) and physiology (how things work) before we can under-

stand pathology. We must understand what is right to know what is wrong.

Basic biology starts with a cell. Each cell has a responsibility. These cells form tissues like fat, muscle, connective tissue, etc. These tissues form organs. These organs form organ systems. And these organ systems form humans.

The reasons people die can be broken down in four categories or manners of death: natural, accidental, homicide (death at the hands of another either intentionally or through negligence), and suicide (death to oneself). The key to living a long, healthy life is to understand the manners that can kill us. Manners of death are manners of pathology in life: natural disease, accidents, hurting ourselves, or being hurt by another.

There are millions of ways a person can experience natural pathology throughout their life, but there are only two different ways to get pathology:

1. Congenital. This is pathology that occurs before birth. These disorders can either be genetic mutations inherited from a parent or problems that occurred during fetal development.

As humans, we all start as two cells. One from our mom (egg) and one from our dad (sperm). There are a lot of steps to form a human, which starts at the moment of conception when the egg and sperm join. This is called fertilization. Cells grow by making copies of each other. Once the egg and sperm cells join, they start dividing. This is the first point of possibility for humans to experience pathology. If a parent has a gene mutation, it can be passed on to their child. Pathology can also occur in the growing fetus that is not due to an inherited mutation.

2. Acquired. This is pathology that we are not born with but can acquire throughout our life. This can be from infections, injuries, or environmental exposures (both intentional and unintentional).

PATHOLOGY IS A BIGOT

Discrimination in pathology is necessary to narrow down the possibilities for doctors so there is not a delay or misdiagnosis. It is not economic or practical to give every patient a full body CT scan every year to have a look inside. Doctors must make guesses to narrow things down based on a patient's history, which includes their age, sex, race, occupation, etc.

Since the possibilities in pathology are endless, medicine has also created parameters or most commons. Most commons in medicine are diseases or conditions that most commonly occur among a certain group of people.

Pathology is racist, sexist, ageist—you name it. But with good reason.

RACE AND ETHNICITY IN PATHOLOGY

Since pathology can be genetic, certain diseases and conditions are more prevalent in certain races or ethnicities. Pathology can

also be acquired and can be linked to certain socioeconomic lifestyles.

People of Ashkenazi Jewish heritage are at an increased risk of certain diseases, like Tay-Sachs disease. Tay-Sachs disease is an inherited genetic disease in which the body cannot break down fatty compounds. These compounds can build up in the brain, damaging nerve cells. In the most common form of this disease, a child will start displaying symptoms within a few months of birth. Within a few years, their symptoms will progress to blindness and paralysis, and they will be dead by four years of age. Luckily, there is genetic testing available to identify if a parent is a carrier of one of these genes. It would not be practical to test every person on the planet who is deciding to have children for Tay-Sachs, especially since it is known to occur most frequently in this population.

Sickle cell anemia is an inherited, genetic disease that is most commonly seen in Black patients. Under normal conditions, our red blood cells are round. In patients with sickle cell anemia, the hemoglobin (a protein on blood cells that transports oxygen) is defective. This causes the blood cells to have a crescent-shaped appearance. Sickle cell anemia can be extremely painful because the abnormally shaped cells do not flow through the blood vessels and organs properly and can get stuck.

Most inherited, genetic diseases are a sign of basic evolutionary principles: natural selection. Natural selection is when nature kills off people with undesirable traits as a way to control the population. These types of diseases usually kill all people who have it. This isn't the case with sickle cell anemia.

Researchers have found that patients either living in areas where malaria is common or patients with ancestors living in those areas are at the highest risk for sickle cell anemia. It seems this very trait is a biological advantage because malarial parasites need a nice, round blood cell to live.

AGE IN PATHOLOGY

Pathology presents differently in different age groups. Although most hospitals can treat patients of all ages, segregated fields of medicine were created for both the young (pediatrics) and the old (geriatrics). That is because their diagnoses and treatments are approached differently.

When a child presents with symptoms, it may be due to a congenital disorder (one they were born with). In an adult, that is much less likely.

Some pathology, especially certain types of cancers, only occur in children.

Neuroblastomas are malignant cancers seen in childhood. It is extremely rare to get this type of tumor later than ten years old. Colon cancer, on the other hand, is almost exclusively seen in adults.

Other types of pathology are also exclusive to certain age groups. Conditions like coronary artery disease and osteoarthri-

tis are a common sign of aging, whereas growth disorders are specific to children.

SEX IN PATHOLOGY

The biological sex a person was born as is important in pathology; that is not to be confused with the gender a person identifies with. Gender is not biological; it is social and refers to the rules, characteristics, and behaviors that society has created for women and men. While most people have matching biological sex and gender identity, some do not.

Biologically, there are not two sexes. When most humans are born, they are either male (XY chromosome) and have a male reproductive tract, or female (XX chromosome) and have a female reproductive tract.

That applies to *most* humans, but not all humans. In some cases, babies are born and it is not clearly defined whether they are a male or a female. This is called intersex. At the time of conception, there can be a problem with the X and Y chromosomes (sex chromosomes). These chromosomes determine what sex a human will be. They are also responsible for other things that make us look typically male or female, like hormones, which give us our sex characteristics, such as body hair and breast size.

Although intersex is rarely talked about, it is more common than you think. It is estimated that almost 2 percent of the world's population is born intersex, which is equivalent to the number of redheads in the world.

Still, because most of the population is either male or female, it is easier for medical professionals to narrow down a pathologic process by knowing what sex a patient was born.

Certain diseases and conditions are more common in patients born female; for example, breast cancer. While other pathology is more common in patients born male, like aortic aneurysms and prostate cancer.

We know the dead teach the living, but what can the living teach us? Over one hundred unique cases of pathology in this book were submitted to me from all over the world!

The biggest lesson that we can learn from these cases is that we, not doctors, know the most about our own bodies. Oftentimes, the best outcome for patients is when doctors along with their patients diagnose their pathology. After all, no one knows as much about the body that a doctor is examining but that body.

Pathology can occur in any cell, in any organ, in any age group, in any race, in any sex. In any human! This book is just a small sample of the possibilities of pathology. ◊

—NICOLE ANGEMI

ABDOMEN

The abdominal wall is a multilayered system of skin, muscle, and fascia that serves both to protect the internal organs and to keep our guts inside our bodies. Pathology of the abdominal wall can be caused by congenital disorders, trauma, or abnormalities that arise during adulthood. Abdominal wall pathology can range from being a minor nuisance to something much more serious.

EAGLE-BARRETT SYNDROME

◇

E agle-Barrett syndrome is also known as Prune Belly syndrome. This disorder was given this name because these babies are born with a partial or complete absence of the abdominal wall muscles, which gives the belly a wrinkly, prune-like appearance. It is unknown what causes this rare disorder. Prune Belly syndrome occurs during fetal development and is usually seen with other defects, especially with the urinary tract.

32 YEARS OLD | PALMERSTON NORTH, NEW ZEALAND

◇

P rune Belly syndrome is a rare disorder and usually occurs in males, although a few females have been diagnosed.

When this patient's mother was pregnant, she received prenatal care that did not include ultrasounds. At birth, the patient was diagnosed with Prune Belly syndrome, with severe urinary tract defects. She was on peritoneal dialysis as a child and was switched to hemodialysis after her kidneys were removed twenty years ago when she was twelve. Five years after having her kidneys removed, she received a kidney transplant from a cadaver donor but is expected to return to hemodialysis within the next few years. Peritoneal dialysis and hemodialysis are both procedures done to remove waste products from the blood when the kidneys can no longer do the job.

As an adult living with Prune Belly syndrome, she has to have yearly imaging and cystoscopies of her bladder. Overall, she is healthy but lives with abdominal discomfort and pain due to scar tissue from multiple surgeries. She is not expected to need any additional surgeries for this condition. ◇

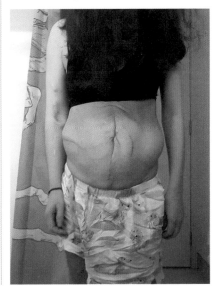

18 MONTHS | LANCASTER, CALIFORNIA, UNITED STATES

◊

This patient was diagnosed with Prune Belly syndrome in utero at nineteen weeks' gestation. His parents were told to abort because he would "likely not make it through the pregnancy full-term, and if he did, he would never sustain life

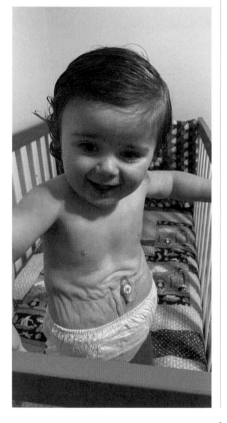

after they cut the umbilical cord." Fast-forward eighteen months and he is very much alive and happy. His mom gave birth to him at thirty-eight weeks' gestation. Just prior to delivery, doctors stuck a large needle through her belly in order to try to drain some fluid from his abdomen, with no success. Because his abdomen was measuring so large on ultrasound, doctors performed a cesarean section because they did not think he could be birthed vaginally.

He was born with a patent urachus. which is an abnormal opening between the bladder and the belly button. He spent two months in the neonatal intensive care unit, where he underwent multiple procedures, including a vesicostomy, to help prevent harm to his badly damaged kidneys. This is a surgical procedure that creates an opening in the skin for urine to drain freely.

At this time, the patient's kidney damage is controlled with medications and a special diet, but it is likely he will need a kidney transplant in the future. He is physically delayed because he spent most of the first year of his life in the hospital than at home. It is hard to dress him because his pants do not fit around his abdomen, and he has to wear double diapers to prevent his vesicostomy from leaking. Despite his medical problems, this little boy has adapted and loves life! ◊

◊

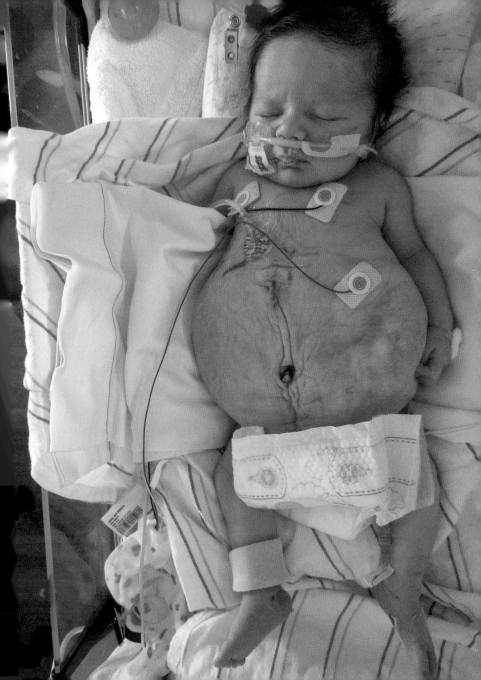

ENDOMETRIOSIS

37 YEARS OLD | PLYMOUTH, DEVON, UNITED KINGDOM

◊

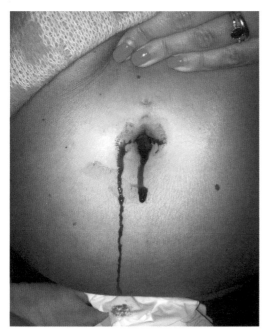

to pathology and diagnosed as endometriosis. Endometriosis occurs when endometrial glands grow outside the uterine cavity.

Endometrial glands are groups of cells that normally line the uterus. These glands change daily with the menstrual cycle and are responsible for preparing the uterus for a pregnancy. If a pregnancy does not occur, these glands become necrotic (dead) and shed. The shedding of the endometrial glands is also known as menstruation, or a monthly period.

Endometriosis can occur anywhere in the body, but most often it is seen seeded throughout the pelvic cavity.

wo years ago, this patient noticed a nodule in her belly button. For six months it was slowly growing and didn't bother her. She decided to get the nodule looked at when it started turning black-and-blue in color. Her doctor examined it and recommended surgery; soon after this, the nodule ruptured and was bleeding continuously. When the nodule was removed, it was sent

In this case, the endometriosis formed a nodule on the patient's bowel which pushed through a small defect in her abdominal wall called an umbilical hernia. Endometriosis acts like the endometrial glands in the uterus, so it builds up and breaks down during each menstrual cycle. This patient's belly button was essentially having a menstrual period! ◊

◊

LINEA NIGRA

48 YEARS OLD | SALT LAKE CITY, UTAH, UNITED STATES

A few years ago, my sister-in-law was pregnant with my twin nephews. She developed a common skin condition often seen during pregnancy called *linea nigra*. The Latin term linea nigra translates to "black line."

Everyone has cells in their skin called melanocytes. These cells contain a pigment called melanin. The amount of melanin a person has determines their skin color: the more melanin pigment, the darker the skin.

The cause of this condition in pregnant women is unknown. However, it is thought to be from a release of hormones causing the melanocytes to produce more melanin. The "black line" of pregnancy is actually not black, but rather a dark brown. This dark pigment is just an increase of melanin in that area of the body. Additionally, the release of these hormones can cause dark skin pigmentation on other areas of the body, including causing the nipples to darken.

Everyone does not develop this line during pregnancy; however, it does seem to be more common in women with darker-pigmented skin compared to women with fair skin tones.

My sister-in-law initially noticed the line appear around her fifth month of pregnancy. She carried my twin nephews to term, and within a month of delivery the line disappeared. ◊

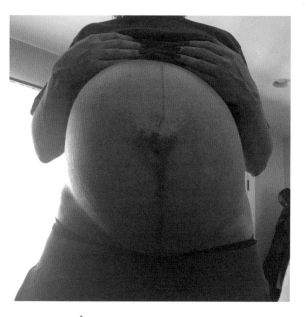

ADRENAL GLAND

◇

The adrenals are tiny triangular, flat glands that lay on top of each kidney. Don't let their small size fool you; their role is essential to the body! The adrenal glands have many layers, each composed of cells responsible for producing specific hormones. Functions of adrenal hormones include regulating blood pressure, metabolism, the immune system, the body's response to stress, and sex hormones. Disease of this gland can lead to an over- or underproduction of these hormones, causing devastating effects on the body.

◇

ADDISON'S DISEASE

29 YEARS OLD | ONTARIO, CANADA

◇

For years this patient had significant, unintentional weight loss, low blood pressure, and discolored skin. She knew she was sick but was dismissed by doctors who diagnosed her with anorexia nervosa. She was told her symptoms were "in her head" and was given antidepressants. It was not until she weighed eighty-eight pounds and in complete adrenal failure that she was taken seriously. A doctor that was not involved with her treatment saw her file and contacted her. That doctor saved her life, as he diagnosed her with Addison's disease.

In Addison's disease, the adrenal glands are not making enough steroid hormones. This can be an autoimmune condition (the body attacking itself), or can be caused by other things, like infections and certain medications such as corticosteroids. Symptoms of Addison's disease include weight loss (Figure 1), darkening of the skin (Figure 2),

without sun exposure, weakness, and low blood pressure. Did you ever notice JFK had a perfect tan every day of the year? It was not because he was lying out daily in the White House Rose Garden! It was

Figure 1

◇

because he had Addison's disease. When the adrenal glands are not making enough steroid hormones, it triggers other hormones to increase. These hormones act like a stimulant to increase melanin production in the skin. Melanin is the pigment that is responsible for giving us our skin color. The more melanin, the darker our skin is.

She was given steroid treatments, which she will be on for a lifetime. She is feeling significantly better, but she will have this disease for the rest of her life. Addison's disease is a serious condition, and if not treated, can lead to severe life-threatening symptoms such as low blood pressure and death. ◊

Figure 2

CUSHING SYNDROME

23 YEARS OLD | CLARK, NEW JERSEY, UNITED STATES

Four years ago, this patient started having symptoms of rapid weight gain (Figure 1), anxiety, depression, and memory loss. She had several appointments with her gynecologist, who at first told her that her symptoms were caused by the stress of her first year of college. Her doctor finally agreed to do testing, and when her blood results came in, she was sent to a specialist called an endocrinologist. An endocrinologist is a doctor who specializes in the endocrine system. The endocrine system is made up of different glands that produce and secrete hormones. These hormones each have different functions, including growth, metabolism, and sexual development.

The endocrinologist was quickly able to identify she had something called Cushing syndrome, and within weeks she had an official diagnosis. Cushing syndrome, or hypercortisolism, occurs when the body is exposed to high levels of cortisol for long periods of time. Cortisol is a "stress hormone" made by the adrenal gland. It regulates our body's metabolism, our immune system, and our response to stress. Under normal conditions, the gland releases different levels of cortisol throughout the day depending on what is needed. If too much is released it can cause widespread issues throughout the body, including rapid weight gain, a round "moon face" (Figure 2), stretch marks, and mood swings, to name a few. Cortisol can be elevated due to a pathology, such as a tumor in the adrenal or pituitary glands, or it can occur from external factors such as medications. In this patient's case, her source of Cushing syndrome is unknown. Since the onset of her symptoms three years ago, she has gained 116 pounds. She is currently on medication, and her symptoms are lessening. Doctors are still investigating why her cortisol is raised, so her prognosis is not completely known at this time. ◊

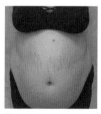

Figure 1

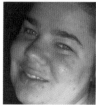

Figure 2

PHEOCHROMOCYTOMA

25 YEARS OLD | MIRAMAR, FLORIDA, UNITED STATES

For years, this patient was dealing with worsening symptoms including crippling anxiety, intense sweating, fatigue, and high blood pressure that were not responding to treatment. She sought medical treatment from multiple doctors, who all attributed her symptoms to anxiety. Luckily, during this time, she was also in nursing school learning about the endocrine system. She learned about a tumor called a pheochromocytoma and the symptoms associated with it. She suggested this to her doctors but was dismissed because these are so rare. One day, despite being treated for high blood pressure, she was diagnosed with malignant hypertension: extremely high blood pressure that develops rapidly. If this is not treated as an emergency, it could lead to a heart attack, stroke, or even death. She knew her life was in danger, so she decided to see a specialist, an endocrinologist. An MRI was ordered, which showed a three-inch tumor on her adrenal gland the size of a large grapefruit (Figure 1)! The MRI findings and her symptoms allowed doctors to give her the diagnosis of a pheochromocytoma. This tumor is usually not cancerous, but it can cause the hormones of the adrenal gland to get out of whack, leading to symptoms including high blood pressure, sweating, shakiness, and a rapid heartbeat. ◊

Opposite page: Figure 1

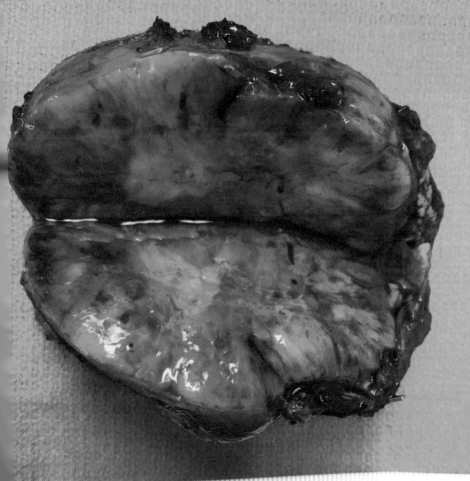

ANUS

◇

The word might be funny, but anal pathology is no joke. The anus works hard every day to remove waste from the body. We must eat to survive. Food is ingested, the body takes the nutrients it needs, and the rest is pooped out through the anus. If the anus is working normally, it's rarely on our minds. When the anus is diseased, it can be extremely painful, severely affecting a patient's quality of life.

CANCER

35 YEARS OLD | MELBOURNE, FLORIDA, UNITED STATES

◊

Anal cancer is not the same as colon cancer: it is much rarer, and most cases arise from an HPV infection. HPV, or human papillomavirus, is a sexually transmitted virus, and certain strains have the capability to turn healthy cells into cancer.

When this patient was thirty-four, she started having what she thought was severe constipation. She consulted with her family doctor and a gastrointestinal doctor. She had a colonoscopy, was diagnosed with constipation, told to make changes to her diet, and prescribed stool softeners. During the months after this diagnosis, she went to the emergency room several times with complaints of severe abdominal pain and stool coming out her vagina. Each time, she was given stool softeners and told to follow up with her doctor. She finally made an appointment with a surgeon who gave her a digital rectal exam and felt a tumor so large that it was almost completely obstructing her anus. Since the tumor was obstructing the normal exit for feces (the anus), her body formed what is known as rectovaginal fistula tract. This allowed the feces to exit her rectum through a tract that communicated with her vagina. The rectovaginal fistula was diagnosed when feces were discovered oozing out of her vagina.

She was admitted to the hospital, where she had an ileostomy placed to route her bowel away from the tumor. The anal tumor was biopsied, and she was diagnosed with stage 3 squamous cell carcinoma of the anus. Unfortunately, she was not a candidate for surgical removal of the anal tumor because it was so large and involved her vagina and lymph nodes. The treatment included radiation for four weeks, causing such severe burns she was hospitalized (Figure 1) for burn treatment and pain therapy. Her burns healed up nicely and she has not had a recurrence of the cancer in two years. She has permanent scars on her bikini line and sex is often painful and not pleasurable. At this time, she is still living with an ileostomy but has plans to have it reversed in the future. ◊

Figure 1

◊

HEMORRHOIDS

61 YEARS OLD | EDGEWOOD, MARYLAND, UNITED STATES

◊

After this patient's pregnancy at sixteen years old, she began experiencing symptoms including anal itching, discomfort while sitting, and rectal bleeding. At her postpartum visit, she was diagnosed with internal and external hemorrhoids. .

There are veins present in and around the anus. If there is an increase in pressure to these veins, the veins can become swollen and protrude into the anal canal. These swollen veins are called hemorrhoids. Hemorrhoids are typically common in pregnancy because the growing fetus puts extra weight and pressure on the veins behind the uterus.

Additionally, hemorrhoids can occur from straining while going to the bathroom, constipation, a low-fiber diet, anal sex, and regularly lifting heavy items.

Once a person has hemorrhoids, they can have repeated episodes of pain and discomfort throughout their life. This is called a hemorrhoid flare. This patient has had multiple flares throughout her life. On occasion, her hemorrhoids would swell up to the size of a cherry; however, she has been able to control them with hemorrhoid cream, pads, and sitz baths (soaking the rectal area).

Sometimes hemorrhoids can become more severe and painful if blood clots within the swollen vein. This is called a thrombosed hemorrhoid. Severe hemorrhoids can require more invasive treatments, even surgery.

Hemorrhoids have stayed with her throughout her life. After her second pregnancy, she experienced a flare-up and continues to experience them periodically. ◊

◊

PROCTECTOMY

28 YEARS OLD | TWEED HEADS, AUSTRALIA

As a child, this patient had multiple bouts of bloody diarrhea with mucous and pus, in addition to weight loss, abdominal pains, fatigue, and nausea. At age eleven, she was diagnosed with a condition known as ulcerative colitis.

Ulcerative colitis (UC) is an inflammatory bowel disease. UC, which is thought to be an autoimmune condition, occurs when the body attacks the lining of the colon, causing severe inflammation and ulceration. These chronic changes can increase the risk of colon cancer in these patients.

The symptoms in patients with UC vary greatly from person to person. Patients with UC can go long periods of time with little to no symptoms and then have periods called "flares" where they experience severe symptoms that can be debilitating and greatly affect the patient's quality of life, even with treatment.

At first, she was given a variety of treatments to suppress her immune system, including biologic and anti-inflammatory medications and oral steroids. Unfortunately, her body did not respond well to the treatments. About five years ago, the only option left was surgery.

When patients have UC, it can affect the whole colon or parts of the colon. Therefore, the approach to surgery with each UC patient is different. In her case, it was decided the best option for her would be to remove her entire colon, but leave a stump of her rectum and anus, so eventually she could return to going to the bathroom normally. During the surgery, her doctor temporarily rerouted her small bowel outside her body through a hole in her abdomen so she could eliminate waste as her body was healing. The waste emptied into a bag called an ileostomy bag.

The next part of her surgical plan was to create a new rectum for her called a J-pouch. A J-pouch is formed when the surgeon sews together two pieces of the small bowel to create a pouch that acts like the rectum to hold stool. During this time, her small bowel was still routed out of her abdomen.

Unfortunately, she experienced several complications with her J-pouch for years following the surgery. The site where the surgeon sewed the two pieces of small bowel together (the anastomotic site) leaked several times, which led to several episodes of localized infections or abscesses. Some of these abscesses became more serious and spread to her bloodstream, leaving her with life-threatening infections.

Through multiple treatments, her J-pouch healed well enough that her doc-

tors felt they could reroute her small bowel from outside her body back to the newly created rectum. After this surgery, she was able to go to the bathroom normally again through her anus, but that was short-lived. Her J-pouch continued to give her severe complications, and within five months, she was told she needed a more drastic surgery called a proctectomy.

The proctectomy, which completely removed the infected J-pouch, the remainder of her rectum, and her anus, was a success. Her small bowel was rerouted back through her abdomen out of her body, this time for good. She now has a permanent ileostomy bag.

After her proctectomy, she was left with no anal opening and has what some UC patients refer to as "Barbie Butt." It is called this because these patients have a butt but no anus.

After years of suffering with the complications of ulcerative colitis and multiple surgeries, she is finally starting to regain her quality of life. She will always be at an increased risk of infections and complications from her long battle with UC, but it looks like the worst is behind her. ◊

APPENDIX

⟡

Considered a vestigial organ, the human appendix is a remnant from our ancestors. While studies suggest the appendix had served a purpose at some point in time, that is not the case today. Scientists don't necessarily know what the purpose was; in fact, it is still not completely known what the appendix does. Since the appendix possesses lymphatic cells, it is thought that it may contribute to the immune system in some way. Even though the appendix does not do much for us, it can cause big problems when it develops pathology.

APPENDICITIS

27 YEARS OLD | HAMPTON, VIRGINIA, UNITED STATES

This patient has a history of diverticulosis (pockets that form in the lining of the colon due to weaknesses in the bowl wall) and constipation. One day while he was at work, he started having abdominal cramping. Later at home, he went to the bathroom twice with no relief. His pain worsened and the cramping increased in frequency by the end of the night. As his wife was getting ready to take him to the emergency room, he passed out twice, and another time as she was getting him into their truck. Once at the hospital, he was given a CT scan, was diagnosed with appendicitis, and was scheduled for a surgery called an appendectomy. This surgery is usually done laparoscopically (through tiny incisions in the abdomen and using a camera). He has since made a full recovery. His wife works at the hospital where his surgery was performed. She was able to view the gross examination of her husband's appendix in pathology, and even held his appendix! ◊

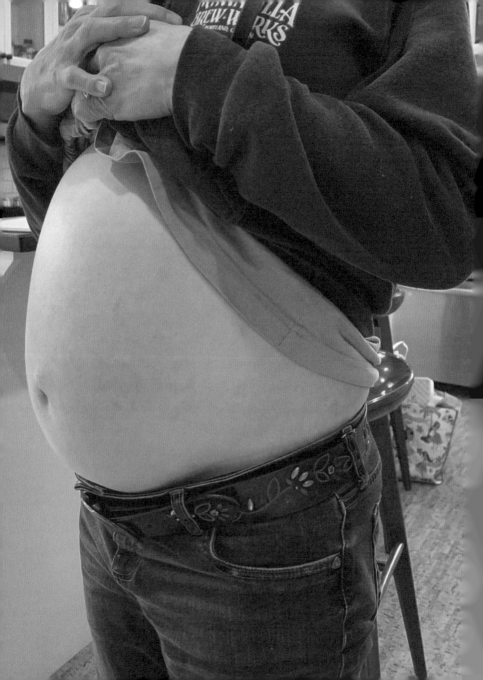

PSEUDOMYXOMA PERITONEI

59 YEARS OLD | PORTLAND, OREGON, UNITED STATES

◇

This patient started having difficulty holding in her urine and would even wet herself on her daily walks. She thought she was having a problem with her pelvic floor muscles and was planning on speaking to her doctor about it after COVID-19 restrictions were lifted. Within two months, her belly started to get big, and she looked like she was pregnant. She was very tired and felt very uncomfortable and full. She called her doctor and described her symptoms, but due to the pandemic, she was not able to be seen for one month. Over the course of that month, her abdomen significantly increased in size, and she had difficulty breathing. She had an ultrasound and CT scan and was told that she had a large mass in her abdomen that was probably originating from the ovary. She was sent to a gynecologic oncologist for surgery. A gynecologic oncologist is a gynecologist who specializes in surgical procedures involving tumors of the female genital tract. When she was opened up, the surgeon quickly realized what was causing her belly to be so distended, and it was not an ovary tumor! Her belly was filled with liters of mucin, and she was diagnosed with pseudomyxoma peritonei.

Pseudomyxoma peritonei, or "jelly belly," is a rare condition when the abdominal cavity fills up with a clear, jellylike substance called mucin. The mucin comes from a tumor somewhere in the abdomen or pelvis, most commonly the appendix, but can also come from the ovary, colon, or stomach. In this case, her tumor was not originating in the ovary as was originally suspected; it was a malignant tumor called a low-grade mucinous neoplasm that was arising from the appendix.

It is unknown why this occurs, but in some cases, mucin-producing tumors can get seeded through the abdominal cavity, causing the body cavity to fill up with the mucin. The accumulation of the mucin causes abdominal distention, as well as compression on the organs, giving the patient the feeling of fullness, pressure, pain, and difficulty breathing.

After the surgery, she was referred to a colorectal surgeon, who plans to monitor her with blood tests and imaging. It is expected that she will need more surgical procedures in the future. Since the surgery, she has lost over thirty pounds, eighteen of which was mucin that was removed from her abdomen. ◇

◇

ARM

◇

Arms are one of our most essential body parts and what makes us different from most animals in the world. Humans are one of the few species of animal to walk on two legs (biped), but we do not use our arms as legs, like most animal species do. Since we walk upright on two legs, the function of our arms allows us to multitask and has been essential for the advancement of humans as a species.

◇

T R A U M A

This patient was a passenger in her boyfriend's car when they suddenly hit a culvert at the side of the road. The car became airborne and hit a telephone pole and a few trees before landing. As the car rolled through the air, the sunroof broke and caused her arm to be partially amputated and degloved. A degloving injury occurs when skin is ripped from the underlying muscle, soft tissue, and bone.

The property owner called 911. First responders arrived at the scene immediately and were shocked to find the victims of the crash were still alive. The patient's boyfriend was thrown 180 feet from the car and had head and shoulder injuries. She was still trapped inside the bent car, and her badly injured arm was pinned. First responders had a difficult time and had to use three separate tools to remove her from the car. A doctor was called to the scene to evaluate the condition of the arm. It was determined that the damage was so extensive that there would be no way to save it, so a decision was made to amputate at the scene, after which she was rescued from the car. Her arm was brought with her to the hospital, but unfortunately, it could not be reattached and was later disposed of as medical waste. She spent two weeks in the hospital and had four surgeries, including a skin and muscle graft from her back to cover the wound. After her wounds healed, she was fitted for a basic prosthetic, but has now decided she can function better without it. She still experiences phantom pain (feeling in a body part that is no longer there).

Since the accident, the patient has had some amazing achievements. Within two weeks of being released from the hospital, she taught herself how to tie her shoe one-handed. She was back to work within six months, building private airplane cabins. She can also cook, play sports, and put her hair in a ponytail one-handed. ◊

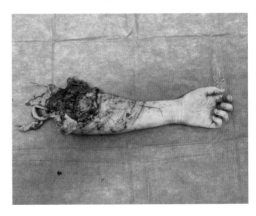

BLADDER

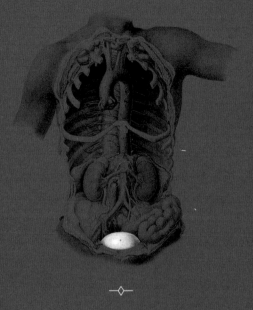

—◇—

The urinary bladder is part of the lower urinary tract. After urine is made in the kidneys, it travels down the ureters, entering a storage receptacle called the bladder. The bladder is a hollow organ made of muscle that expands when filled and contracts when emptied. Our bladders store waste our body doesn't want. Sometimes this waste can be filled with toxins and carcinogens, especially in patients with chemical exposures or those who are smokers. These toxic substances can leave patients susceptible to pathology in the bladder, especially after repeated exposure.

CANCER

36 YEARS OLD | BOISE, IDAHO, UNITED STATES

◊

This patient started having blood-tinged urine five years ago. After six to eight months of this, he finally told his wife, who immediately called his doctor. He was referred to a urologist but couldn't get an appointment for two months. The urologist ordered an MRI and performed a procedure to view the inside of the bladder called a cystoscopy (Figure 1). He was diagnosed with bladder cancer, and surgery was scheduled immediately. The tumor was successfully removed and diagnosed as a noninvasive papillary urothelial carcinoma, low-grade. Luckily, the tumor was superficial and could be easily removed by surgery. No other treatment was required. The patient will continue to be monitored, however, for the rest of his life. The urologist was quite surprised to find bladder cancer in someone as young as thirty-one years old with no apparent risk factors.

Bladder cancer has a high association with tobacco use and chemical exposures, neither of which this patient had. It is also associated with chronic irritation of the lining of the bladder. Two years prior to his diagnosis, he was traveling often for his job, spending long hours on the road. He was drinking two to three energy drinks a day to stay awake. Often there were no bathroom breaks for hours, and he wasn't drinking enough water. His urologist believes this may have contributed to his cancer. ◊

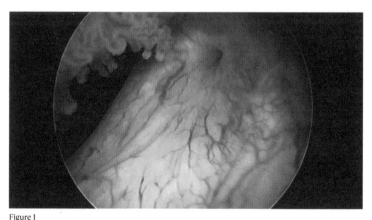

Figure 1

◊

BONE

—◇—

A human infant is born with around 270 bones—that is more than an adult! As the child grows, some bones start to fuse, or stick together. By the time a baby reaches adulthood, they will have around 206 bones. This number varies because of anatomic variation. Each of our bones has a specific structure and function aiding in movement, stability, and protection of the body. Bones also store nutrients and house bone marrow, which is responsible for the development and storage of blood cells. Bone pathology is something a patient can be born with or something that can be acquired throughout their life from exposures, trauma, or natural disease.

EWING'S SARCOMA

27 YEARS OLD | BUSHTON, WILTSHIRE, UNITED KINGDOM

◊

When this patient was fifteen years old, she started having pain that she attributed to growing pains for a year. The pain started interfering with her sleep, and she began having night fevers. Then, she noticed an almond-sized nodule in her groin. Within a week, she went to her doctor for treatment. For six months, she was misdiagnosed with viral infections, anemia, even TB! Her pain level was repeatedly ignored, until her mother demanded she get an X-ray. Doctors immediately saw something suspicious and quickly ordered an MRI, PET scan, and biopsy. The biopsy came back as Ewing's sarcoma, a rare cancer that arises in bones and soft tissue. It can occur at any age, but is most common in children ages ten to twenty, with a slightly higher incidence in males. The prognosis is determined based on the patient's age, tumor location, and extent of the tumor at diagnosis.

At the time of this patient's surgery, her tumor was localized and did not spread. The surgery removed the mass (Figures 1 & 2), and her follow-up treatment included aggressive chemotherapy, followed by additional surgery, a hip replacement (Figure 3), more chemotherapy, and finally, six weeks of radiation. She was given an 80 percent chance to live, and after ten years, she is alive and doing well with no sarcoma recurrence. ◊

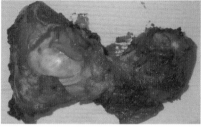

Figure 1

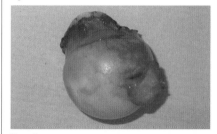

Figure 2

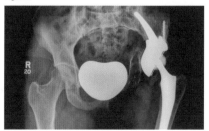

Figure 3

◊

GIANT CELL TUMOR

31 YEARS OLD | NIPOMO, CALIFORNIA, UNITED STATES

This patient was working out a couple years ago when she took a deep breath and felt a terrible pain in her ribs. She noticed a very hard bump on the upper right side of her chest. She went to her doctor, who was not sure what the bump was, but ordered a mammogram with ultrasound because she had a family history of breast cancer. The radiologist that performed the testing suspected that the mass was not from the breast but from the bone, and ordered a CT scan to confirm. The CT scan showed a huge mass on the third rib. They performed a biopsy, which diagnosed the mass as a giant cell tumor. A giant cell tumor is a benign tumor of the bone.

These tumors are not cancerous, but they will destroy healthy bone, so it is important that they are removed. The patient was sent to a specialist, who confirmed the diagnosis and scheduled her for surgery. Surgeons had to make an incision under the right breast to access the tumor. A portion of the third rib, along with the tumor, was removed (Figure 1). The recovery was long, and she has lost feeling in her right breast, but the tumor was completely removed and she is doing well. She will have yearly CT scans to monitor and ensure that the tumor has not grown back. ◊

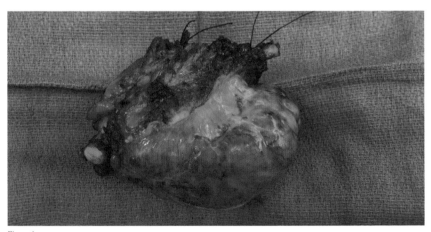

Figure 1

PECTUS EXCAVATUM

20 YEARS OLD | PITTSBURGH, PENNSYLVANIA, UNITED STATES

◊

This patient was diagnosed with a condition known as pectus excavatum at birth. Pectus excavatum is a bone deformity in which a patient's sternum (breastbone) is sunken into the chest. A patient can live a long, healthy life with this condition without having any problems, but sometimes the deformity is so severe it can compress the underlying heart and lungs. It is unknown what causes this deformity, but it tends to be seen in families and is more common in males. This patient's brother and father also have pectus excavatum. Luckily, his deformity has not caused any underlying health effects, but he was told he could elect to have surgery in the future to repair it for cosmetic reasons. ◊

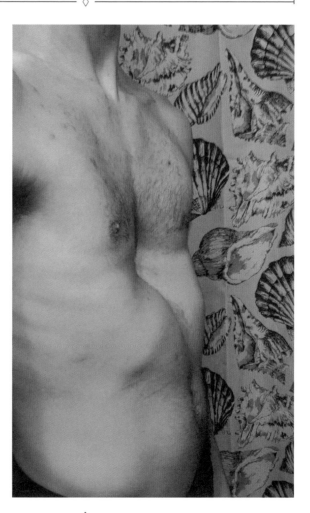

◊

THORACIC OUTLET SYNDROME

19 YEARS OLD | FORT WORTH, TEXAS, UNITED STATES

This patient was a competitive cheerleader. Three years ago, she started seeing her pediatrician for right shoulder, arm, and hand pain and numbness. Her doctor noticed she had an unusually tight trapezius muscle and sent her to an orthopedic specialist. She went through multiple treatments, including physical therapy and a custom cast for sleeping to stabilize the arm, and testing including X-rays, MRIs and an EMG/NCV (tests done to check if nerves are working properly). After all of the testing, it was determined she had thoracic outlet syndrome and needed surgery to remove her first rib (Figure 1) and the surrounding muscle.

Thoracic outlet syndrome occurs when the nerves or blood vessels in the space between the collarbone and first rib become compressed. In this patient's case, strenuous exercise and weight bearing on her shoulders for years as a cheerleader was the cause. It has been one and a half years since her surgery. While she is feeling some relief, she still experiences symptoms of numbness and tingling. She has had to make some changes, including avoiding strenuous activities, and she is no longer able to be a cheerleader. ◊

Opposite page: Figure 1

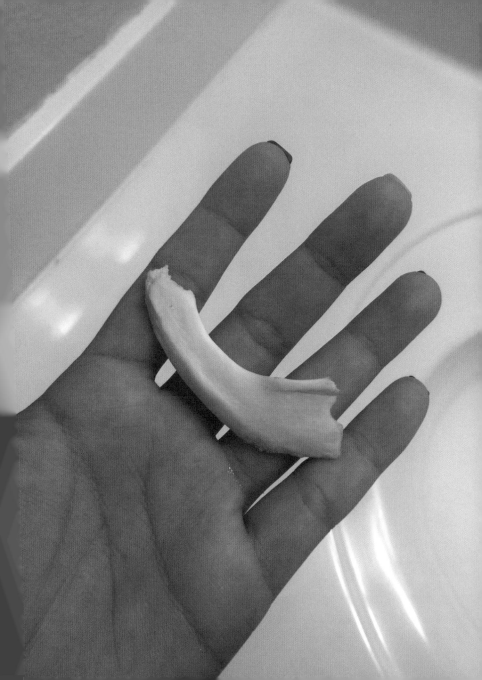

BRAIN

The human brain is only about three pounds but is one of the most powerful things on earth! It's responsible for making humans the most intelligent animal on the planet. Although males tend to have larger brains than females, brain size does not always correspond to intelligence. The human brain is way larger than it looks. The wrinkles on the outside of the brain are actually folds. The brain is folded up like an accordion so it can fit into the tight storage unit known as the skull. Brains are very soft (similar to the consistency of gelatin) and are protected by layers of tissue called the meninges within the skull. Since the brain is so tightly enclosed in this rigid storage unit, there is not much space for swelling or accumulation of blood if trauma or natural disease occurs. The brain is the central command center for our entire body; if it is injured, it can lead to severe debilitating effects, and in some cases, death.

SUBARACHNOID HEMORRHAGE / ANEURYSM

31 YEARS OLD | NORMAN, OKLAHOMA, UNITED STATES

◇

Six years ago, this patient and her husband were in school to become physician assistants. For months, they were assigned different rotations in different cities and were living apart. In their first month living back together again, the patient started experiencing a severe headache, followed by vomiting. She had a long history of migraines. This headache was worse than any migraine she ever experienced, but she was content taking medication and trying to sleep it off. Luckily, her husband recognized this was more than her typical migraine and called 911. Soon after, she lost consciousness and was rushed to the hospital. At the hospital, she was diagnosed with a brain bleed called a subarachnoid hemorrhage.

There are many layers under the skull to protect the brain. These layers are called the meninges. There is a thin, translucent layer of the meninges that covers the brain itself like a piece of cling wrap. This layer is called the arachnoid mater. If a bleed occurs under this layer, it is called a subarachnoid hemorrhage.

Bleeds under this layer can happen in cases of trauma; however, they most commonly occur in patients with a ruptured brain aneurysm. A brain aneurysm is when there is a weakness in an artery wall within the brain that causes the artery to bulge out. This bulge essentially is a ticking time bomb. If the aneurysm ruptures, blood will accumulate under the arachnoid layer, causing a patient the worst headache of their life and ultimately death if it is not treated quickly.

The patient has no known risk factors for a brain aneurysm. The most common risk factors are a history of cigarette smoking and high blood pressure. A family history of aneurysms can also be a risk factor. It is possible her grandmother suffered from the same condition, however, that has not been confirmed.

In the neuro-ICU (a special intensive care unit for patients with brain injuries), she was diagnosed with a ruptured aneurysm, and the decision was made to do a minimally invasive procedure called endovascular coiling (Figure 1).

The brain is contained within the skull, and it is difficult to access without cutting through skin and bone. Over the years, different procedures have been discovered that allow surgeons to enter the brain without cutting the patient.

◇

Endovascular coiling is when a catheter is placed in an artery in the groin and fished all the way up into the brain near the aneurysm. Once the catheter is in place, platinum coils are released. These coils promote clotting so the blood can no longer leak out.

This patient credits her husband for saving her life and was thankful the two were together when this ruptured aneurysm occurred, otherwise she would be dead.

About eighteen months later, her husband had a feeling something was not right and nudged his wife to move up her follow-up appointment. During her screening, it was discovered that another aneurysm had formed next to the coils. It was at this time the surgeon recommended surgical clipping.

During this procedure, the surgeon removes a piece of skull to enter the cranial cavity. The surgeon then identifies the blood vessels where the aneurysm is located and clips it off to prevent blood flow. This surgery has more risks and is more invasive than endovascular coiling; however, the couple knew they had to make this choice to save her life.

Since the surgical clipping, she is continually monitored but has had no further complications from her subarachnoid hemorrhage and ruptured aneurysm. She is the mother to two children and is working successfully as a physician assistant in orthopedics. ◊

Figure 1

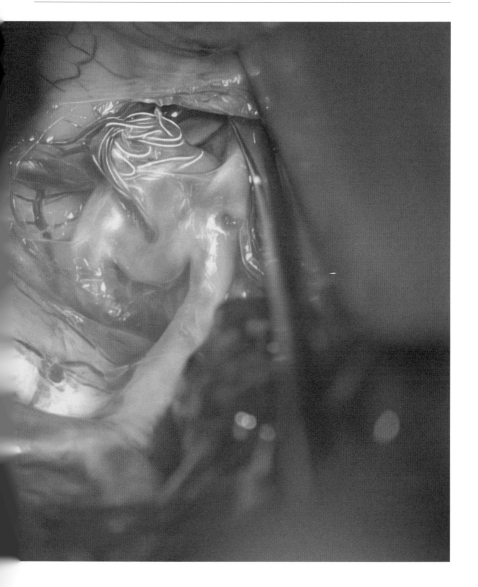

BREAST

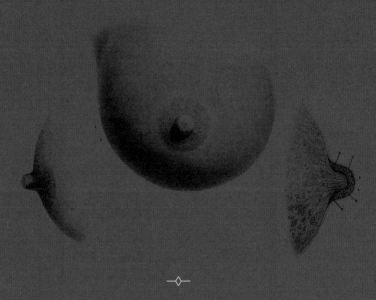

The anatomy of both female and male breasts are almost identical, except for specialized lobules in females. The female breast was anatomically designed for one purpose: feeding babies! The milk glands, or lobules, of the female breast make milk that travels through ducts and exits the body through the nipple. These lobules and ducts are surrounded by fibrous tissue and fat. Pathology most frequently occurs in the lobules and ducts. Since males don't have these, breast pathology is more common in females.

CANCER / IMPLANTS

54 YEARS OLD | CALAVERAS COUNTY, CALIFORNIA, UNITED STATES

When this patient had a routine mammogram seven years ago, calcifications were seen. Calcifications are small deposits of calcium that can be seen on mammography. Most calcifications are benign, but the presence of calcifications can indicate the presence of a cancerous tumor. She was sent for a second mammogram, followed by a biopsy that showed abnormal cells. A lumpectomy surgery (in which a portion of the breast is removed) was performed, removing a small (0.4 cm) tumor that was diagnosed as Stage 1 invasive breast cancer. At the time of her diagnosis, she was given two options: radiation or further surgery. She opted for surgery so she would not have to worry about yearly mammograms or a possible recurrence. She had a double mastectomy, during which textured tissue expanders were inserted to stretch the skin for future reconstructive surgery. Five months later, the tissue expanders were removed and replaced with smooth silicone breast implants. After the incisions healed, she had her nipples reconstructed and tattooed (Figure 1).

Everything looked great, and she was happy with the results. Shortly after, she started developing symptoms including arm, shoulder, back, and neck pain, followed by unexplained blistery rashes on her hands, legs, shoulders, and chest. She was put on steroids, but as soon as she was done taking them, the rashes returned. The rashes were followed by daily headaches, joint pain, weight gain, fatigue, dry skin, and generalized discomfort. After talking to other women who experienced similar symptoms, she decided to have her implants removed (Figure 2). She chooses to be "flat," with no future plans of reconstruction. She is feeling great and would rather be healthy and active than sick with nice breast implants. ◊

Figure 1

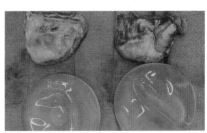

Figure 2

GYNECOMASTIA

19 YEARS OLD | DURHAM, NORTH CAROLINA, UNITED STATES

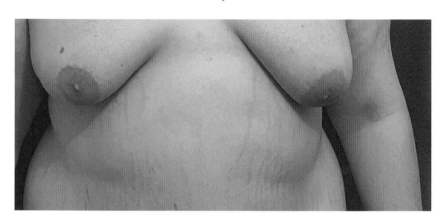

This patient noticed his breasts were starting to enlarge at age thirteen. At first his mother thought it was associated with puberty, but it persisted over the years. It was suggested by a doctor to lose weight in the hope that the breasts might shrink, but after losing weight, his breasts remained enlarged. He was diagnosed with a condition known as gynecomastia after his doctor confirmed his enlarged breasts were due to an increase of breast tissue, not just fat.

Gynecomastia is a condition that causes the breast tissue in males to grow, giving the appearance of female breasts. The most common reason this occurs is a hormonal imbalance. The hormone estrogen is responsible for female sex characteristics, including breast growth, while testosterone is responsible for male sex characteristics such as muscle mass and body hair. Both males and females have both of these hormones, the balance is just different in each sex. Gynecomastia usually occurs when a male is making too much estrogen or the balance of estrogen to testosterone is off.

In this patient's case, doctors have not been able to determine the cause of gynecomastia after several tests. He has consulted with a plastic surgeon and was approved by his health insurance for a mastectomy to remove the unwanted breast tissue, as well as a nipple graft. He has not yet decided whether to have the surgery. ◊

PHYLLODES TUMOR

41 YEARS OLD | TALLAHASSEE, FLORIDA, UNITED STATES

◇

This patient started feeling a mass growing in her breast ten years ago. As it grew, it became painful and itchy. She ignored it because she was afraid, but eventually sought treatment when it grew to the size of a cantaloupe (Figure 1); so big that it made her right breast three times larger than the left. She even named her tumor Barbara! The tumor was surgically removed and was diagnosed as a phyllodes tumor of the breast.

This is a rare tumor that grows from the tissue surrounding the glands of the breast. Most of these tumors are benign (as in this case), but a small percentage of them can be malignant, which is why it is important to have it removed and examined by pathology. Because this patient was relatively young, with dense breast tissue, the defect from the tumor removal is barely noticeable and did not require reconstructive surgery. ◇

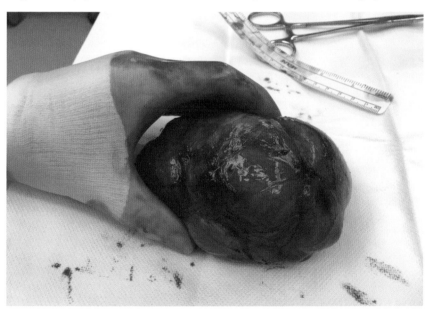

Figure 1

◇

MASTITIS

29 YEARS OLD | BATON ROUGE, LOUISIANA, UNITED STATES

This twenty-nine-year-old female from Baton Rouge, Louisiana, developed a condition known as mastitis shortly after giving birth to her first child. Her baby was born with a condition known as ankyloglossia, or was "tongue-tied." This caused the baby to have difficulty latching, to be more aggressive on the nipple, and have extended feedings of up to forty-five minutes. The patient's nipples quickly became extremely cracked, allowing bacteria to be introduced into the breast, causing an infection in the breast called mastitis (Figure 1). Her milk became thickened and was not able to leave her body due to the clogged ducts, creating a backup in the system, burst ducts, and a pocket behind the nipple called a galactocele. This was extremely painful, but she continued to breastfeed. She had a procedure to aspirate the accumulation of milk behind her nipple, which was unsuccessful. Within two weeks, she developed an abscess (a collection of pus) behind the nipple. Doctors told her at this time she was no longer able to feed from that breast, and she made the difficult decision to discontinue breastfeeding her baby. The abscess was lanced to release the pus (Figure 2). The wound had to be packed and cleaned twice a day for thirty-eight days. It has since healed, and she has a small scar. Her doctors attribute her pathology to her fatty breasts and extremely cracked nipples. She also has a history of breast implants seven years prior which doctors think is noncontributory. The surgeon and lactation consultants have advised that the milk ducts that burst may not reform, and she may have problems breastfeeding from that breast in the future. There is no way for her to know until she tries again. A diagnosis of mastitis for this mother was a very painful and emotional experience. ◊

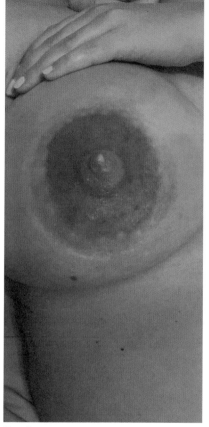

Figure 1

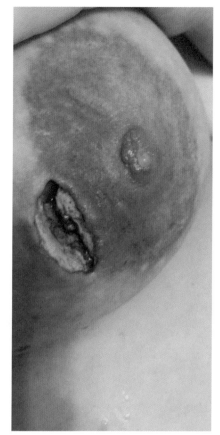

Figure 2

CIRCULATORY SYSTEM

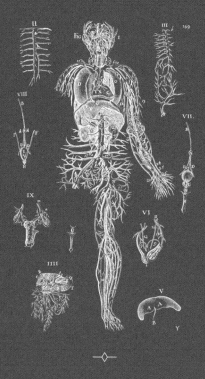

The circulatory system is responsible for circulating! Arteries bring oxygenated blood from the heart to all our organs. This is what keeps our bodies alive. After the organs use up all the oxygen they need, veins bring the blood back to the heart. Pathology of the circulatory system can occur in the blood vessels or the blood that flows through them.

ARTERIOSCLEROSIS

66 YEARS OLD | MEXICO CITY, MEXICO

This patient has a long-standing history of uncontrolled diabetes and alcoholism. He developed gangrene on one toe, and it spread to the top of his right foot. Despite having access to adequate healthcare, he opted for a home remedy which consisted of teas and foot soaks. That treatment failed, and he was forced to go to the hospital. First, he had a procedure done called a debridement, which removed all of the dead tissue (Figure 1). That treatment was not aggressive enough, so they scheduled him for a toe amputation. During the surgery, he was "woken up" to get consent to amputate his entire foot below the ankle. He refused the amputation and was told there was a possibility he would have to have his leg amputated below the knee. Gangrene is a serious complication of diabetes. Diabetes is a condition in which there is too much glucose in the blood. Glucose is a type of sugar the cells in our body need to function and survive. Normally, our pancreas makes a hormone called insulin. Insulin helps glucose get into the cells. With diabetes, there is a problem in the pancreas with insulin where it either does not make enough or it does not make any at all. The sugar cannot make it to the cells and stays in the blood. Too much sugar in the blood over time can damage the elasticity of blood vessels, causing them to become damaged. Over time, the arteries can become hardened and oxygenated blood cannot go where it needs to go. Gangrene occurs when there is death to a body part due to a lack of oxygen. ◊

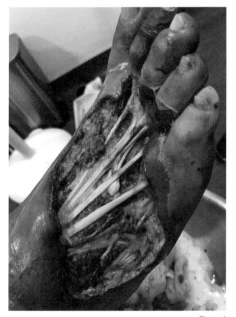

Figure 1

DEEP VEIN THROMBOSIS

18 YEARS OLD | NANAIMO, VANCOUVER ISLAND, BRITISH COLUMBIA, CANADA

This patient has a history of Ehlers-Danlos syndrome, a connective tissue disorder. A few months ago, she started feeling really tired, then developed lower abdominal pain, as well as pain in her left upper thigh. She went to a clinic and was seen by two nurse practitioners who were convinced she had an STD and ordered a pelvic ultrasound, despite her telling them she was not sexually active. She went for the ultrasound and was told they found nothing. That night, as she was changing into her pajamas, she was surprised to find that her left leg was very swollen and dark purple. She told her mom, and they immediately went to the emergency department, where there was a five to six hour wait. While waiting in the triage line, she fainted and was immediately taken to a bed. She was sent for an ultrasound and CT scan, and they found a massive clot in her upper left thigh and three smaller clots in her left lung. Doctors told her that she was at immediate risk for a leg amputation, stroke, or death. The vascular team decided the best treatment would be blood thinners, as surgery would be too risky. Luckily, she had a pulse in her left foot, and they were able to save her leg. She is recovering slowly after a one-week hospital stay and will be on blood thinners for the rest of her life.

DVTs are very unusual in healthy people. They usually occur in patients that have predisposing factors such as a history of cigarette smoking, use of contraceptives and hormone replacement therapy, a history of recent surgery, and prolonged bed rest. A DVT occurs when the blood in the deep veins of the leg clots. These large clots in the large veins can break off and travel to the lungs/heart, causing instant death.

In this case, the patient already has a history of a connective tissue disorder that can affect her vessels, but she had two additional risk factors that are known to cause DVTs: she was a smoker, *and* she was on oral birth control. Smoking constricts the blood vessels, and birth control hormones can increase blood clotting. The two can be a deadly cocktail. ◊

HEMATOMA

62 YEARS OLD | FREDERICK, MARYLAND, UNITED STATES

◊

hen this patient had a minor fall, he was not expecting what he saw when he looked at his injury in the mirror!

The patient was diagnosed with atrial fibrillation (A-fib) twelve years ago and is on a blood thinner called Warfarin. A-fib is a condition that occurs when the upper chambers of the heart beat irregularly. The blood is not moved through the chambers of the heart properly and can clot as a result. If a clot breaks off, it can travel to the brain and cause a stroke; this is why A-fib patients are put on blood thinners.

During his work as a home inspector, he had tripped, fallen off a step, and landed on his hip. When he arrived home, he was shocked to see a large bruise on his butt in the mirror. He went to the hospital, where staff were not too concerned with his bruised butt, but whether he had hit his head during the fall.

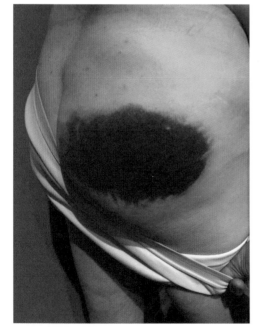

When a patient is on blood thinners, even small injuries can cause massive bleeding. When this patient fell on his hip, a small vessel in the butt was ruptured, causing a massive collection of blood under the skin called a hematoma. If he had hit his head, he would be at risk for a serious brain bleed. Luckily, he did not.

His hematoma has since healed, and now he is extra careful, using handrails on stairs while inspecting homes. His doctor has also switched him to a new medication that is less likely to cause bleeding like this. ◊

◊

RAYNAUD'S PHENOMENON

◊

Raynaud's phenomenon is a condition that causes an interruption of blood flow to the extremities due to exposure to cold or emotional stress. When a person is having a Raynaud's attack, the skin of the affected area (fingers, toes) turns white, then blue and cold. This condition is more common in women than men. Though Raynaud's itself is benign, it can be a sign of a more serious underlying condition, such as an autoimmune disease like lupus or scleroderma.

30 YEARS OLD | OMAHA, NEBRASKA, UNITED STATES

◊

Raynaud's phenomenon can also be an isolated finding associated with no underlying disease. This thirty-year-old from Omaha, Nebraska, was shocked when she received her engagement photos and saw she has been in the middle of a Raynaud's attack when the photos were taken! ◊

33 YEARS OLD | SAN DIEGO, CALIFORNIA, UNITED STATES

◊

At seventeen years old, this patient started experiencing Raynaud's attacks. Recently, at thirty-three years old, she was diagnosed with an autoimmune disorder called CREST syndrome. CREST is an acronym used to describe the symptoms of this syndrome: calcinosis (bumps of calcium deposits under the skin), Raynaud's, esophageal dysmotility (difficulty swallowing), sclerodactyly (hardening of the skin of the hand), and telangiectasia (spider veins). It is a limited form of systemic sclerosis (scleroderma, meaning "hardened skin"). ◊

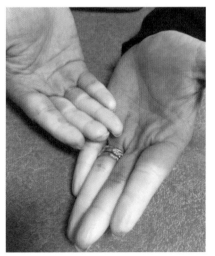

◊

VENOUS MALFORMATION

30 YEARS OLD | SEATTLE, WASHINGTON, UNITED STATES

This patient started having mild but persistent pain in her right forearm three years ago. Figuring it was a muscle strain, she backed off her right hook while kickboxing. Last year, the pain increased suddenly, and she wasn't able

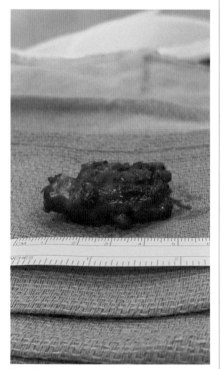

Figure 2

to sleep. She saw a doctor, was diagnosed with a muscle strain, and sent to three weeks of physical therapy. The pain did not improve, and she then noticed a large lump under her skin (Figure 1). MRIs and a CT scan revealed a vascular tumor that was nestled against her radial nerve. She was referred to a specialist, who told her she had a venous malformation.

A venous malformation occurs when a person is developing as a fetus. The veins in a certain area of the body do not form correctly and can become kinked and enlarged, forming a benign mass which is basically a ball of veins! The cause is unknown; most grow spontaneously, while some are thought to have a genetic component.

This patient was treated with embolization to make the mass firmer and easier to remove, because it was embedded within the nerve. Surgery was performed the next day, removing most of the mass from the arm (Figure 2), but the surgeon had to leave a small piece behind in order to save her nerve functions. She is now all healed and recovering well! ◊

Opposite page: Figure 1

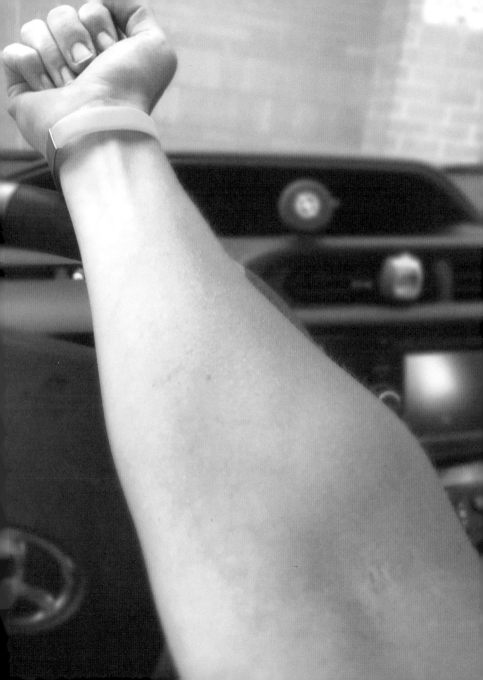

DIGESTIVE SYSTEM

The digestive system performs magic every day. It can take a slice of warm, delicious, gooey cheese pizza and transform it into a brown, smelly turd! The digestive system is essentially an enclosed tube within our bodies, starting at the mouth and ending at the anus. Since eating is an essential part of life, pathology of the digestive tract can be extremely life-altering for some patients.

BEZOAR

19 YEARS OLD | CLARINGTON, OHIO, UNITED STATES

When this patient was twelve years old, she was having frequent vomiting and was not gaining any weight. She was sent to an endocrinologist, who felt a hard mass in her belly during a physical examination. After an X-ray, her doctor asked if she chewed or ate her hair. She was given an endoscopy to confirm the X-ray findings and was diagnosed with a trichobezoar, an

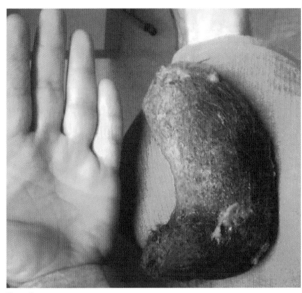

Figure 1

accumulation of ingested hair that forms a mass. This mass of hair cannot be digested and can cause an obstruction, as happened in this case. The patient had to have open abdominal surgery to remove the giant hair ball (Figure 1). At the time, she did not realize she was suffering from a condition known as trichotillomania: a psychological disorder where a person compulsively pulls out their hair. When she was watching TV, she would unknowingly pull out her hair and ingest it. Her parents caught her doing it a few times, but they did not think it was a concern. She has since healed from the surgery and has gained a normal amount of weight for age. She still occasionally pulls her hair out. ◊

CELIAC DISEASE

35 YEARS OLD | SAN DIEGO, CALIFORNIA, UNITED STATES

For most of her life, this patient has had abdominal pain and migraines. She thought these pains normal, especially because most of the people in her family experienced similar symptoms.

As she got older, she started to experience an increase in the severity of her symptoms, including severe diarrhea, weight gain, swollen ankles (Figure 1), bloating, migraines, and ataxia (difficulty with balance and walking). Over the course of several years, she went to the emergency room twice and visited four different gen-

Figure 1

eral practitioners. Most of the doctors dismissed her symptoms as stress related. The last doctor she saw took her symptoms seriously and sent her to a gastrointestinal doctor for a consultation. There, she was given a blood test, followed by an endoscopy (when a camera is inserted into the esophagus, stomach, and small intestine). A biopsy was taken of her small bowel, and she was diagnosed with celiac disease. She was thirty-two years old at the time of her diagnosis.

Celiac disease is a genetic (meaning, it runs in families), autoimmune (when the body attacks itself) disease. Celiac disease is also called gluten-sensitive enteropathy. Gluten is a protein found in wheat.

Normally, the small bowel is lined with tiny fingerlike projections called villi. Villi in the small bowel are responsible for grabbing the nutrients from the food we eat. When a patient with celiac disease eats gluten, their body creates an immune response which attacks the villi. When the villi are damaged, the patient cannot absorb nutrients properly.

Symptoms and severity in patients with celiac disease vary greatly. Some patients may experience little to no symptoms, while others have severe,

debitating symptoms that greatly affect their quality of life.

Since celiac disease is an autoimmune condition, it is common for celiac disease to be associated with other autoimmune disorders. If celiac disease is left untreated, it increases the risk of these patients developing additional autoimmune disorders.

The treatment for celiac is simple: eliminate gluten from the diet, the small bowel will heal over time, and the symptoms will go away. While this treatment is considered simple, it is not easy to maintain, especially when eating outside the home. Cross contamination and gluten hidden in foods can be a huge source of anxiety for patients with celiac disease.

Some celiac patients are so sensitive to gluten that a tiny crumb in their food can set off serious symptoms. After eliminating gluten from her diet, this patient had an accidental exposure at a restaurant. She was told the vanilla ice cream with chocolate topping she ordered was gluten-free. Almost immediately after eating it, her abdomen bloated, and she was in severe pain. Her abdomen was so swollen that she looked pregnant (Figure 2).

Celiac disease is genetic, and while no one in her family has been given a formal diagnosis of celiac disease, her maternal great-grandfather and grandmother suffered from similar symptoms most of their life. Most people with celiac disease have a gene variant they inherited from a parent,

Figure 2

which is a permanent change to the DNA of a gene. If a person is born with one of these gene variants, they may or may not have celiac disease throughout their life. This patient has tested positive for one of the gene variants and has also learned she passed this variant to her son. Fortunately, at this time, he is not affected by gluten.

Celiac disease will always be a part of her life. Something as simple as eating is a constant source of anxiety for her. She has taken part in countless research studies and trials to help find a cure for celiac disease. ◊

COLON CANCER

23 YEARS OLD | UBERLÂNDIA, MINAS GERAIS, BRAZIL

This patient was having problems going to the bathroom. He went to the doctor and was told he needed a colonoscopy. After taking the medication to clean out his colon for the procedure, he started having severe abdominal pain. He was rushed to the hospital, where a CT scan and colonoscopy showed a 3.5-inch tumor in his colon that was blocking his intestines. At the time of colonoscopy, the doctor marked the area of the tumor with tattoo ink so it would be easy for the surgeon to identify. The following morning, a portion of his rectosigmoid colon was surgically removed and sent to pathology (Figure 1). With additional testing, he was diagnosed with Stage 4 colon cancer, with metastasis to the liver and bone.

Colon cancer is a malignant tumor that arises in the large intestine. The stage of disease is based on the size of the tumor and where it has spread. In the most advanced (Stage 4), the cancer has left the colon and spread throughout the body. This cancer most commonly occurs in people over fifty years old. Other risk factors include family history and genetic syndromes.

In this case, the patient was a healthy twenty-three-year-old with no family or personal medical history of colon cancer. Doctors are unsure why he has such an aggressive colon cancer at his age, but have attributed it to weight gain, a lack of exercise, and stress caused by the pandemic. His prognosis is poor, but his attitude is not. He is fighting for his life every day and is living with his diagnosis one day at a time. ◊

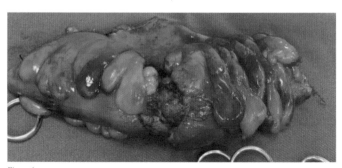

Figure 1

STOMACH CANCER

22 YEARS OLD | WOODLAND, WASHINGTON, UNITED STATES

Last year, this patient's grandmother died from stomach cancer associated with a gene mutation known as CDH1. Since this mutation can be inherited, the oncologist suggested that her whole family get tested. Soon after, this patient's test showed that she carried the gene mutation as well.

People with the CDH1 gene mutation have up to a 70 percent chance of getting gastric cancer. Hereditary diffuse

Figure 1

gastric cancer can be deadly if not found early. This type of cancer, unlike others, does not form a well-defined mass that can be detected easily through imaging or an endoscopy. Therefore, the only preventative measure is to totally remove the stomach.

The patient went to the National Institute of Health (NIH) and had over fifty stomach biopsies taken, in which they were able to find a small area of cancer. This further confirmed her decision to have such a drastic surgery. When she was just twenty-one years old, she had a total gastrectomy (Figure 1). Surgeons removed her stomach and attached her esophagus directly to her small intestine! She has to eat small meals every two hours, but surprisingly enough, she is still able to eat everything she did prior to surgery. The CDH1 gene is not only implicated in its association with gastric cancer, but with other cancers as well. Up to 50 percent of female patients have a chance of developing lobular carcinoma of the breast as well. Because of this, she is also scheduled to have a prophylactic double mastectomy. This is a procedure in which all of the breast tissue is removed because there is such a high chance of developing cancer. After all of her surgeries, her prognosis is good, and she is expected to live a long, cancer-free life! ◊

ESOPHAGEAL ULCER

27 YEARS OLD | CAMBRIDGE, ILLINOIS, UNITED STATES

Three years ago, in the middle of the night, this patient's fiancé found him unconscious on their bathroom floor. She was able to revive him, and he immediately started vomiting a substantial amount of blood. She called 911, and he was taken to the hospital. His fiancé felt the doctors were not taking his condition as seriously as she thought they should be and showed them photos of all the blood he vomited. They

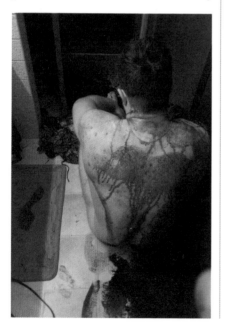

estimated he lost multiple liters of blood and decided to perform an emergency endoscopy, in which a flexible tube with a camera is inserted through the mouth to look in his stomach. This revealed multiple bleeding ulcers in the area where the esophagus meets the stomach (the EG junction). One of the ulcers was so bad it perforated a hole straight through the esophageal wall. They were able to close the hole with sutures and control the bleeding during the procedure.

An esophageal ulcer can have causes that include the bacteria H. pylori, use of NSAID medications (aspirin, ibuprofen), and GERD (gastroesophageal reflux disease).This patient had a history of reflux for over a year and a family history of Barrett's esophagus (changes in the esophagus over a period of time due to long-standing GERD and increased risk of esophageal cancer). He was also taking Alka-Seltzer to relieve his symptoms, which contains aspirin. The combination of GERD, a family history of esophageal disease, aspirin, and a night drinking at a friend's wedding caused the ulcers to bleed and perforate. His GERD is now regulated with medications, and he is expected to live a healthy life knowing all about his condition and understanding how to treat it. ◊

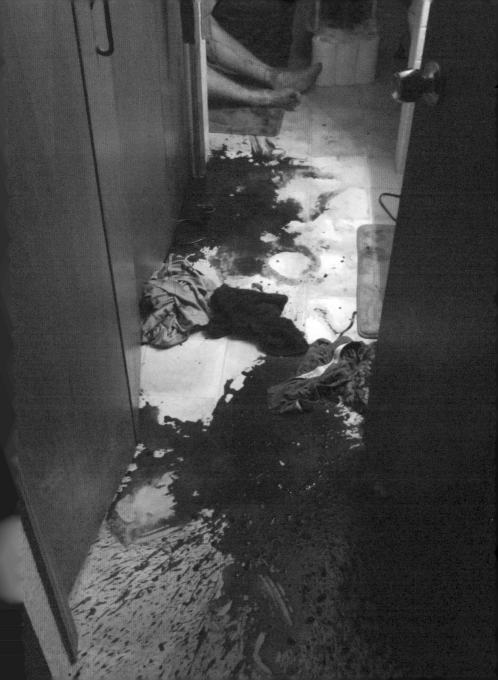

EAR

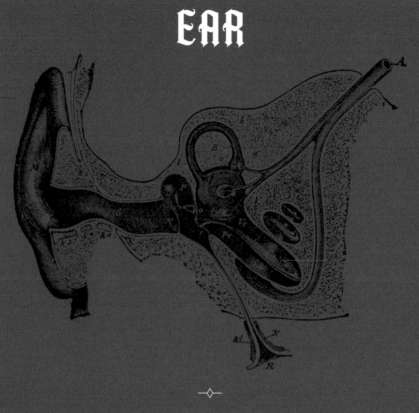

◇

The ear is a complex structure made up of three parts. The part of the ear you can see, the external ear, is made of skin and cartilage that funnels sound into the middle and inner ear, where it is processed and sent to the brain. Our ears are also responsible for our balance. Although we don't need the external ear to hear, pathology can be a major cosmetic concern for some patients.

◇

ACCESSORY TRAGUS

18 MONTHS OLD | GLOSTER, MISSISSIPPI, UNITED STATES

◊

hen this patient was born, his doctors noticed what they thought was a skin tag on his neck (Figure 1). He was examined by a pediatric ENT (ear, nose, and throat specialist) and was diagnosed with an accessory tragus.

The tragus is the small, elevated piece of skin and soft tissue surrounding the ear canal on the external ear. An accessory tragus is a congenital defect that occurs when a fetus is growing. In the fifth to sixth week of gestation, the external ear is formed. If something goes wrong while the ear is developing, a duplicate tragus can result. This defect is usually cosmetic only, and rarely can be associated with renal anomalies. At eighteen months old, an ENT surgeon removed the anomaly (Figure 2), and the patient is now left with only a tiny scar. ◊

Figure 1

Figure 2

◊

PERICHONDRIAL HEMATOMA

29 YEARS OLD | CHARLOTTE, NORTH CAROLINA, UNITED STATES

As a teenager, this patient was a wrestler. During a match one day, he began to experience some intense pain and realized his ear was swollen and squishy to the touch. Eventually he sought treatment due to his ear severely swelling up and covering his external auditory canal, which affected his hearing. This patient was diagnosed with a common condition seen in wrestlers called cauliflower ear, or a perichondrial hematoma.

The external ear is made of cartilage. When the cartilage is damaged due to trauma, it bleeds under the skin. The blood causes the outer surface of the cartilage (the perichondrium) to lift from the internal layer of cartilage. This lifting damages the blood supply to the cartilage and creates a space between the perichondrium and the cartilage. The blood can then get trapped in that space. Consequently, the damaged blood supply causes the cartilage to harden, and the result gives the ear a nodular, cauliflower-like look.

His doctor extracted the excess blood from his ear with a needle and used a metal compress to prevent the blood from flowing back. This device consists of two magnets that are placed on either side of the external ear to compress the ear. This treatment reduced the swelling in his ear and restored his hearing. Over time, however, the blood in his ear hardened, resulting in permanent deformation of his ear.

This patient has been offered a cosmetic procedure where the hardened blood would be removed in an attempt to restore his ear back to its normal shape. He has denied treatment, however, because he feels his cauliflower ear is a rite of passage as a combat athlete. ◊

MICROTIA AND ATRESIA

6 YEARS OLD | AUCKLAND, NEW ZEALAND

◊

 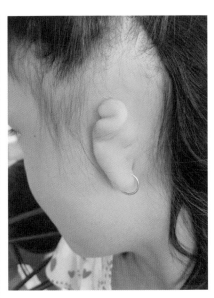

When this patient was born, her parents noticed her ear looked a little different. She was diagnosed with microtia and atresia.

Microtia is simply defined as a small ear. This defect can be seen in patients with other congenital anomalies, but most often, as in this case, it is just random. The deformity can range from mild and barely noticeable to severe, with a complete lack of an external ear. Atresia is the absence or underdevelopment of the middle ear structures, which are responsible for hearing.

This patient has a total absence of the ear canal and is missing one of the inner ear bones called the stapes. Because of this, she has total hearing loss in that ear. In a few years, she will be eligible for reconstructive ear surgery, in which doctors will use a piece of her rib cartilage to form an outer ear. This procedure is for cosmetic purposes only, and will not improve her hearing loss in that ear. ◊

◊

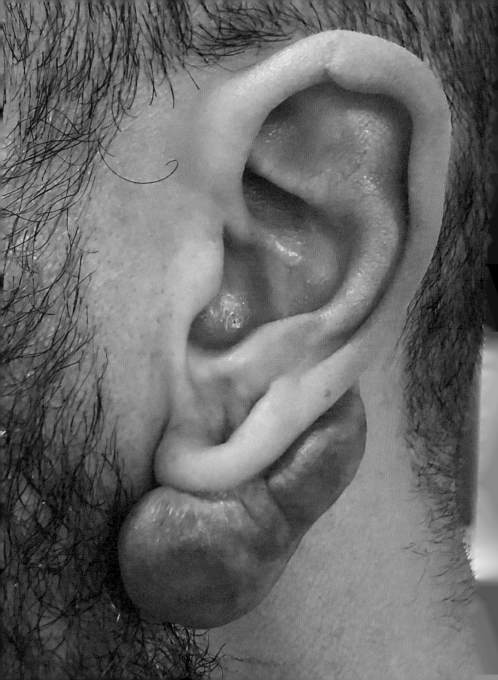

KELOID

◊

As a small child, this patient started developing scars that didn't heal properly. It first occurred when he had chicken pox at four years old and scratched a scab on his chest. As the scar healed, it became very thick, large, and nodular. His mother took him to a dermatologist, and he was diagnosed with keloids. Normally, when skin is injured, strong fibrous tissue grows to help protect and regenerate the damaged skin. In some cases, this tissue can overgrow, becoming even larger than the original wound. This excessive growth of fibrous tissue is called a keloid. A keloid can get large, bulky, and painful, but often the main concern is its cosmetic appearance.

When this patient was sixteen years old, he had his ears pierced with a piercing gun. Shortly after that, he noticed large keloids growing on the back of his ears. He had them surgically removed, but one of them grew back. The keloid grew larger over the next three years and was painful and heavy. He was given steroid shots to stop the growth, but the keloid remained bulky, heavy, and made him very insecure about his appearance. After doing research on keloid removal, he decided to have it removed by a body modification artist who is experienced in keloids rather than a plas-

tic surgeon. He was happy with the results of that procedure for a year and a half, but the keloid starting to grow back, and he is again looking into other treatment options.

Keloids are most common in patients with darker skin, especially those from Asian and Latino descent. Patients who are prone to keloid scarring commonly get them on the ears from piercing, but they can occur anywhere on the body. Keloids can also occur in families, but in this case, there was no family history. ◊

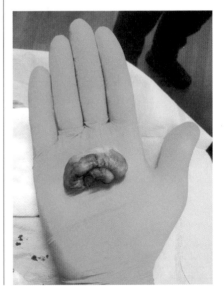

◊

EYE

Fig. III

—◇—

Looking into someone's eyes is a sign of life. The eyes are specialized sensory structures taking in the world around us and processing it within the brain. Anatomically, eyes are set in the orbits of the skull and held in place with ocular muscles. The back of the eye connects to the brain via the optic nerve. Eyeballs are firm, hollow globes filled with a gel-like fluid. Pathology of the eye can have a severe impact on one of our most essential senses: our sight.

CHALAZION

9 YEARS OLD | MELBOURNE, VICTORIA, AUSTRALIA

When this patient was four years old, he started to develop a red, puffy eyelid. His mother brought him to the emergency room on five separate occasions, and he was misdiagnosed with a sty and sent home with antibiotics. On the fifth visit, a general surgeon referred the child to ophthalmology, and he was in surgery within forty-eight hours. The ophthalmologist gave him the diagnosis of a chalazion.

A chalazion is a bump that occurs on the eyelid when an oil gland is blocked. This bump can be treated with warm compresses and antibiotics, but if the infection is severe, as in this case, surgery is required.

At the time of this patient's surgery, the chalazion was so advanced that surgeons were not able to scrape the infection out, and the pus ruptured from his eyelid. Now, at nine years old, he suffers from chronic eyelid inflammation. ◊

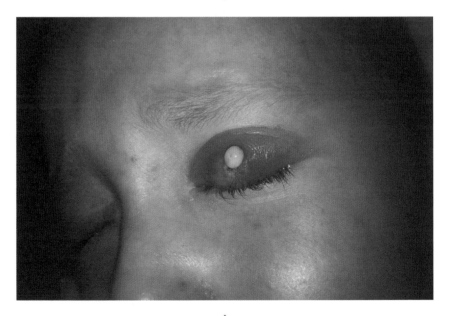

COLOBOMA

23 YEARS OLD | MINNEAPOLIS, MINNESOTA, UNITED STATES

◊

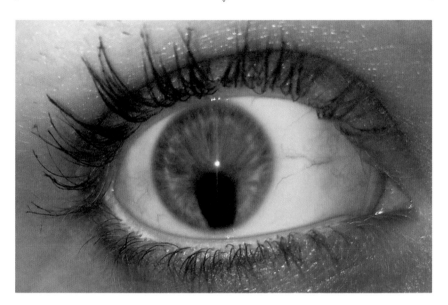

This patient was born with an eye condition called a coloboma. A coloboma is a rare abnormality of the eye that occurs during development in utero. It is thought that an abnormal gene causes the eye to not develop properly, causing the coloboma defect. There are multiple types of colobomas, which are classified according to what part of the eye is involved. Coloboma symptoms can range from none to severe, and include sensitivity to light, loss of field of vision, and total loss of vision.

Sometimes colobomas are seen in syndromes, but usually they are just an isolated anomaly, as in this case. Rarely are they inherited from a parent, but people who have them are at a slightly increased risk of passing them to their children.

This patient has bilateral colobomas, one in each eye. She has complete color blindness and is blind in her left eye. Her doctors have no explanation as to why she has no vision in one eye. ◊

◊

CORNEAL ABRASION/SUBCONJUNCTIVAL HEMORRHAGE

8 YEARS OLD | FAYETTEVILLE, NORTH CAROLINA, UNITED STATES

When this patient was six years old, he was shopping with his mom when he ran into a display rack in the store. One of the metal hooks on the display rack punctured his eyeball. His mother took him to urgent care, where they placed dye in his eye to look for any injuries to the cornea. As a result, multiple scratches were seen, and he was diagnosed with a corneal abrasion and subconjunctival hemorrhage.

The eyeball is made up of several layers. The center part of the eye, which contains the iris (our eye color), pupil (the black circle in the center of the iris that regulates intake of light), and the lens (which helps us focus on objects near and far) is protected by a clear covering called the cornea. A corneal abrasion is when there is a scratch or a cut to this layer. The white part of the eye, or the sclera, is covered by a thin, translucent layer called the conjunctiva. If there is trauma to this thin layer of blood vessels, they can rupture and lead to bleeding under the conjunctiva. Consequently, this gives the white of the eye a red appearance.

The doctor prescribed numbing eye drops for pain, but no further treatment was necessary because the cells of the cornea repair themselves in most situations. If the corneal scratch is really deep, it can permanently damage a person's vision. Luckily, that did not happen in this case.

He had several days of blurred vision, but the corneal abrasion healed itself, and the now-eight-year-old has had no further complications. ◊

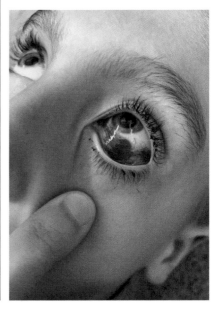

HERPES

27 YEARS OLD | BANBURY, OXFORDSHIRE, UNITED KINGDOM

◊

This patient was not feeling well and had cold symptoms. Over the course of the next couple of days, she developed redness, pain, swelling, and itching in her eye. She went to her family doctor, who was not sure what her symptoms indicated and referred her to an eye specialist. Subsequently, the eye specialist prescribed her antibiotic eye drops to treat a possible bacterial infection. Over the course of the next day, her symptoms worsened, and she developed small spots around her eye that were itchy and painful. She was referred to an eye hospital, where a team of doctors looked at it and diagnosed her with ocular herpes.

Ocular herpes usually occurs when a previous herpes infection reactivates and spreads to the eye. Many people are exposed to the herpes virus at some point in

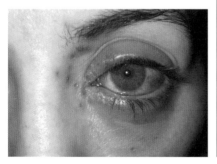

their life, typically through non-sexual contact with saliva (like sharing a drink). The herpes virus can also be spread through sexual contact. Oftentimes when a person is infected with the herpes virus, there are no symptoms. A person may not even notice that they have been infected. Once a person has herpes, the virus remains in their body forever. The virus can remain inactive in a person's body for the rest of their life, while others have frequent reactivation of the virus, which causes outbreaks. Reactivation of the herpes virus is often caused when the body is stressed, due to a cold, for example. This is where herpes gets its nickname of cold sores!

In this case, the patient was not aware that she was infected with the herpes virus. Her doctor prescribed medication for pain and oral and topical antiviral medications. It took two weeks for her eye to get back to normal. Since the initial outbreak in her eye, she has had several herpes outbreaks on her face, including her mouth, nose, and eyes. Her infections are less severe since recognizing the symptoms and getting prompt treatment. Because she was getting herpes outbreaks so frequently, she was put on a daily low dose of antiviral medications, which has lessened her outbreaks. ◊

◊

TRAUMA / PROSTHETIC

24 YEARS OLD | FORT LAUDERDALE, FLORIDA, UNITED STATES

At four years old, this patient was involved in a freak accident which caused him to lose his right eye. A family member was fixing the kickstand on his bike with a pair of needle-nose pliers and accidentally punctured him in the eye. His parents knew the injury was serious because his dad was holding a chunk of his son's iris (the colored part of the eye) in his hand.

They called 911, but there was not an ambulance available, so a fire truck was sent. Firefighters suggested his parents take him to an ophthalmologist. After seeing the extent of the injury, the ophthalmologist referred them to the emergency room. After waiting at the hospital for hours, the family was told that the doctors there did not have the expertise to handle such a severe, high-risk injury, and referred him to an eye institute almost an hour away.

When doctors at the eye institute examined the boy's eye, they quickly realized there was a very low chance of the patient recovering his vision. Doctors performed three surgeries over the course of the next two days, but they were unable to save his vision.

The doctors at the eye institute decided at the time to leave the eye in place and fit him for a prosthetic eye. Because the injured eye was still able to move, it could assist in moving the prosthetic. He still has the remnants of his small, damaged eye, which has not grown since the injury twenty years ago. He also still has some feeling in the eye.

Prosthetics are used often in medicine for a variety of reasons, including amputation, congenital defects, and trauma. Sometimes a prosthetic can aid with function, but a prosthetic eye is purely for aesthetics. It will never help with vision.

He was fitted for his first prosthetic when he was four years old, and every year has had a replacement to accommodate his growing eye socket (Figure 1). His prosthesis is constructed at a prosthetic eye institute, where they fit, mold, and hand-paint the prosthesis to look like an exact match to his other eye.

As a result of the injury, he has narrow peripheral vision and is not able to see three-dimensionally. When a person loses an eye, they are not able to see three-dimensionally because both eyes take in dual two-dimensional images and convert them to three-dimensional images in the brain.

Despite his injury and loss of vision, he was never held back in life. He played football and baseball as a child and is continuing to live a normal life with one eye. ◊

Figure 1

FASCIA

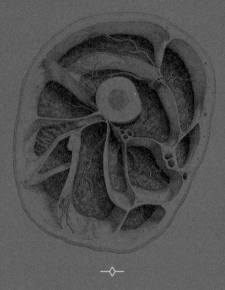

—◇—

Fascia is connective tissue that compartmentalizes, separates, and protects all our tissues throughout our body, including our muscles and organs. There are many types of fasciae throughout the body, which can be thin or thick depending on what layer of protection is needed for that body part. Fascia works by keeping our tissues compartmentalized. When there is pathology, however, our fascia can work against us. This compartmentalization leaves a plane where infection can easily travel if it is introduced. In some cases, tissue swelling from natural disease and trauma is also limited because of the tight compartments created by fascia.

NECROTIZING FASCIITIS

58 YEARS OLD | CYNTHIANA, KENTUCKY, UNITED STATES

◊

This patient thought she had an infected ingrown pubic hair, but it turned out to be much worse. The infection soon swelled up to the size of a softball, close to her vulva and anus. She went to the hospital and was scheduled for surgery the following day. The infection grew so rapidly that she was transferred to a larger university hospital for two more surgeries in order to remove all the dead, infected tissue. She was diagnosed with a life-threading infection called necrotizing fasciitis.

Necrotizing fasciitis is also referred to as "flesh-eating bacteria." It is given that name because the bacteria causes the death of the skin and underlying soft tissues. It spreads rapidly, and if not treated quickly, will lead to death.

The patient was sent home from the hospital with a large open wound (Figure 1). Luckily, her daughter was a wound care nurse and was able to take care of it. The dressing had to be changed six times a day because it became contaminated every time she went to the bathroom. The wound took over six months to heal, and at one point, her daughter was able to stick her whole fist in the wound.

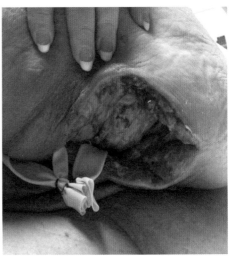

Figure 1

A weakened immune system, diabetes, alcohol use, and smoking are all risk factors for necrotizing fasciitis; so is obesity. This patient is a smoker and has obesity, but the very factor that predisposed her to necrotizing fasciitis is what saved her life. Doctors were very concerned because her infection got dangerously close to her pelvic bone; luckily, she had some extra layers of subcutaneous tissue the bacteria had to get through before getting to her bone. Necrotizing fasciitis has a high mortality rate, and this patient is lucky to be alive. ◊

◊

FEET

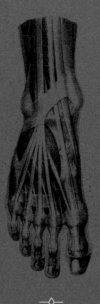

◇

While relatively small in comparison to the rest of the body, feet are very complex! They each contain twenty-six bones and thirty-three joints, and are filled with nerves, blood vessels, and sweat glands. Our feet are one of our most overworked body parts, with the average person walking over a hundred thousand miles in their lifetime! The appearance of our feet can be a sign of our underlying health, from the condition of our skin to the thickness of our toenails. Pathology of the feet can be something a person is born with or acquires throughout their life.

◇

HALLUX VALGUS (BUNIONS)

◇

A bunion is a bony bump that forms at the joint where the first foot bone meets the big toe bone (metatarsal phalangeal joint). The bump itself is the pathology, but it is caused by an anatomic defect in the foot. This defect causes the big toe to push inward toward the other toes rather than straight forward. Bunions are more common in women. This is because the anatomy of the connective tissue in the foot of a female is weaker than a male. Contrary to popular belief, bunions are not caused by wearing shoes that are too tight—but wearing tight shoes can make bunions more prominent.

43 YEARS OLD | CLINTWOOD, VIRGINIA, UNITED STATES

◇

This patient has a textbook example of a bunion on her right foot compared to the normal anatomy of her left foot. Bunions can occur in anyone, but they are usually inherited and run in families. ◇

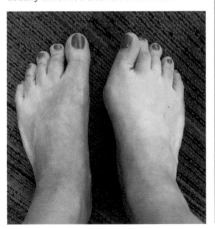

26-YEAR-OLD TRIPLETS | BOGOTA, COLOMBIA

◇

Look at the bunions on these triplets. Symptoms of bunions range from person to person. Some people live their whole life with bunions and have little to no symptoms, where others live in chronic pain and require surgery to repair them. ◇

◇

PLANTAR WART

60 YEARS OLD | BEND, OREGON, UNITED STATES

This patient is a swimmer who frequently used the pool at her local health club. About six years ago, she noticed a wart on the bottom of her foot, which she believed developed from being barefoot in the public shower used after her morning swims.

Warts on the bottom of the foot are called plantar warts. These warts are caused by the same virus that causes warts on other parts of the body: HPV or human papillomavirus. Warts can develop after the HPV infection enters the body through an area of broken skin, like a cut. Certain strains of HPV cause plantar warts. These strains are not highly contagious, but they thrive in warm, moist environments. Therefore, the shower floor at the gym is a perfect environment for transmission.

Those exposed to the strains of HPV causing plantar warts will not automatically develop warts. Rather, it is dependent on how a person's immune system reacts to the virus. Healthy children and adults can develop plantar warts; however, people with weakened immune systems are at greater risk.

The patient in this case is considered immunosuppressed because she has received two kidney transplants in the past ten years. When a person has an organ transplant, they are placed on antirejection drugs so their body does not reject the new organ. These drugs work by suppressing the immune system so the body does not attack the foreign organ. Unfortunately, a negative side effect of these drugs is that it causes the immune system to not function properly. Her decreased immunity. along with exposure to the virus and the right environment, caused her plantar wart to develop.

During the first three years of having the plantar wart, she picked it often, which caused it to spread and grow larger. She has tried multiple methods to remove the wart, including cider vinegar and duct tape, with no results. Warts are very difficult to remove and usually go away only when the immune system decides to get rid of them. She was told by her dermatologist that she would more than likely have this wart the rest of her life because of her immunosuppression. ◊

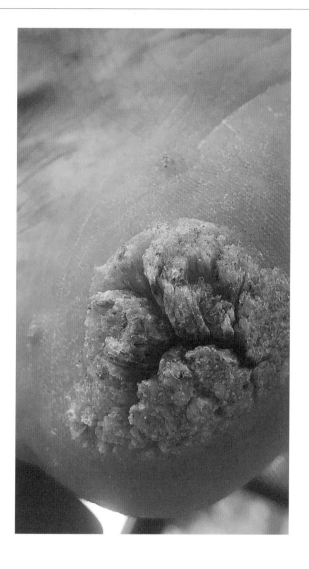

POLYSYNDACTYLY

26 YEARS OLD | TOPEKA, KANSAS, UNITED STATES

When this patient was born, her mother noticed that one of her toes was slightly different from her other toes. She was born with a congenital malformation known as preaxial polydactyly type 4, or polysyndactyly (poly: more than one, syn: stuck together, dactly: digits). In this case, the bones in her foot are normal, but she has duplicate toe bones. Polysyndactyly occurs when a fetus is developing in the womb. This condition often presents with other limb malformations, which can be a sign of an underlying genetic disorder. Polysyndactyly can run in families, but it can also be an isolated incident, as in this case. As a child, she had difficulty finding wide enough shoes to accommodate her extra toe. As a result, surgery was discussed, but due to the complexity of the deformity, it was decided the risks outweighed the benefits and surgery was not performed. As an adult, she occasionally has minor issues with ingrown toenails, but is otherwise living a normal life. ◊

GALLBLADDER

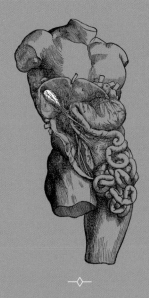

The gallbladder is a hollow, saclike organ adherent to the underside of the liver. The liver makes bile, which is a thick, sticky fluid containing multiple components including bile salts, bilirubin (product of broken-down blood cells), and cholesterol. Bile is responsible for breaking down the fat in the foods we eat. Oftentimes, patients with pathology of the gallbladder will experience episodes of severe pain, particularly after eating a fatty meal, either from an anatomical defect with the gallbladder or an obstruction from bile. Due to this, surgical removal of the gallbladder is common. Fortunately, we do not need our gallbladders to live.

GALLSTONES

50 YEARS OLD | BRASILIA, BRAZIL

Gallstones form from standing bile in the gallbladder. The stones are concentric (meaning they are made up of layers), so they start small but can greatly increase in size. Many compounds make up bile, but it is mostly composed of bilirubin (the breakdown product of red blood cells), cholesterol, and bile salts. Gallstones can vary significantly in color, size, and shape depending on what component of the bile formed the stones. As an example, stones made of cholesterol are yellow, and stones made of bilirubin are dark green/black.

The main function of bile stored in the gallbladder is to aid with breaking down the fat in the food we eat. When we eat a meal, particularly a fatty one, bile squirts out of the gallbladder into the small bowel to break down the fat. As that bile is trying to squeeze out of the gallbladder, a stone or stones can get stuck in the opening, leading to extreme pain in the location of the gallbladder—under the right ribs—which is sometimes referred to as a gallbladder attack. Gallbladder attacks are more likely to occur after eating a fatty meal, such as a hamburger, rather than after eating a plate of vegetables.

When this patient had an episode of extreme pain under her ribs, she was initially worried, because she was feeling healthy and had no other symptoms. The pain dissipated for about a day, however, it then became so severe the following day that she visited an emergency room.

Ultimately, she was diagnosed with cholecystitis (inflammation of the gallbladder) and cholelithiasis (stones in the gallbladder) and taken in for emergency surgery the next day to remove her infected gallbladder. When her gallbladder was opened, these beautiful stones (made of cholesterol) were revealed.

Gallstones are most common in middle-aged females, and they tend to run in families. For medical students to remember the profile of patients presenting with right upper abdominal pain, a mnemonic was created, called the five Fs: female, fertile, fat, fair, and forty. ◊

HAIR

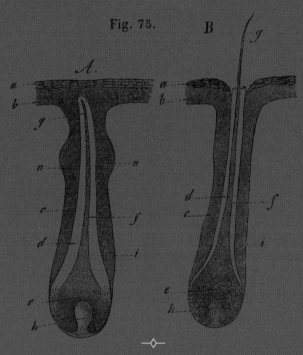

Fig. 75.

Hair is a characteristic that makes us mammals. Hair is a thin, needlelike projection that arises from the skin and contains a protein known as keratin. Since hair is one of the fastest growing tissues in the body, once a hair is plucked from its follicle, it immediately starts growing back. Although hair is not essential for life, pathology can be a cosmetic concern and a source of severe emotional distress.

ALOPECIA

29 YEARS OLD | BURNT CABINS, PENNSYLVANIA, UNITED STATES

◇

rowing up, this patient had long, thick hair. At fourteen years old, she noticed a spot of missing hair on the crown of her head. Her mother immediately brought her to their family doctor, who then referred her to a dermatologist (a skin and hair specialist).

Since she was a new patient, it took almost a full year before she was seen by the dermatologist. By this time, the hair along the crown and sides of her head had disappeared. Due to the severe and visible nature of her condition, she had to cut her hair to chin-length. She was ultimately

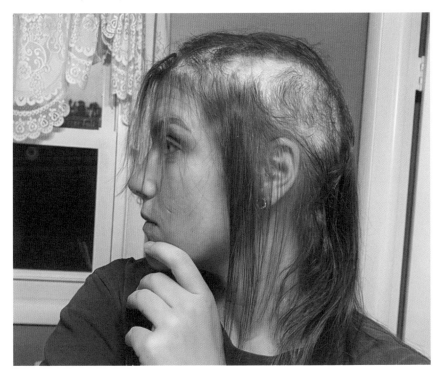

◇

diagnosed with a condition known as alopecia areata.

Alopecia areata is an autoimmune condition where the body attacks its own healthy hair follicles, causing hair loss. There are various types of alopecia depending on the presentation of hair loss; however, alopecia areata is the most common type. The presentation of alopecia areata varies from mild to severe patchy hair loss.

Her treatments started with intramuscular steroid injections in her arms every three months, with no success. This treatment was not only unsuccessful, but her hair loss progressed, and she eventually lost her eyebrows. After this treatment, she decided to visit another dermatologist for a second opinion.

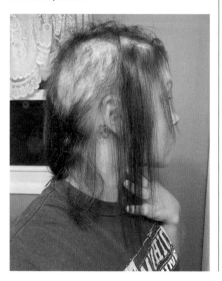

The new dermatologist administered steroid injections directly to the areas of hair loss on her scalp and eyebrows. These was around twenty to thirty shots every three months. This treatment went on for a year with no success. She was eventually referred to an alopecia specialist at a larger hospital.

This specialist did a topical acidic treatment. The theory behind this treatment is to apply a mild acid to the areas of hair loss to create an allergic reaction. This allergic reaction could irritate the skin just enough that it will stimulate new hair growth. This treatment has been shown to resolve alopecia in some cases. Unfortunately, it did not help in this case. After a year of the acidic treatment and additional steroid treatments, her doctor told her there was nothing else they could do to help her, so she decided to quit all treatments and live with her patchy hair loss.

Aside from the hair loss, living with alopecia areata has taken an emotional toll. The treatments were long and painful, with no reward. As a teenager in high school, she was severely bullied for her condition. She eventually dropped out of school due to the constant teasing.

After some time doing remote learning, she decided she wanted to go back to school. Her mother made the decision to move to a new school district so she could have a new start. This patient had a better experience at the new school, but she is forever emotionally scarred from the experience. ◊

POLIOSIS CIRCUMSCRIPTA

◇

I t is standard procedure that when a baby is first born, doctors will give a quick examination to make sure everything appears healthy.

6 YEARS OLD | PONTYPRIDD, RHONDDA CYNON TAF, WALES, UNITED KINGDOM

◇

W ith this patient, she appeared to be a healthy baby; however, doctors noticed an interesting white patch of hair on the back of her head.

When a baby is born with a localized patch of white hair, it is simply not a birthmark, but rather a condition known as poliosis circumscripta, or simply just poliosis.

When an area of poliosis is examined under the microscope, cells called melanocytes in the hair bulbs are either scant or absent. Melanocytes are the cells found in our skin and eyes which are responsible for giving us our skin, hair, and eye color.

Poliosis can be seen in a variety of genetic conditions, as well as skin conditions, that affect pigmentation of the skin, which is why it's important for children born with this condition to have a thorough examination.

Since birth, this child has also developed white patches of skin, with loss of pigmentation. She is also being seen by a cardiologist (a doctor who specializes in heart disease) for a possible heart condition.

Poliosis is not something you have to be born with; it can occur at any age. The cause of poliosis is unknown. However, it is commonly seen within families. ◇

45 YEARS OLD | CAMDEN, NEW JERSEY, UNITED STATES

◇

I t is even present in my family! Here is a photo of my late mother-in-law and her son (my husband). Both my mother-in-law and my husband acquired poliosis as adults. ◇

◇

PILONIDAL CYST

27 YEARS OLD | FRØYA, TRØNDELAG, NORWAY

Five years ago, this patient had a painful bump near the area of her tailbone that was tender and warm to the touch. Eventually, the pain became so severe that she went to the doctor and was told to go to the hospital the following day. They did an ultrasound and diagnosed the bump as a pilonidal cyst.

In some patients, hair on the surface of the skin can tunnel deep underneath the skin and form a cyst. The word pilonidal is derived from the Latin word pilus, meaning "hair," and nidus, meaning "nest." This cyst can become inflamed and infected causing an abscess, or a collection of pus mixed with hair under the skin. The cyst can become extremely painful and rupture, emitting a strong odor.

A pilonidal cyst is most common in patients who have sedentary jobs and sit for long periods of time. As an occupational therapist, this patient is on her feet all day. A family history of pilonidal cysts can also increase the risk of a patient developing them. Her aunt and uncle both have a history of having pilonidal cysts.

The most common location for this cyst is over the gluteal crack, also known as the butt crack. It has also been reported in other areas of the body, such as the male or female genitals, scalp, abdomen, groin, or any areas where hair growth is present on the body.

This condition has been diagnosed in many US soldiers because of long periods of sitting in military vehicles; the condition is sometimes referred to as jeep disease.

She was admitted to the hospital, and a procedure was done to cut open the cyst and clean out the infected tissue and pus. This treatment to excise the entire cyst is less invasive than surgery, but it is not always effective. The drainage was only temporarily successful, and over the course of the next couple of years, she had to have it drained additional times, along with antibiotic treatment. Since the cyst persisted and she had repeat infections, her doctor suggested surgery to excise the entire cyst and surrounding skin.

The surgery was a success for a few years until she became pregnant. Unfortunately, there is a high incidence of recurrences in these cases. The skin over her gluteal crack where she had the excision is very thin. The cyst has recurred and continues to burst open, emitting a pungent odor.

She has been told she needs another surgery and is currently waiting until her child is done breastfeeding before having the procedure. ◊

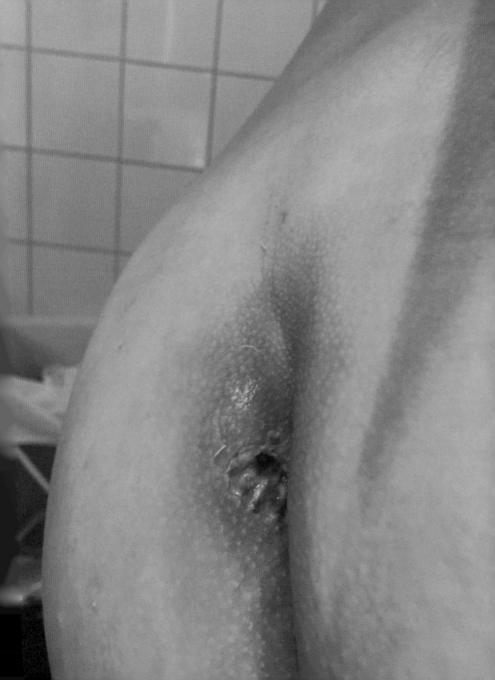

HANDS

Fig. 10.ᵗ

⬦

What separates human hands from most other animals is our opposable thumbs. This allows us to have dexterity and grip that many other animals are not capable of. Although hands are not needed to live, anatomic defects of the hand that a patient is either born with or acquires throughout their life can cause challenges with simple daily tasks.

◇

ACROSYNDACTYLY

6 YEARS OLD | KELSO, WASHINGTON, UNITED STATES

◊

When this child was born, he appeared completely healthy; however, his family and doctors were surprised to see one of his hands had not developed normally. His left hand had three webbed fingers and a thumb (Figure 1). He was referred to a hand specialist and diagnosed with a condition known as acrosyndactyly.

Syndactyly is a condition where a child is born with fused digits (fingers), giving the hand a webbed appearance. Acrosyndactly is when the fingers are separated as they leave the hand but are fused together at the tips of the fingers.

Acrosyndactly occurred when this child was growing in the womb. Although the fingers appear fused, the fingers actually do not become stuck together in the womb. When a fetus starts growing, the hand is already webbed. As the fetus develops, the webbed hand begins to separate into fingers. In this case, the fingers did not separate properly, giving the fingers a fused appearance.

Sometimes this hand deformity can be seen in children with other conditions or syndromes. However, in this case, the acrosyndactyly is incidental.

Doctors recommended this child should have surgery to improve the mobility and function of his hand. Surgery was not performed until the child was fifteen months old, when doctors felt it was safe for him to undergo anesthesia for multiple hours.

The surgery for this condition lasted about four and a half hours. Surgeons determined the middle digit was severely underdeveloped, with no knuckle in the middle, so the decision was made to amputate that finger. A skin graft was taken from his groin to close the open wounds on his hand. After surgery, he was left with a functioning

Figure 1

◊

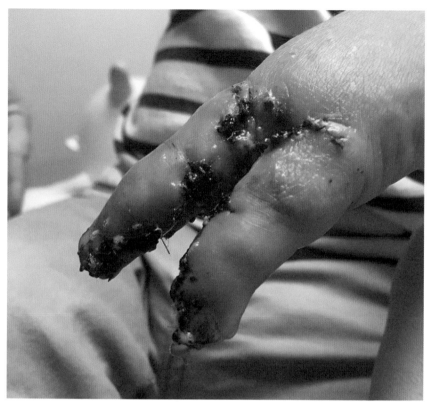

Figure 2

hand that now consists of two fingers and a thumb (Figure 2).

Hand deformities can oftentimes be identified during a mother's pregnancy via ultrasound. This mother was surprised to learn her son had this hand deformity at birth. After examination of her prenatal ultrasounds, doctors were also surprised this condition was missed.

This child is a thriving six-year-old that has not been held back from anything by only having eight fingers. He even races competitive motocross! His fingers are not straight when flexed, but that does not seem to be affecting his abilities. At this time, his surgeon does not think he will need any more surgeries. Only time will tell as he continues to grow. ◊

SYMBRACHYDACTYLY

24 YEARS OLD | MUDEN, KANSAS, UNITED STATES

◊

When this patient was born, her parents were shocked when they noticed their baby's left hand was missing fingers. The doctor, however, did not seem surprised. During her mother's pregnancy, the deformity was seen on an ultrasound, but the information was never relayed to the family.

She was born with a condition known as symbrachydactyly. This is a rare, congenital (it happens in the womb during fetal development) hand defect that causes the fingers to be abnormally short or stuck together. The roots of the word symbrachydactyly are derived from the Greek root words (*sym*-joined, *brachy*-short, and *dactyl*-digit). This hand defect can range in severity from mild to more severe, as in this case.

This patient was born with no fingers and only a remnant of a thumb. The thumb has no bone, but it does have a tiny fingernail. The thumb does not have much function, but is useful for things like tying her shoes, putting her hair up, and buttoning her shirts.

Her defect has not caused her any medical problems, and she never received any treatment for her condition. She even has the words "little bit" tattooed on her left wrist to celebrate her different hand. ◊

◊

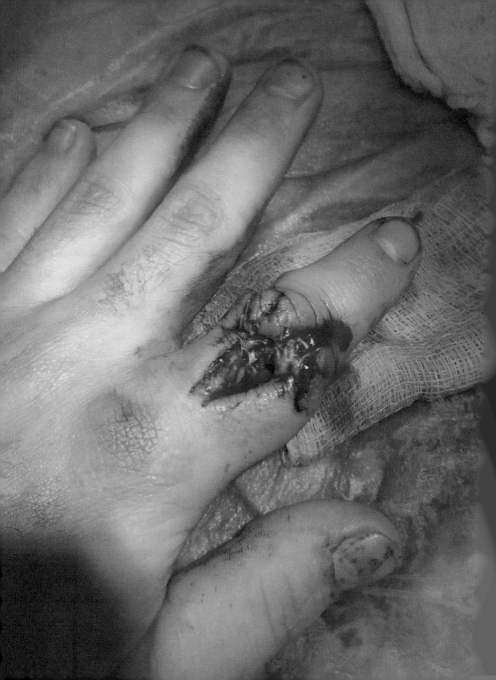

GUNSHOT WOUND

20 YEARS OLD | NEW SMYRNA BEACH, FLORIDA, UNITED STATES

One afternoon, this patient went shooting at the gun range. The next day, he was cleaning his gun (a Glock 19 Gen4 9mm handgun) by locking the slide and pulling his slide release pins down. As he was taking down the gun, the slide slammed and the gun fired, shooting him in the left hand (Figure 1). He did not realize a bullet was still in the chamber after his visit to the shooting range the previous day.

Upon initial exam at the hospital, doctors were concerned he would require an amputation due to the severity of the injury. The gunshot wound caused multiple fractures to the bones in his finger.

Luckily, through a series of surgeries, doctors felt optimistic that they would be able to save his finger. He had pins placed in his bones to encourage healing (Figure 2), and his doctors determined he would be eligible for a bone graft within a few months after the incident. In some cases,

when a person has severe fractures, a piece of bone (taken either from another bone in the patient's body or a cadaver) is placed in the area where the bone needs to heal. The grafted bone will then heal to the patient's existing bone.

In the United States, it is estimated that a third of reported non-fatal firearm injuries are unintentional. On average, roughly five hundred people die as a result of unintentional firearm injuries, half of which are self-inflicted. ◊

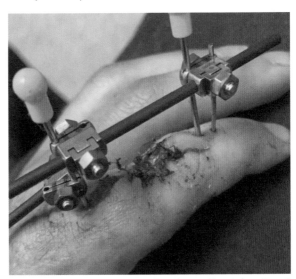

Opposite page: Figure 1, above: Figure 2

HEART

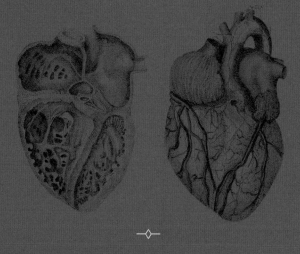

The human heart is one of the most recognized anatomic structures of a human. It was once thought that the heart was the center of all thought processes, and therefore it became known as a symbol for love. Although we now know that the brain is mostly responsible for love, there is a known connection between our emotions and the heart. In rare cases, a person can even die from a broken heart. The heart is an essential organ, and without it, we cannot live. It is a hollow, muscular structure made up of four chambers acting as a pump to bring oxygenated blood to all our organs. The heart physically works harder than any other organ throughout a person's life. On average, the heart beats forty-two million times a year. That is a lot of movement over the course of a person's life!

AORTIC ANEURYSM

67 YEARS OLD | KUNA, IDAHO, UNITED STATES

Three years ago, this patient was preparing a canopy to install on a classic airplane he was in the process of restoring. He was standing on the wing of the airplane and fell about eight feet, landing flat on his back. At the time, he thought that he had broken a rib. However, he did not immediately seek treatment. He initially thought there was nothing a doctor could do, but after a few days of severe pain, he decided to make an appointment.

During the examination, his doctor agreed that there was a strong possibility of a broken rib and ordered additional testing and imaging to confirm. His imaging results showed he did not have a broken rib and indicated he had a much bigger problem. He was sent to a thoracic surgeon for a consultation.

A thoracic surgeon is a surgeon who specializes in the organs present in the thorax (chest). The thoracic surgeon diagnosed him with a condition known as an ascending aortic aneurysm (AAA).

The aorta is the biggest artery in the body. It comes out of the top of the heart and extends down the spine. It is responsible for bringing oxygenated blood to the entire body.

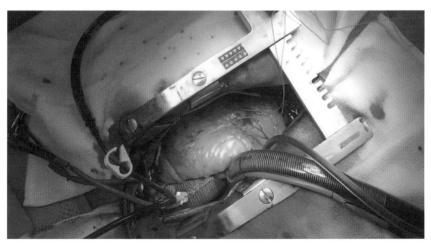

Figure 2

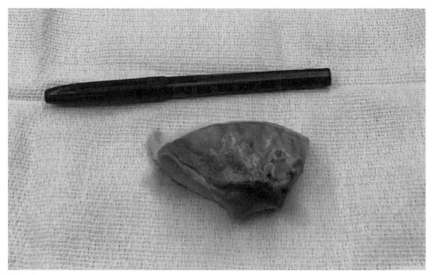

Figure 1

An aortic aneurysm is a bulge in the artery which causes it to dilate. The bulge alone is not a huge concern, but it is a ticking time bomb. Patients with an aortic aneurysm are at a high risk of aortic dissection (when blood tunnels up the aorta between the layers of the artery) and rupture (when the artery bursts). If untreated, an aortic aneurysm can lead to sudden death.

High blood pressure, high cholesterol, smoking, and connective tissue disorders like Marfan's syndrome are the leading causes of aortic aneurysms. In this case, his doctors are not sure what caused his aorta to dilate.

This patient was scheduled for surgery to replace the dilated portion of the aorta (Fig-ure 1). He had a history of negative reactions to anesthesia, so his aortic aneurysm repair had to be done while he was semi-awake (Figure 2)! During the surgery, he was able to hear the doctors and OR staff talking and discussing his case. He felt no pain during the procedure, just movement and pressure.

Surgeons replaced the diseased portion of his aorta with a Dacron aortic graft (a graft made of a synthetic polyester material).

After surgery, he was up and walking within twenty-four hours. He was not able to lift anything heavy for three months after the surgery. Since then, he has taken no medications for this condition and has no restrictions. His fall from the wing of an airplane saved his life! ◊

◊

TRANSPLANT

63 YEARS OLD | SANTEE, CALIFORNIA, UNITED STATES

This patient has a long family history of heart disease. He is one of seven siblings, three of which died from heart-related conditions. He also lost his mother to heart disease.

At just forty-four years old, he had a heart attack and was diagnosed with coronary artery disease.

Coronary artery disease is one of the leading causes of death worldwide. While there is a strong genetic component to this disease, it can also be caused by external factors like cigarette smoking and high cholesterol. The coronary arteries supply the heart with oxygenated blood. Therefore, if there is a blockage in the coronary arteries, the heart muscle cannot get the proper oxygen that is needed, and it can die. Another name for a heart attack is a myocardial infarction, which simply means there is death to the heart muscle. Death to the heart muscle can cause pumping problems over time, or can cause sudden death.

In this case, doctors placed a stent in his coronary artery to open the blockage. A few years after the stent was placed in 2009, he noticed that his legs were swollen while he was in the hospital visiting for the birth of his granddaughter. A nurse at the hospital suggested he revisit his cardiologist. Subsequently, his cardiologist diagnosed him with congestive heart failure. Congestive heart failure occurs when the "pump" of the heart–or the left ventricle–does not pump blood as it should. Eventually his doctors surgically placed a defibrillator. A defibrillator is an implanted device that assists with the rhythm of the heart.

Figure 1

Around 2015, just a few years later after receiving the defibrillator, he started experiencing shortness of breath and fatigue. At that time, his doctors decided that his heart failure was so severe that he needed a left ventricular assist device (LVAD). An LVAD is a large, mechanical pump that is surgically placed in patients when their heart can no longer pump adequately on its own.

After years of surgeries and interventions, his doctors decided there was not much more they could do for him. Ultimately, on November 16, 2018, they placed him on a heart transplant list. He was 473rd place in line to receive a new heart.

While he was waiting, he was updated at his monthly cardiology appointments about his status on the list. His team felt he had a good chance to get a heart because there was not much competition for the type of heart he needed based on his blood type and his body size.

At 4 P.M. on July 7, 2021, almost three years after being put on the transplant list, he received the call that there was a heart for him. He was told to be at the hospital within an hour. During the drive to the hospital, he was very nervous and discussed his finances with his family on the chance he did not make it through the surgery.

He was admitted to the hospital for the transplant, and by 11 a.m. the following morning, the new heart was in his body and beating on its own! Only fourteen days later—his old heart was sent to pathology for examination (Figure 1) and found to be about three times larger than the average heart (Figure 2)—he was discharged from the hospital.

Since his surgery, this patient is feeling much better, and his new heart is working great. He was even able to hold his old heart! (Figure 3). He has to visit his cardiologist weekly for checkups and is on anti-rejection medication. He has frequent heart biopsies to check if the transplanted heart muscle is healthy. Within ninety days of the surgery, he will learn more information about the donor heart that gave him new life. ◊

Above: Figure 2; opposite page: Figure 3

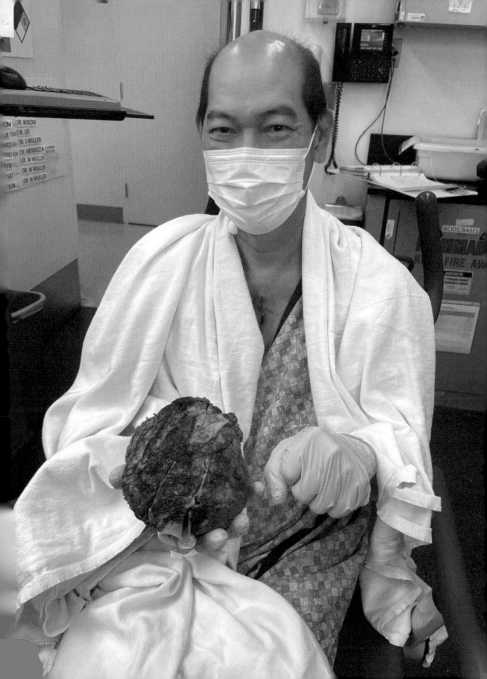

IMMUNE SYSTEM

Our bodies have specialized cells protecting us from foreign substances. These cells are scattered throughout our body and are deposited in many organs that work together to form the immune system. When the body recognizes something as foreign, like a virus, it attacks it. The immune system also creates antibodies to protect us if we ever see that foreign object again. Unfortunately, in some situations, the immune system misfires and mistakenly attacks parts of its own body. This is called autoimmunity.

ALLERGY

26 YEARS OLD | RIVERSIDE, CALIFORNIA, UNITED STATES

◊

This patient ate bananas her whole life, especially during her pregnancy. Bananas were one of her everyday cravings. After the birth of her son, she was sick of bananas, so she did not eat one for a couple years.

One day before going to work, she decided to have a banana. Shortly after she ate it, her stomach started to hurt. She figured it was from her morning coffee and went to work. Within an hour, her eyes started burning and itching. At the time, she was working in a warehouse and assumed she got chemicals into her eyes, so she was sent home from work. When she got in her car, she noticed two small hives under her eyes. Within the time frame of the twenty-minute car ride, her eyes became swollen shut, and her tongue swelled so much she would bite it when she tried to speak.

Her dad rushed her to the hospital, and she was diagnosed with a severe

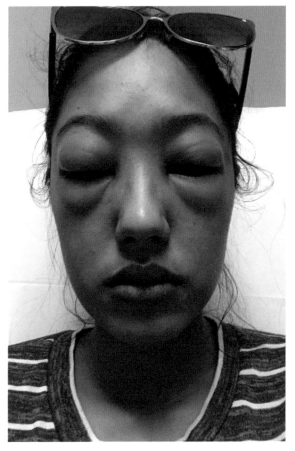

◊

allergic reaction. She was given an IV with antihistamines and steroids. Doctors admitted her to the hospital for two days for observation.

Allergies occur when the body mistakes something as harmful. People can have allergies to many things, including chemicals, the environment, animals, and food, to name a few. Once the immune system has identified something as harmful, the next time it sees it, the immune system will release a substance called histamine. Histamines help the immune system by removing harmful substances from the body, but they also cause allergy symptoms, including hives, itching, and swelling.

Doctors who were treating her in the hospital did not think the banana would be the culprit because she had a twenty-two-year history of eating them with no reaction.

Most people develop allergies as children, but sometimes, for unknown reasons, adults can develop mild to severe allergies from things they never had a reaction to.

When a person has a severe allergic reaction like this, it is important to identify what caused the reaction, especially because each exposure can be more severe. In rare cases, a person can have such a severe allergic reaction that it can cause anaphylaxis. Anaphylaxis is a severe, life-threatening allergic reaction that can affect a person's breathing and blood pressure.

After several weeks of allergy-testing this patient, they determined that she had a severe food allergy to bananas. She has not had any more allergic reactions since avoiding bananas, but in the past four years, there is not a day that goes by that she does not dream of a banana split. ◊

LUPUS

26 YEARS OLD | NORTH PLAINS, OREGON, UNITED STATES

◊

hen this patient started experiencing painless swelling in the joints of her fingers, she initially thought nothing of it. She also had a mild cough with mucus and face/eye swelling that she attributed to seasonal allergies. Over the course of the next six months, her symptoms started increasing in severity, and she soon realized she was having a significant medical problem.

Shortly after her mild symptoms started, this patient developed a rash on her face that was diagnosed as papulopustular rosacea.

Papulopustular rosacea is a skin condition that causes redness and small pustules (tiny blisters) on the face. While the cause of papulopustular rosacea is unknown, it most frequently occurs in lighter-skinned, middle-aged females. The patient was eventually given steroid treatment. It helped with the redness; however, the pustules never went away.

About a month after developing the rash, she became extremely sick. She was bedridden for four days with a fever, body aches, nausea, fatigue, and eyelid swelling. A few weeks later, she started experiencing significant leg swelling with pitting edema (pitting edema is when an indentation occurs after pressing on skin filled with body fluid),

tachycardia (fast heart rate), chest pain, and extremely high blood pressure.

She went to her local urgent care, where they performed a urinalysis (when the urine is examined). Her urine showed a significant amount of blood and protein. This can be a sign of kidney disease. Due to the test results and nature of her symptoms, she was advised to go to the emergency room for further testing.

The hospital conducted blood tests and discovered she had significant inflammation in her body. She was referred to a nephrologist (a doctor who specializes in kidneys) for follow-up.

Subsequently, the nephrologist performed a kidney biopsy on her. Biopsies are when the doctor takes out a small piece of tissue from an area, in this case the kidney. The piece is then sent to pathology, where it is processed and looked at under the microscope by a pathologist. She was then diagnosed with lupus nephritis from the pathologist's tissue findings.

Lupus nephritis is an autoimmune disease that occurs when the immune system attacks the kidneys. This causes the kidneys to become inflamed and damaged, leading to high blood pressure and traces of blood and protein in the urine.

Lupus nephritis is commonly seen in people who have the most common type of lupus, systemic lupus erythematosus, or SLE. Her nephrologist referred her to a rheumatologist (a doctor who specializes in autoimmune conditions) to confirm her condition. After further testing was conducted, she was also diagnosed with SLE.

SLE is also an autoimmune condition when the immune system attacks many organ systems throughout the body, such as the joints, lungs, skin, and kidneys.

Lupus is a disease that can remain relatively calm and suddenly cause flare-ups, with mild to severe symptoms. These flare-ups can be induced by triggers such as emotional stress, physical harm to the body, and surgery, to name a few. Lupus cannot be cured.

When the symptoms initially appeared, she was under a lot of emotional stress due to moving, finishing nursing school, and preparing to take her board exam. Her rash, which was originally misdiagnosed as rosacea, was triggered by exposure to UV light. The rash is a common symptom seen in about half of lupus patients and is called a "butterfly rash." This name is due to the typical presentation involving the cheeks and the bridge of the nose having a rash with a butterfly-like appearance, although the rash can present in different ways. as in this case.

Lupus flare-ups can be managed with medications. Since this patient's diagnosis, she has been treated with multiple medications, including antirheumatic drugs and steroids. The diagnosis of lupus has changed her life; however, she is working hard to manage the symptoms with lifestyle changes such as avoiding UV light exposure. She also works with her rheumatologist frequently to adjust her medications according to the severity of her symptoms. ◊

RHEUMATOID ARTHRITIS

◇

75 YEARS OLD | PHILADELPHIA, PENNSYLVANIA, UNITED STATES

◇

My dad worked as a diesel truck mechanic until he was seventy years old. In his early forties, he started experiencing pain in his hands, predominantly in his right hand. He went to a hand specialist and was diagnosed with a condition called carpal tunnel syndrome. Carpal tunnel syndrome occurs when nerves from the arm become compressed in the wrist, causing pain. The specialist suggested surgery.

◇

During his surgery, his doctor mentioned that he noticed my dad had significant arthritis in his joints. After the surgery, the pain in his right wrist subsided, but he continued to have pain in the joints of both his hands.

Around the same time, he started experiencing dizziness, severe pain, and stiffness in his neck. My dad was a working machine, often working twelve-hour days six days a week. His symptoms were so severe at one point he expressed concern to my mom that he was not sure if he would be able to continue working in his current condition. He went to his primary doctor, who then sent him to a rheumatologist. After conducting a series of tests, the rheumatologist ultimately diagnosed him with a condition known as rheumatoid arthritis.

As a person ages, the padding around the joints, called articular cartilage, rubs away. This is called degenerative joint disease, or osteoarthritis. Rheumatoid arthritis is different, and it is not associated with the normal wear and tear on the joints. This type of arthritis can occur at any age. It is a result of an autoimmune disease which causes the body to attack its own joints and tissues.

Rheumatoid arthritis typically starts in the smaller joints of the body but can progress to larger joints over time. In addition to the joints, this disease can also affect areas of the body such as the heart, lungs, kidneys, and nerves.

After my dad's diagnosis, he was put on a variety of medications. These helped with the pain and stiffness he was experiencing, but it did not stop the progression of his disease.

Over time, his rheumatologist noticed his hands began to physically change similar to other patients with rheumatoid arthritis. Due to these changes, his doctor decided to change his treatment plan.

In his early sixties, my dad started on a newer treatment, which required infusions every six weeks. This treatment was successful in controlling his pain and ultimately stopped the progression of his disease. Unfortunately, a complication of the infusion treatment was immunosuppression.

My dad continued this treatment for ten years before he had a life-threatening Methicillin-resistant Staphylococcus aureus (MRSA) infection. This almost killed him and forced him into retirement.

For the past five years, my dad has not received any treatment for his rheumatoid arthritis. Although he still suffers from pain associated with his rheumatoid arthritis, most of the complications he encounters today are long-term side effects from the medications and treatments he has received over the years; the most significant being stage 3 kidney disease.

As with many other autoimmune diseases, there is an increased risk of having rheumatoid arthritis if someone in your family has it. ◊

◊

77 YEARS OLD | SEWELL, NEW JERSEY, UNITED STATES

This is one of my dad's three sisters (one of my aunts). Over forty years ago, my aunt noticed that the bones in her hands were starting to look abnormal. Over the course of the next few decades, her hands became deformed. She did not feel any pain, so didn't think treatment was necessary.

Rheumatoid arthritis causes deformities of the joints which are visible in the hands. My aunt's hands display a classic finding seen in patients with rheumatoid arthritis called ulnar drift. Ulnar drift is when the fingers (which are normally aligned with the ulnar arm bone) bend or drift toward the pinky finger.

Unlike my dad's manual labor career, my aunt had a desk job for most of her life. My dad was in severe pain every day from overuse of his degenerating hands. He started his infusion treatment twenty years after experiencing symptoms, which stopped the progression of his hand deformity.

My aunt, however, did not use her hands as much in her career. Although she experienced severe pain in other joints, she was never treated for rheumatoid arthritis. This could easily explain why her hands are significantly more deformed than my dad's.

Their father—my paternal grandfather—died at an early age from cancer, but also had this deformity in his hands prior to his death. Their two other siblings experience significant joint pain, however, they do not show the hand deformities commonly associated with rheumatoid arthritis.

There is no known cure for rheumatoid arthritis, and the severity can range from person to person. With new available treatments, patients are able to live well into old age with the disease. ◊

JAW

TAB.I.V. Part 3. Pl.96.

Fig. 5. Fig. 6.

Fig. 14.

---◇---

The jaw is one of our most powerful body parts. The front teeth of the jaw bite with as much as 55 pounds of pressure, whereas the back teeth can chomp up to 200 pounds of pressure!

Anatomically, the jaw is the only double-hinged bone in the body. It consists of an upper part called the maxilla and a lower part called the mandible. It's powered by the most powerful muscle in the body based on its weight, called the masseter muscle.

The jaw holds and moves the first part of our digestive system, our teeth. The jaw is essential in the process of breaking down the food we eat.

ODONTOGENIC MYXOMA

23 YEARS OLD | WOODSTOCK, VIRGINIA, UNITED STATES

◇

After having dental braces three times, this patient was required to wear a daily invisible retainer to keep her teeth aligned. One day she noticed a bump on her gum that slowly started increasing in size over time (Figure 1). Over the next nine months, the bump continued to grow. It was not painful, but it was causing her retainer to no longer fit.

Figure 1

She went to an oral surgeon, who initially thought it was a benign bony growth due to irritation of the retainer. To make sure, he took a CT scan and was surprised that it was not an overgrowth of bone, but rather a mass that had to be surgically removed.

During the surgery, she was awake, and local anesthesia was used. The surgeon completely removed the mass with clear margins (Figure 2). This is when there is a healthy, normal rim of tissue around an excised mass.

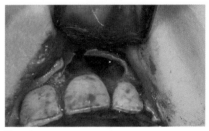
Figure 2

The mass was then sent to pathology. It came back as a rare, benign tumor called an odontogenic myxoma. These tumors arise from the cells in the jaw that are responsible for forming new teeth during fetal development. These cells are referred to as mesenchymal cells.

Odontogenic myxomas are benign (non-cancerous) tumors, however, they can be locally aggressive and destroy healthy surrounding tissue wherever they grow. These tumors are more common in females than males.

Since her tumor was removed, she has not had a recurrence. Patients with odontogenic myxomas have an increased risk of the tumor coming back, and this patient is continually monitored for the condition. Ultimately, her surgeon informed her that if the tumor did return, there is a possibility that she will need more extensive surgery to remove that section of her jaw. ◇

◇

JOINTS

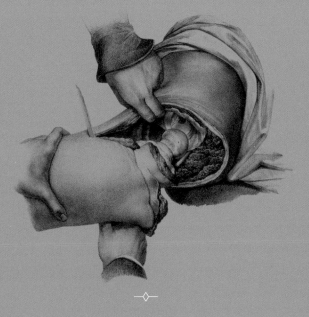

A joint is the connection point between two bones. In total, there are 360 joints throughout the body. Some of them move, while some do not. The joints that move have assistance from other tissues to prevent the bones from rubbing together and to aid in flexibility.

Damage to the bone or the tissues that assist the joint, either from something a patient is born with or acquires throughout their life, can cause a joint to be too flexible or not flexible enough. This can lead to chronic pain and problems with mobility.

EHLERS-DANLOS SYNDROME

◇

35 YEARS OLD | STAFFORD, STAFFORDSHIRE, UNITED KINGDOM

◇

As a child, this patient was able to bend her joints farther than any other children she knew. Getting older, she realized this party trick turned out to be a more serious condition known as Ehlers-Danlos syndrome.

Ehlers-Danlos syndrome, or EDS, is a group of inherited disorders of the connective tissue. Currently, there are thirteen subtypes of EDS.

There are many types of connective tissues within the body that support our bones, skin, blood vessels, and other organs. EDS symptoms can range from mild to severe, and life-threatening depending on what connective tissues are affected.

As a teenager, she began experiencing pain in her left hip, and over the course of her adult life, she had injuries from overextending her joints while running. Her doctor tested her for hypermobility (when a joint can be extended beyond the normal range of motion) and diagnosed her with hypermobile Ehlers-Danlos syndrome (formerly EDS type 3), the most common type.

Patients with this type of EDS can experience flexible joints, and it is common for

them to have dislocations. Over time, the wear on the joint can cause chronic pain.

Hypermobile Ehlers-Danlos syndrome is the least severe type of EDS. Because EDS can affect any connective tissue, this disease is not always confined to the joints. In more rare types of EDS, the blood vessels throughout the body can become damaged, which can lead to serious life-threatening complications, and even death.

It is common for patients with hypermobile Ehlers-Danlos syndrome to have a range of symptoms. Most patients experience some degree of joint hypermobility; however, some patients can also have signs of EDS in their skin as well. ◇

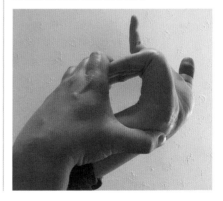

◇

37 YEARS OLD | JERSEY, CHANEL ISLANDS, UNITED KINGDOM

This patient was diagnosed with EDS very early in life. Early detection was possible due to a strong family history on her dad's side, including her father, grandmother, uncle, and cousins. She has suffered with hypermobile joints (particularly in her fingers) and joint pain throughout her body for most of her life. The most striking feature of her Ehlers-Danlos syndrome, however, is visible in her skin. Although her family has a strong history of EDS, no one has been formally diagnosed with one of the thirteen types.

EDS can affect the connective tissue in the skin, making it more fragile. Her skin is soft, velvety, and very elastic, but she bruises easily. Her skin also takes longer to heal, and she also scars easily.

It is important for EDS patients to make their doctors aware of their condition. Studies have shown that these patients are less responsive to local anesthetic, and their incisions do not heal as well after surgery. In some cases, the suturing after an injury or surgery needs to be approached differently in patients with this kind of fragile skin. ◊

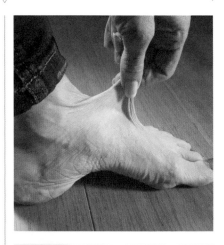

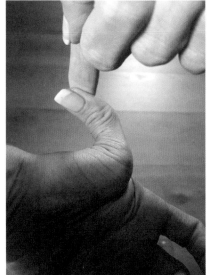

GOUT

53 YEARS OLD | ROYAL OAK, MICHIGAN, UNITED STATES

◊

When this patient was thirty-two years old, he woke up with excruciating pain in his big toe. He went to a podiatrist, who performed a series of tests including a blood test to check his levels of uric acid. His levels came back high—12 mg/dl—when the normal levels are between 3-7 mg/dl. He was diagnosed with a condition known as gout.

Gout occurs when urate crystals form in the joint. This can happen from an increase in uric acid in the blood. When a patient with gout has an episode of severe pain in the joints, this is known as a gout attack.

Uric acid is a waste product that is normally found in the blood. Uric acid is a chemical produced by the body after it breaks down a substance known as purine. Purines occur naturally in the body but are also present in certain foods.

Under normal conditions, uric acid is eliminated from the body by the kidneys. When a person has gout, the body is either producing too much uric acid or the kidneys are not working hard enough to remove the uric acid from the body.

When uric acid accumulates in the blood, it can form sharp, needlelike crystals in the joint, which cause severe pain. It is common for a patient to experience their

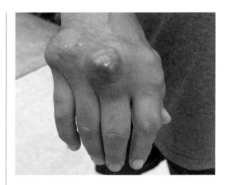

first gout attack in the joint of their big toe. Without treatment, the crystals can accumulate in other joints, causing them to look nodular and bulbous. This is called a tophus.

When this patient was first diagnosed with gout, he was hesitant to take the prescribed medication because of the side effects. Over time, the increase of uric acid in his blood caused him to develop tophi in multiple joints, including his elbows and knuckles.

Since he developed the tophi, he has been on a stricter regimen. He takes medication daily and, because purines are present in some foods, he has made changes to his diet. He will always have gout; however, with medication, diet, and lifestyle changes, he has been able to keep it under control and has not had a gout attack in over a year. ◊

◊

KIDNEY

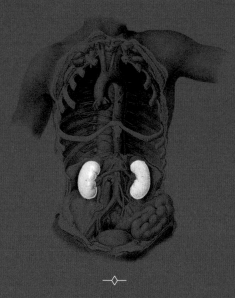

◇

Although kidneys are small (about the size of your fist), they are essential for life. In most cases, a human is born with two, but only needs one to survive. The kidneys are nestled deep in the back of the abdomen under the lower ribs for protection. Kidneys are essential because they filter toxins from the blood, maintain our fluid balance, and keep our blood pressure under control. Since the kidneys are responsible for removing toxins from the body, they are exposed to potentially harmful substances, increasing a patient's risk for pathology. In other cases, pathology occurs before a patient is even born.

DUPLICATED URETER / HYDRONEPHROSIS

19 YEARS OLD | NEWBURGH, NEW YORK, UNITED STATES

◊

As a small child, this patient experienced years of unusual symptoms, including chronic back pain, difficulty breathing, nausea, and fevers. Her skin had an unusual tone, and she was not able to tell when her bladder was full. Her parents brought their concerns to the child's pediatrician, who initially diagnosed her with constipation. Not satisfied with that diagnosis, they demanded further testing and were referred to a gastroenterologist.

The gastroenterologist was concerned with her symptoms and ordered additional testing, including an ultrasound. These tests revealed that this patient was not, in fact, having problems with her gastrointes-

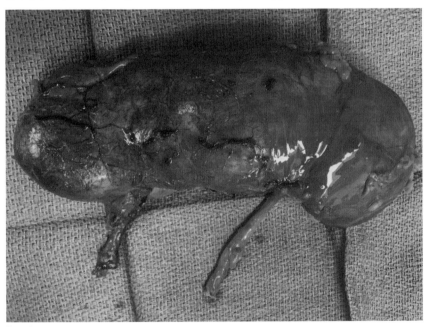

Figure 1

◊

tinal tract; rather, the issue was within her urinary tract. She was diagnosed with a serious condition known as a duplicated ureter with hydronephrosis.

The ureter is a duct that allows urine (made in the kidney) to travel to the bladder and then eventually be excreted from the body. Under normal conditions, humans have only one ureter that leaves the kidney.

A duplicated ureter is a congenital anomaly. As the kidneys are forming during fetal development, the ureters can split or become duplicated.

A duplicated ureter is the most common congenital anomaly of the kidney. Many people are born with this condition and do not even know it. A person can live with a duplicated ureter their entire life without any complications. Other people, as in this case, can have serious, life-threatening complications.

The duplicated ureters can have abnormal anatomy and can cause problems with the way urine exits the body, which can lead to urine backing up. This causes a condition known as hydronephrosis.

After testing, it was determined that her kidney was damaged and needed surgery. Two eight-hour surgeries were performed to repair her double ureters. The surgeries were not successful. Next, she was given a nephrostomy bag. This is a drain that is placed in the kidney to bypass the ureters. The urine leaves the kidney and exits the body through the drain into the nephrostomy bag.

When doctors saw her drastic improvement in symptoms after having the nephrostomy bag, they made the decision to remove her entire left kidney (Figure 1). She was fourteen years old at the time.

When the diseased kidney was removed, she was finally able to start having a better quality of life. As a child, she missed school and holidays because of multiple hospitalizations. As an adult, she is expected to live a normal life—minus one kidney. ◊

LIVING DONOR

25 YEARS OLD | LYNDHURST, NEW JERSEY, UNITED STATES

This story is unlike any other in this book because this patient has no pathology! She was perfectly healthy, and she put her life at risk to help someone who was dying.

Five years ago, this patient lost her father. He was a Jersey City police officer who was a first responder on September 11, 2001. He died from cancer because of chemical exposures from the September 11 attacks.

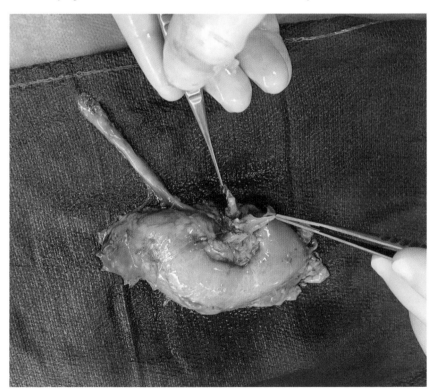

Figure 1

A few years later, she found out that a Jersey City police officer needed a kidney. When she heard the news she thought of her father, who was the light of her life. She thought of how generous he was to his friends, family, and the community he served. She wanted to do something to carry on his legacy, so she volunteered to donate her kidney to the officer in need.

She reached out to the hospital to see if she could donate, but fortunately, they already had a donor. Since she had already made the decision to donate to a stranger, she decided she still wanted to do this act of kindness in honor of her father. She signed up to be a living donor.

A living donor is a person who voluntarily donates one of their healthy organs to a person who is dying from organ failure. If the donor is healthy, they can spare an organ or a piece of an organ and still live a normal, healthy life. Currently, living donors can donate one kidney, one liver lobe, up to one lung, part of the pancreas, and part of the intestines.

Over six thousand people a year donate their kidneys to someone; however, it is usually to a loved one. Less than 5 percent of kidneys donated every year are donated to strangers.

Most humans are born with two kidneys, but we only need one to live. The other kidney is a backup. Deciding to be a living donor means giving up the backup kidney.

Leading up to her donation, she was given a series of tests to make sure she was healthy enough to donate, and that her kidney was healthy enough to transplant. She also had to meet with a social worker, a psychologist, dietician, pharmacist, and urologist to make sure she was both mentally and physically prepared for her upcoming surgery.

The surgery to remove her kidney took four hours, and she spent a day and a half in the hospital (Figure 1). At twenty-five years old, she recovered quickly and felt back to normal within a week. Her kidney was flown to California and transplanted into a complete stranger. She does not know much about the recipient; however, she has heard from her transplant team that he is doing well with his new kidney.

She considers her decision to donate the healthiest decision she has made in her life, for both her body and mind. She is now motivated to take care of herself and feels good that she was able to save a life. ◊

ONCOCYTOMA

37 YEARS OLD | PEORIA, ARIZONA, UNITED STATES

When this patient was in his early thirties, he suddenly started having high blood pressure, or hypertension. He was treated with medications for hypertension for two years, but his high blood pressure was never really gotten under control. His doctor decided to order an ultrasound to see if there was a problem with his kidneys contributing to his hypertension. Subsequently, the ultrasound revealed a mass on his right kidney. This was confirmed by a CT scan, and his doctors were certain it was renal cell carcinoma (kidney cancer). About a week later, his entire right kidney was surgically removed (Figure 1).

After surgery, the kidney was sent to surgical pathology. There, it was determined that it was not cancer, but a benign tumor called a renal oncocytoma. Renal oncocytomas are a common benign tumor of the kidney, however, they are uncommon in this age group. These types of tumors most com-monly occur in patients in their seventies. Even though these tumors are benign, there have been rare cases of them metastasizing (spreading) to the bone and liver. Therefore, it is important these patients are monitored regularly. In most cases, surgery is the cure, and these patients go on to have no further complications.

Living with one kidney has placed some limitations on this patient. He has been advised not to take ibuprofen and to avoid a diet high in protein. Otherwise, his prognosis is excellent, and his high blood pressure is now under control. ◊

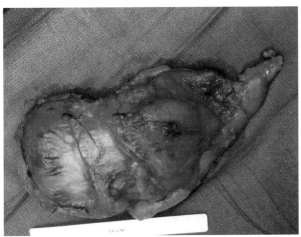

Figure 1

POLYCYSTIC KIDNEY DISEASE

36 YEARS OLD | ST. LOUIS, MISSOURI, UNITED STATES

◇

Starting at eighteen months old, this patient had four recurrent bladder infections within six months. After the fourth infection, her pediatrician sent her to a urologist (a doctor who specializes in the urinary tract) at a local children's hospital. She received an ultrasound and was diagnosed with autosomal dominant polycystic kidney disease.

Autosomal dominant polycystic kidney disease (ADPKD) is a genetic, autosomal dominant trait. This means if one parent carries a mutated gene for PKD, their children will have a 50 percent chance of developing the disease. In rare cases, ADPKD can happen without an affected parent, and the gene can mutate on its own when a fetus is developing. This is what happened in this case.

After she was diagnosed with ADPKD, all living members of her family were tested for the gene mutation, but they were all negative. Even though her ADPKD mutation was not passed down from a parent, she is still able to pass this on to any children she may have one day.

Most people who have the mutated gene for ADPKD do not develop symptoms until they are thirty to fifty years old, which is why it is sometimes called adult polycystic kidney disease. In some cases, people can start showing symptoms when they are children, like this patient.

When people with ADPKD start developing cysts in their kidneys, the kidneys slowly become replaced by cysts. Over time, there are so many cysts that there is no normal kidney tissue left.

Once the cysts take over both kidneys, the patients will start to have kidney failure. You cannot live without at least one functioning kidney.

At the time of her diagnosis, she was told to limit her caffeine intake, which can cause the cysts to grow more rapidly. For years she lived without symptoms, but as she grew, her symptoms started to increase. At fifteen years old, she was put on medication for high blood pressure.

The medication controlled her blood pressure for years until she was about thirty years old. She went for a routine checkup to her nephrologist after experiencing symptoms of fatigue. After testing, she was told that she had stage 3 kidney failure, and she would need a kidney transplant. As she waited on the transplant list, her fatigue increased, and her kidney function went down to only 6 percent. She had to quit her job and go on disability.

One day, while at a family party, she was telling her story to her boyfriend's cousin's wife. She eagerly stated, "Well, I will give you my kidney!" The two did not know each

other well and had only chatted at family parties. She was humbled by the gesture but did not think much of it. Over the years, multiple people had said the same thing to her, but no one followed through on their offer when the need for a transplant was real.

By this time, she knew she had to schedule surgery to start the process of peritoneal dialysis, but she was scared. As a result, she pushed it off a couple of months. Peritoneal dialysis replaces the function of the kidneys. This procedure consists of a tube that is surgically inserted into the abdominal cavity. During peritoneal dialysis, a cleansing fluid called dialysate is circulated through the tube to absorb waste products produced from the blood vessels in the abdominal lining. The waste products are then drawn back out of the body and discarded.

Little did she know that her boyfriend's cousin's wife was quietly getting tested to be a living kidney donor (a person who donates their organs while they are still alive). After testing, it was determined that she would be a good donor. On Christmas Day 2019, the family member told this patient that she would be getting a new kidney. Within a couple of months, she received her life-saving kidney transplant. The donor is doing well and has had no complications.

At the time of the transplant, the decision was made to leave the patient's diseased polycystic kidneys in her body because it was too risky to remove them in the same surgery. She was told her transplant was a success. Due to the nature of the disease, however, the polycystic kidneys continued to grow larger.

Over the course of the next couple of years, the kidneys continued growing larger, and the patient was becoming increasingly uncomfortable. She was having difficulty eating, breathing, bending, and moving overall. She did some research and found a surgeon in another state who could remove the diseased kidneys laparoscopically (through small incisions with the assistance of a camera) as opposed to having to cut her open again.

After her polycystic kidneys were removed, they weighed in at over 11 pounds (5000g) each (Figure 1). A normal kidney is about one-third of a pound (150g).

As of today, her new kidney is functioning at about 66 percent, and she is feeling great. She is expected to do well with her new kidney if her body does not reject it. She was told by her doctor that there is a much better chance of her living a longer life with a kidney from a live donor versus a cadaver donor. Every day she is thankful for the selfless person who risked their own life to save hers. ◊

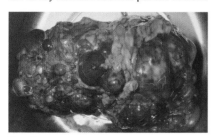

Figure 1

LIVER

The liver is the largest internal organ and has hundreds of important functions. It acts as a filter to remove toxins from the blood, stores vital nutrients, produces blood-clotting factors, and produces bile, which helps break down the fat in our foods. We can't live without a liver, but luckily, most of our livers have the amazing ability to regenerate, healing themselves if damaged. Unfortunately, in some cases, damage to the liver either naturally or from exposures can be irreversible and pose a life-threatening situation for the patient.

ALCOHOLIC CIRRHOSIS

66 YEARS OLD | MEDINA, OHIO, UNITED STATES

◊

This patient had a thirty-year history of alcohol abuse and addiction. Over the last two years of his life, his alcohol intake increased. He progressed to drinking large quantities of wine, vodka, and beer morning, noon, and night.

He developed many symptoms, including abdominal distension, bloating, poor appetite, difficulty breathing, confusion, and weakness that landed him in the hospital. Initial testing showed his liver enzymes and ammonia levels were dangerously elevated. After a CT scan and a physical exam, he was diagnosed with end-stage liver disease with ascites due to alcoholic cirrhosis.

Chronic alcohol use has known toxicity to the liver. At first, the liver will show damage that is reversible if alcohol use is discontinued. Over time, however, the liver will become scarred or cirrhotic. The scarred liver increases pressure in the blood vessels that pass through the liver. This causes the fluid in the blood to back up into the tissues and body cavities (ascites).

Ascites cause extensive abdominal extension and a tremendous amount of pressure.

Unfortunately, he was told his condition was terminal. Doctors gave him a procedure called a paracentesis to make him comfortable for the remainder of his life. This procedure is when the fluid is drained out to relieve some pressure on the organs. Each time his abdomen was tapped, five to six liters of fluid were removed. Paracentesis is only a temporary procedure. The fluid will eventually reaccumulate, and the procedure will need to be done again.

One month after this photo was taken, this patient died from complications of alcoholic cirrhosis. ◊

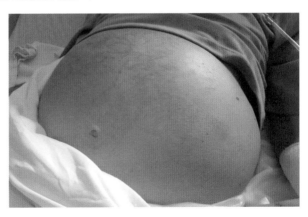

◊

BILIARY ATRESIA

13 MONTHS OLD | VERDIGRIS, OKLAHOMA, UNITED STATES

When this baby was born, she seemed perfectly healthy despite being about one pound smaller than average. At birth, her belly was distended, and X-rays were taken and she was diagnosed with gas. Over the course of the next couple of months, the baby was not gaining weight and had pale, clayish stools. The whites of her eyes also had a yellowish tint. Despite this, her doctor did not seem concerned.

One day, her mother noticed the whites of her baby's eyes were now bright yellow. Her mother messaged the pediatrician and demanded lab work. The doctor agreed and was seemingly surprised when the results read abnormal the following day. The pediatrician then advised the mother to take her baby to the emergency room due to a dangerously high level of enzymes in her liver.

After arriving at their local emergency room, they were ultimately sent to a children's hospital about two hours away. There, the baby could be examined by doctors specializing in liver conditions.

Within the week, multiple tests were done to determine what was causing the baby's high liver enzymes. She was given exploratory procedures to examine her liver and bile ducts. During those procedures, doctors took a little piece of the liver (known

as a biopsy) and sent it to surgical pathology. There she was diagnosed with a condition known as biliary atresia. She was three months old at the time of her diagnosis.

Biliary atresia is a rare condition when a baby is born with defective bile ducts. Normally, bile is made in the liver and transported to the gallbladder, where it is held. In this case, the bile that is made in the liver cannot be transported because the bile ducts are not developed properly. This causes bile to back up in the liver. The backup of bile causes liver damage and eventually cirrhosis (scarring of the liver). Most people diagnosed with biliary atresia will die without a lifesaving liver transplant.

There is no known cause or cure for biliary atresia. In some cases, a surgical procedure can be done to bypass the abnormal ducts so the bile goes directly into the small intestine. That procedure is not a cure for biliary atresia, but it can buy a patient some time before they need a liver transplant. This procedure was not an option for this baby because she was not diagnosed until she was three months old and her liver already had irreversible damage.

After her diagnosis, she was placed on the transplant list, and in a little over two months, had her lifesaving surgery: a transplant of the left lobe of her liver. Her

diseased liver was sent to pathology for examination (Figure 1).

The transplant was a success, and she was discharged from the hospital only twelve days after surgery.

A liver transplant for biliary atresia has a high long-term success rate, but it still has risks for complications, including rejection of the organ. She will have to be on medications the rest of her life due to this condition. Transplant recipients are considered immunosuppressed and are at a greater risk for certain types of infections called opportunistic infections. An opportunistic infection is caused by an organism (bacteria, virus, etc.) that normally does not make healthy individuals sick, but has the opportunity to make a person with a weakened immune system sick.

It has been a rough road for this baby and her mother. She did not really come to life until after she had her transplant and was feeling better. Before her surgery, she was not lively. She did not eat any pureed or solid foods. She had tube feedings and vitamin injections because she could not gain weight and absorb nutrients on her own. She also did not meet the normal childhood milestones for motor skills.

Since her transplant, she has been eating and gaining weight successfully. By twelve months old, she was crawling. It is expected she will continue reaching her adolescent milestones without issue; however, she will have to be monitored for biliary atresia for the rest of her life. ◊

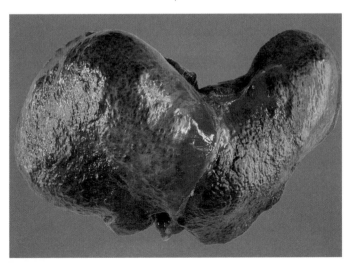

Figure 1

LYMPHATIC SYSTEM

The lymphatic system helps maintain fluid balance around the body and works as part of the immune system. It is a network of tissues, organs, and ducts that transport a fluid called lymph, which is a filtrate of blood collected from tissues. The lymph fluid moves through these ducts and filters through hundreds of little bean-like structures called lymph nodes. Lymph nodes act as a filter to clean the lymph fluid by destroying any foreign substances, such as bacteria and viruses. Together with the organs of the lymphatic system, the lymph fluid is filtered and returned to the bloodstream to maintain fluid balance. Lymph fluid moves slowly because there is no pump like the circulatory system to move it. It relies on gravity and movement to flow freely. If there is pathology, the fluid can back up and have a great impact on a patient's quality of life.

PRIMARY LYMPHEDEMA

65 YEARS OLD | HARLEYSVILLE, PENNSYLVANIA, UNITED STATES

When this patient was fifteen years old, she started noticing swelling in her left calf. Her mom was a nurse and was concerned with this symptom, so she took her to the doctor right away. Over the course of the next couple of years, she was monitored and tested. Doctors were not sure what was causing her leg to swell, and she was diagnosed with a condition known as primary lymphedema.

Her treatment for primary lymphedema includes manual lymphatic drainage (lymphatic massage), diuretics (water pills), keeping the leg elevated, and compression garments. She once had a lymphatic massage which yielded four and a half gallons of fluid!

Primary lymphedema is less common than secondary lymphedema, which occurs when there is trauma to the ducts, causing scarring and a blockage. This trauma can be caused by car accidents, parasitic infections, and surgeries like cancer treatments. ◊

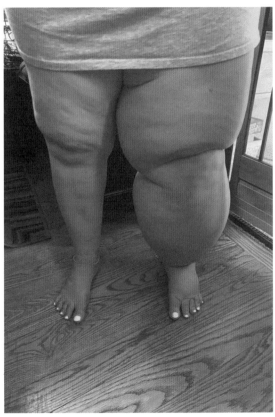

SECONDARY LYMPHEDEMA

44 YEARS OLD | FORT WORTH, TEXAS, UNITED STATES

Three years ago, this patient felt a lump in her right breast. After a biopsy and imaging, she was diagnosed with stage 3 breast cancer and scheduled for a surgery called a double mastectomy. A double mastectomy is when both breasts are removed.

During this surgery, another procedure is done to determine if the cancer has spread locally to the axilla (armpit) called a sentinel lymph node biopsy. The axilla has a series of lymph nodes that are responsible for draining fluid from the arms, breast, and chest. If the cancer has spread locally to the axillary lymph nodes, there is an increased chance of it spreading to a more distant location like the liver or bones.

During the surgery, radioactive blue dye is injected into the breast tumor to locate the first (sentinel) lymph node in the axilla where the tumor is draining. That lymph node is then removed and sent to surgical pathology. While the patient is still under anesthesia, the lymph node is looked at under the microscope by a pathologist. If cancer is not present, the surgeon will leave the axillary lymph nodes in place.

In this case, however, this patient's cancer had spread to the sentinel lymph node, and her surgeon removed all the lymph nodes from her right axilla. Due to the removal, the arm is no longer able to drain, causing swelling and discomfort in the patient's arm for the rest of her life.

A sentinel lymph node biopsy is intended to prevent any unnecessary surgery in patients who have a low risk of cancer spreading and to avoid secondary lymphedema. For this patient, the removal of her lymph nodes was necessary to prevent her cancer from spreading and caused secondary lymphedema. To manage the swelling, she wears a compression garment on her arm. Although secondary lymphedema will always be part of her life, it is far less problematic than metastatic breast cancer. ◊

MALE REPRODUCTIVE SYSTEM

The male reproductive system is anatomically designed for one purpose: to make babies. This system consists of testicles, housed in the scrotal sac, and are responsible for producing sperm, and the prostate gland, which makes a liquid to transport the sperm. Together they make semen, which exits the body through the penis. The penis is not just for semen, though; the male urethra serves as a double transport system for both semen and urine. Pathology of the male reproductive tract can cause severe discomfort and embarrassment, as well as infertility.

ORCHIECTOMY

31 YEARS OLD | WEST JORDAN, UTAH, UNITED STATES

During a routine self-exam, this patient felt a mass on his left testicle. He scheduled an appointment with his doctor, and upon examination, the doctor insisted the mass was a cyst and surgery was not necessary. To confirm this diagnosis, the patient decided to get a second opinion, and this doctor recommended surgery. Ultimately, the patient decided to go with the second doctor's opinion and have the cysts removed, a decision that changed his life forever.

During the surgery, his doctor removed multiple cysts from the epididymis of his left testicle in what was supposed to be a relatively routine, uncomplicated surgery.

The testicles are the male sex organs, and their anatomic location is outside the body. They are attached to the body by a structure called the spermatic cord, which is partially external and partially internal. Within this cord are multiple blood vessels and a duct that brings the sperm from the outside of the body to the inside of the body. The function of the male testicle is to produce sperm. The sperm that is produced in the testicle first goes through a coiled duct called the epididymis, which is an external structure on the outside of the testicle. Sperm is then transported into a duct, bringing it into the body so it can exit through the penis. All the external structures of the testicle are encased in a protective skin sac called the scrotum.

For unknown reasons, the sperm in the epididymis can sometimes back up, causing

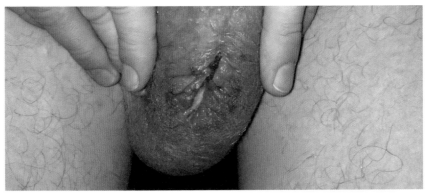

cysts to form. A cyst in the epididymis is called a spermatocele. If the cyst grows large, it can be felt by the patient through the scrotum.

Spermatoceles are benign, and in most cases, they should be left alone. Sometimes a patient will have pain and discomfort due to the cysts, and a surgical procedure will be performed to remove them. During this procedure, an incision is made in the scrotal sac to access the epididymis. This surgery carries some risks, the most common being a blood clot that can form behind the incision site.

When this patient had his post-op appointment, the surgeon thought the incision was healing well, even though his incision was very painful and was still oozing blood and had a foul smell.

Shortly after his appointment, he went on a flight for a quick day trip for work. On that flight he had a severe onset of pain in his testicle, and when he got off the plane, examined his scrotum, finding that his incision had burst open and was oozing blood. He immediately went to the hospital.

At the hospital, the doctor explored his open incision and determined he had a very serious infection called MRSA (methicillin-resistant *Staphylococcus aureus*). He was told he needed emergency surgery to remove the infected testicle, called an orchiectomy. This surgery was drastic but was necessary to save his life.

Staphylococcus aureus is a bacterium that is normally found in the nose and sometimes on people's skin. This bacterium is responsible for staph infections. MRSA is also a staph infection; however, it is more severe due to its resistance to many antibiotics. This makes it more difficult to get under control.

When his second surgical procedure was performed, all the infectious tissue was removed, including his left testicle. The incision was left open for weeks, and during that time he was able to see his other testicle in his scrotal sac.

He was given multiple antibiotics after surgery, however, the bacteria were so resistant, it took over eight months to completely get it out of his body.

Generally, the risk of developing a MRSA infection after a surgery like this is low but can happen. This MRSA infection has taken both a physical and emotional toll on his body. He regrets not listening to the first doctor, who advised him to leave the cysts alone.

Coincidentally, when he was having his testicle removed, his wife was in the hospital giving birth to what would be their second and last child. Complications from his surgeries and subsequent infection have left him sterile.

Although the couple is disappointed they cannot have any more children, they are happy this MRSA infection did not take his life. ◊

VASECTOMY

46 YEARS OLD | BRUGES, BELGIUM

After the birth of his second child, this patient and his wife decided on a more permanent birth control option: sterilization. Male sterilization is done by a procedure called a vasectomy.

For a pregnancy to occur, male sex cells called sperm need to unite with female sex cells called eggs. The male testicles produce and store sperm. During ejaculation, sperm leaves the testicles via a duct called the vas deferens. The sperm is then joined with fluid made in the prostate gland to make semen. The semen exits the body into the female, where it can join with the egg.

The vas deferens is a duct that is located both in and outside the body. The external part of the vas deferens exits the testicle within the scrotal sac before entering the body. This makes it easily accessible for the surgeon in an outpatient setting.

During a vasectomy, a small segment of each vasa deferentia is surgically removed (Figure 1). Each end of the duct is either tied off or cauterized.

A vasectomy does not provide immediate pregnancy protection. Sperm will still be created in the testicles, and fluid will still form in the prostate gland. The patient needs to ejaculate around twenty times after the surgery to be sure there are no residual sperm coming through.

Six to twelve weeks after the surgery, patients should provide a sperm sample to make sure the procedure was successful. The semen will be sent to the lab for analysis, where it will be looked at under the microscope.

In most cases, a vasectomy is a reliable source of birth control, but it is not 100 percent effective. In rare cases, sperm can travel across the cut ends of the duct leading to pregnancy. A vasectomy is considered a permanent sterilization option, although it is possible in some cases to reverse it and have a successful pregnancy. ◊

Figure 1

PENIS TRAUMA

45 YEARS OLD | BANNING, CALIFORNIA, UNITED STATES

This patient was having sex with his wife on the couch in their living room. She was sitting on his penis, and as she moved up and down, his penis jammed, creating a popping noise.

When they looked at his penis, blood was gushing out of its tip. The blood was squirting out with such force that it hit the ceiling and traveled to the dining room and hallway.

His wife was alarmed by the amount of blood loss and decided to call an ambulance. He was taken to the emergency room, where a variety of tests, including a CT scan and a cystoscopy or a bladder scan, were conducted. During a cystoscopy, a thin tube is inserted inside of the penis and contrast dye is inserted into the bladder. This allows the doctor to see the bladder more clearly. During this test, they found no pathology with the bladder, urethra, or prostate gland.

The bleeding subsided in the emergency room, and no treatment was necessary. He was told to avoid erections for six weeks, but four days after being discharged from the hospital, he woke up in the middle of the night after having an erection to find his sheets soaked with blood. The following two weeks were followed by additional episodes of painless bleeding with every erection.

He could not be seen by a urologist for three weeks. During that time the injury healed, and the doctor was still not able to properly identify the source of the bleed. The couple was told the blood loss was more than likely due to a vessel that ruptured when the penis was injured. They were advised to be more careful during their sexual activities. The bleeding has not happened since the initial injury healed. ◊

NAILS

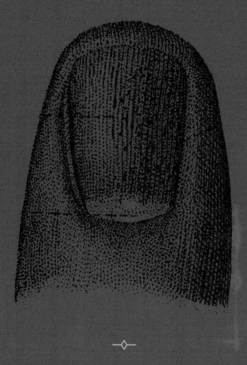

Both fingernails and toenails are made from the same protein as hair, keratin. Keratin is a protein made of dead cells, which is why it does not hurt when nails are cut. While the nails are anatomically designed for protection of the finger- and toe tips, they can be a window into a patient's state of health.

BEAU LINES

38 YEARS OLD | MOSCOW, IDAHO, UNITED STATES

◇

Three years ago, this patient was diagnosed with stage 2 breast cancer. The current recommended age for mammograms in the United States is forty-five, unless the patient has a mass or family history of breast cancer. In this case, she was already getting early mammograms because her half-sister was diagnosed with breast cancer at age thirty-one, and her mother was diagnosed with breast cancer at age fifty-eight. They were all tested for a common gene mutation associated with breast cancers in families; however, they were all negative.

A year before her diagnosis, a cyst was seen on her mammogram screening. She

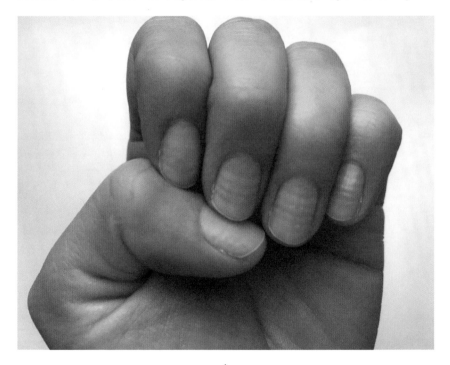

◇

was told this cyst may change and to keep an eye on it. Over the course of the year, the cyst started to grow larger and displaced her nipple. At her next mammogram screening, she mentioned the change and a more detailed mammogram was ordered. The area looked suspicious, so an ultrasound was done to get more details. During the ultrasound, a little piece of the mass was removed with a needle, which is called a biopsy. This piece of tissue was looked at under the microscope by a pathologist, and the patient was diagnosed with invasive ductal adenocarcinoma (IDC), or breast cancer.

On the imaging, the suspicious area appeared small (less than a centimeter); however, due to her family history of breast cancer, it was recommended she have both breasts removed. This surgery is called a double mastectomy. When her breasts were examined in pathology, the tumor was three times larger than it was on imaging (1.37 in). Due to the large size of the tumor, she was diagnosed with stage 2 breast cancer and was told she needed chemotherapy.

Chemotherapy is a drug treatment that is intended to kill cancerous cells in the body. Different drug therapies are given to patients depending on their medical history, the type of cancer they have, and the oncologist (a doctor who specializes in cancer treatment) who is administering the chemotherapy.

After her third round of chemotherapy, she noticed her fingernails looked different. She showed her oncologist and was told the changes in her fingernails were called Beau's lines and were related to her chemotherapy treatment.

Beau's lines are common in patients who receive certain chemotherapy drugs. They can result from an interruption in the growth of the fingernail due to illness or exposure to toxins. Beau's lines are horizontal indentations in the nail plate. Each line shows exposure to a toxin, in this case, chemotherapy.

Since her double mastectomy and four rounds of chemotherapy, her scans have been clean and show no evidence of recurrent breast cancer. ◊

AVULSION

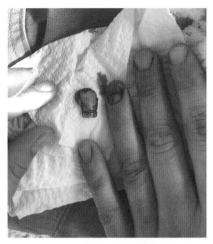

One day, this patient was using a hammer to drive stakes into the ground for a gate. While he was on a downward swing, he slammed his finger against the curb, fracturing his fingertip and ripping off his fingernail completely.

Losing a fingernail because of an injury is called avulsion. The fingernail itself has no nerve endings, however, its function is to protect the fingertip, which has a lot of nerve endings. This is why it is so painful to have an injury to a fingernail.

Fingernail trauma can permanently damage the nail root and the nail bed. These types of injuries can usually be repaired by an emergency room physician, but more serious trauma may need to be treated by a hand surgeon.

Although this injury looked serious, it was evaluated by emergency room doctors, and it was found that there was no trauma to the nail root or bed. The treatment was simple: just a splint. The splint stabilized his finger and allowed his fractured fingertip to heal while his nail grew back.

Within two months, his fingernail grew back completely but was disfigured. Over time, the fingernail grew back normal and had no signs of a previous traumatic injury. ◊

CLUBBING

29 YEARS OLD | VILLA DE MERLO, SAN LUIS, ARGENTINA

◊

At birth, this patient was seemingly healthy until at about eleven months old, when she became sick with a viral respiratory illness. As the days passed, she was not getting better, she was getting worse. What was a common childhood cold turned into something much worse: severe pneumonia.

She was hospitalized while doctors tried to work frantically to see what was causing such severe illness in this baby who appeared healthy. After many consultations with doctors and much testing, she was diagnosed with a congenital condition known as pulmonary atresia.

Under normal circumstances, when we breathe oxygen into our lungs, it is transferred to our blood to bring oxygen to all the organs throughout the body. After the organs use up all the oxygen, the deoxygenated blood is sent back to the right side of the heart. This blood goes through the right side of the heart and enters the lungs, where it picks up oxygen, returns to the left side of the heart, and is pumped out to the rest of the body through the aorta.

With pulmonary atresia, the valve on the right side of the heart that controls the deoxygenated blood from entering the lungs does not develop properly when the fetus is growing. When the baby is born, there is difficulty getting the proper amount of oxygen to all their organs.

Pulmonary atresia is not a problem with the developing fetus because both the mother and the placenta assist with providing the fetus with oxygen. When a fetus is in the womb, the heart has a hole (the foramen ovale) that allows the blood to bypass the lungs because the fetus is getting oxygen from the mother. In normal cases, shortly after the fetus is born, that hole will close on its own as the fetus will now be oxygenating for itself. It may not close in cases of pulmonary atresia.

Additionally, there is a small artery that forms a temporary connection between the pulmonary artery and the aorta called the ductus arteriosus. This artery also usually closes after birth, but in cases of pulmonary atresia, it may stay open.

Pulmonary atresia is a congenital defect that occurred as the baby was a growing fetus. It is unknown why a baby develops heart defects during development, but it could be due to a defective gene or exposures the mother has during pregnancy (such as to medications, viruses, etc.).

When this patient was born with pulmonary atresia, her lungs were not receiv-

◊

ing the oxygenated blood it needed, and her body had to find another way to get the deoxygenated blood to her lungs. For the first few months of her life, her body compensated by keeping the ductus arteriosus open and forming new blood vessels called collateral vessels. This is what kept her condition hidden for months.

Under most circumstances, pulmonary atresia is usually noticed after birth, because the lack of oxygen—depending on the severity—can give the newborn baby blue-gray-looking skin. In her case, she did not present with symptoms until she was exposed to a viral infection.

When she was first diagnosed, she was put on medications to keep the vessels that

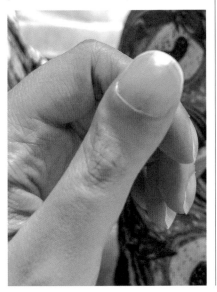

had been assisting with oxygenating her blood for the first few months of her life open. This treatment was effective for years, and she was able to live a relatively normal life as a child. She did notice one strange thing about her body as she grew up: her fingernails were abnormal—the tips of her fingers appeared wider, and her fingernails curved over her fingertips.

She did not realize her fingernails looked different until it was pointed out to her. Her doctor explained that she had a condition that is associated with patients with some cardiorespiratory diseases called fingernail clubbing. Fingernail clubbing is when there is an increased curving of the nail plate, giving the fingers the appearance of a drumstick.

It is unknown what causes fingernail clubbing in these patients, but it is thought to be caused by soft tissue swelling at the ends of the fingertips due to the release of growth factors when there is a lack of oxygen in the blood.

From the age of fifteen to twenty-one, her medication regimen began to fail her, and she was hospitalized several times and placed on oxygen. Doctors felt her condition was severe enough that she was placed on the list to receive a heart and lung transplant.

As of now, her condition is being stabilized with medications. Due to the extreme risks with the heart and lung transplant, however, her doctors feel the surgery may be too risky for her. ◊

◊

NERVOUS SYSTEM

◇

The nervous system allows our brain, which is the central control system of our body, to relay messages back and forth within our bodies. It is made up of the brain, spinal cord, and nerves, which contain billions of nerve cells that respond to stimuli, both from inside our body and our outside environment. Depending on what part of the nervous system is damaged, the symptoms can range from minor inconveniences to serious disability and ultimately death.

PARAPLEGIA

22 YEARS OLD | DALLAS, TEXAS, UNITED STATES

◇

This patient did not begin to walk until after she turned two years old. When she did start walking, she had an unusual gait, or walking pattern. These concerns were brought to her pediatrician, who did not seem concerned, even joking that she was a "lazy baby."

By four years old, her family became increasingly concerned about her abnormal walk. She was brought to another pediatrician for a second opinion, and an MRI was ordered. It became clear what the problem was. She was diagnosed with multiple congenital abnormalities of the spine, including spina bifida occulta and a tethered cord.

Spina bifida occulta occurs during fetal development when the bones of the spinal column do not form properly, leading to a gap in the backbone. Sometimes the spinal cord can get stuck in the gap and cause a condition known as a tethered cord. Normally the spinal cord should freely float within the spinal canal to allow for growth of the child. If the cord is stuck, it will stretch and cause damage to the spinal nerves. Her spinal cord is also split (diastematomyelia), and she has a sideway curvature of her backbone known as scoliosis (Figure 1), both conditions which are common in patients with spina bifida occulta.

Although these conditions are congenital, meaning they occurred when she was growing as a fetus, none of them were identified on ultrasound while her mother was pregnant.

Over the course of her life, she has had six surgeries to untether her spinal cord. After each surgery she was able to heal, but then her symptoms, including leg weakness, loss of sensation, foot drop, and urinary incontinence, would return. After the fourth and fifth surgeries, she started to lose her ability to ambulate. Finally, after the sixth surgery, at only seventeen years old, she was unable to walk. She is now considered an incomplete paraplegic and has been living in a wheelchair ever since.

Her injuries are at the level of the thoracic backbone (mid-back) at bones #10-12 (T10-12). The repeated trauma from the surgeries to untether the spine made her partially paralyzed on the lower half of her body. It is termed incomplete paralysis because she is not able to walk but still has sensation in her legs.

Around the time she lost her ability to walk, she used a heating blanket with an automatic shut off. The blanket was on a low heat setting. During the night the blanket never turned off, and when she woke up, she

◇

had a large, second-degree burn that blistered over her right hip (Figure 2). Since she is a paraplegic, she saw a special wound-care specialist who treated her burn. It took three months to heal.

Patients with a complete or almost complete loss of sensation must be careful not to get injured because of their inability to feel pain when something is wrong. When these patients do get injuries, they also tend to heal slower than the average person.

Since the burn from the heating blanket, she has had another serious injury that resulted from a roller coaster ride at a popular theme park. The vigorous ride caused her to injure her lower back. The wound did not heal and continued to worsen over the course of three years, eventually turning into a stage 4 decubitus ulcer. This is a serious infection that causes a destructive wound that goes deep into the tissues of the lower back. This type of infection can be life-threatening because it can travel so deep into the back that it enters the underlying spinal bones and can spread throughout the entire body. A seemingly small injury led to years of additional surgeries and hospitalizations, but eventually healed.

She continues to have chronic nerve pain. She needs to be aware of her condition and loss of sensation for the rest of her life to avoid additional injuries. ◊

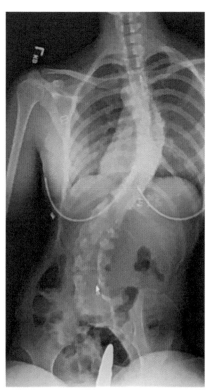

Figure 1

◊

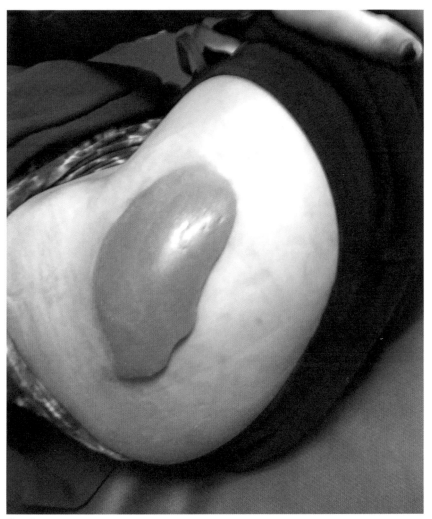

Figure 2

NOSE

—◇—

Noses come in all shapes and sizes and are a distinguishable anatomic feature, front and center of our face. The nose, however, is not just a cosmetic feature of our face, it is a complex organ, being the first part of our respiratory system. As we breathe in, hairs in our nose trap dirt and debris, capture it in mucus, and push it down the back of our throat, where it is swallowed. Our nose is also responsible for our sense of smell, which can play a critical role in memory and emotions. Pathology of the nose can cause respiratory problems, as well as physical disfigurement, that can lead to emotional distress.

PERFORATED NASAL SEPTUM

40 YEARS OLD | WESTMINSTER, COLORADO, UNITED STATES

As a teenager, this patient broke her nose. She had to have several surgeries to repair her nose and sinuses because of the injury.

Following her latest surgery, her ENT doctor put her on an over-the-counter steroid nasal spray, which she began to use regularly. One day, she was looking up her nose and noticed a hole in her nasal septum. This patient then went to her ENT doctor and was diagnosed with a pinhole perforation of the nasal septum (Figure 1).

The nasal septum is the piece of firm-yet-flexible cartilage in the center of the nose that separates the two nostrils. A perforated septum is when there is a hole in a piece of that cartilage. Perforated septums can occur from inflammation, infection, or trauma, but they can also occur from illegal drugs like cocaine and methamphetamine, or medications like inhaled steroid nasal spray.

A nasal septal perforation is a known complication with steroidal nasal spray use. The manufacturer has issued a warning against its use in patients who have recently had nasal surgery because the tissues are weakened. Despite that warning, her ENT doctor still recommended she use the drug.

She was able to see the hole clearly in the mirror and disagreed with her surgeon when he diagnosed it as being small and nothing to worry about. After seeking a second opinion through another ENT, that doctor thought the perforation was large enough and opted for reconstructive surgery.

Along with the physical discomfort and additional surgery, this patient incurred an additional $45,000 in medical bills. Since the reconstructive surgery, she has experienced minor discomfort and occasional numbness, but most of her symptoms have subsided. ◊

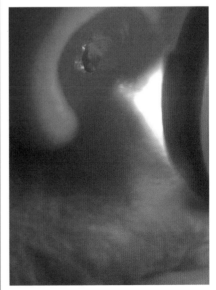

Figure 1

TRAUMA / NECROSIS

23 YEARS OLD | RIVERSIDE, CALIFORNIA, UNITED STATES

The day before his twenty-third birthday, this patient was hanging out with his brothers and was under the influence of alcohol. He started playing roughly with his brother's dog (a pit bull mix) and suddenly, the dog bit his face. When he realized what happened, he saw that the dog had bitten off a significant chunk of his nose.

His brothers called an ambulance and he was taken to the hospital, along with the chunk of his nose. At the hospital, they were able to attach the amputated piece of his nose; however, there was no guarantee it would heal properly. He was given antibiotics and told to see a cosmetic surgeon for a consultation.

After being discharged from the hospital, he was unable to find his antibiotic prescription for three days. During that time, an infection set in. He noticed the tip of his nose had turned black and had an unpleasant odor.

He went back to the hospital, and doctors told him there was not much they could do.

They said the reattached part of the nose was dead, or necrotic. Necrosis occurs when there is an interruption in oxygenated blood flow. In some cases, if an amputation occurs, it can be surgically reattached and heal with little to no problems. This is dependent on the extent of the injury, the time lapse between the injury and treatment, and the general health of the patient.

Doctors did not want to remove the dead tissue and risk further scarring. He was told that the necrotic tip of his nose would eventually fall off, and he would need a consultation for reconstructive surgery. He was given another prescription for antibiotics, and within three days the tip of his nose indeed fell off (Figure 1).

His next course of treatment will involve a consultation with a plastic surgeon to discuss the reconstruction of his missing ala of the external nose (Figure 2).

Understandably, he was a little apprehensive to approach the dog after the incident. It took some time, but he was able to rebuild his relationship with his brother's dog. ◊

Opposite page, top: Figure 2, bottom, Figure 1

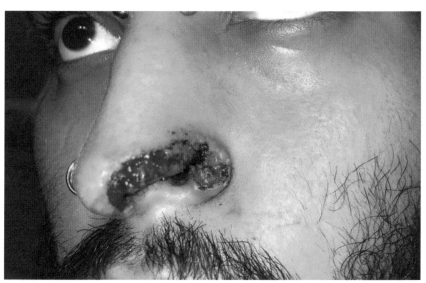

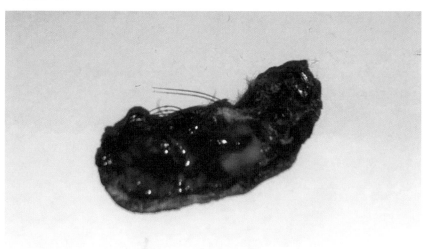

OVARIES

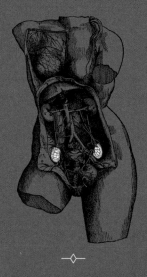

Ovaries are a part of the female genital tract and are anatomically designed to produce and release eggs to make babies. A female is born with all the eggs she will have throughout her life. Although she is born with thousands of eggs, only a few hundred will be released over the course of her life for fertilization. The ovaries are active organs and are susceptible to pathology. They are located in the female pelvis, which anatomically has space for a pregnancy to grow. Because of this space, ovaries can grow large and cause nonspecific symptoms like bloating, which can lead to a delay in diagnosis. Pathology of the ovaries is not only physically painful, but it can cause infertility, leading to severe emotional distress.

MALIGNANT MIXED GERM CELL TUMOR

32 YEARS OLD | PHOENIX, ARIZONA, UNITED STATES

◊

At fourteen years old, this patient thought she was gaining weight. Her mother noticed too, especially when they went shopping for school clothes and she had to keep bringing her larger pant sizes to try on. Her mother thought her weight gain was due to her sweet tooth and told her to lay off the cookies. Additionally, this patient noticed she was urinating more than usual. Thinking she had a urinary tract infection, her mother brought her to see a doctor.

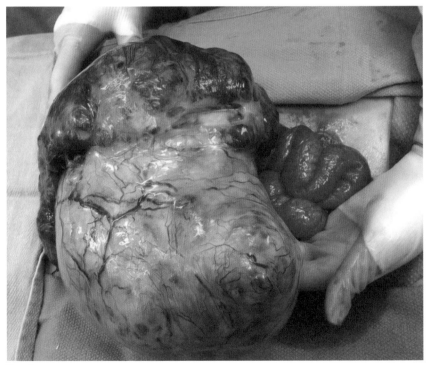

Figure 1

◊

Her urine tested negative for an infection. The doctor performed a physical exam and noticed her abdomen was hard. Despite telling her doctor she was a virgin, three pregnancy tests were performed, which were also negative.

Initially, the doctor was concerned with her hard abdomen and sent her for an ultrasound that same day. The ultrasound revealed a large mass on her right ovary, and a call was made to an oncologist (a doctor who specializes in treating cancer). She was seen the following morning.

At the oncologist, she was sent to get an MRI, and the following morning, she was scheduled for surgery.

A large incision was made in her abdomen, and an eleven-pound tumor was removed from her abdomen/pelvis (Figure 1). The tumor was sent to pathology and was diagnosed as a stage 2 malignant mixed germ cell tumor.

An ovarian germ cell tumor arises from the reproductive cells in the ovary called eggs. The words "germ cell tumor" are used to describe several types of tumors that grow from these cells. In this case, her tumor was made up of several types of germ cell tumors (mixed).

Mixed malignant germ cell tumors are very rare and can be very aggressive. They are most common in teenagers and young women. These types of tumors tend to grow quickly, and symptoms present early on. This can be good, because the earlier these tumors get treated, the better the patient's prognosis is.

After her surgery she was given chemotherapy for four months, eight hours each day, five days a week. Her mother was there by her side the entire time, taking her to each chemotherapy appointment and sitting with her the whole time.

Unfortunately, due to her surgery and surgery treatment, she had to miss an entire semester of her freshman year of high school. Luckily, her teachers worked with her, so she was able to make up her work and continue to her sophomore year.

Since her cancer treatment, she has had to have regular ultrasounds and occasional MRIs. She has not had a reoccurrence of the cancer; however, when she was twenty years old, she had another scare. A mass was found on her left ovary, which had to be surgically removed.

Fortunately, when the mass was removed, it was a benign tumor filled with hair called a teratoma. A teratoma is also a type of germ cell tumor, but it is not cancerous.

The only lingering effect of her cancer diagnosis has been an abnormal pigmentation of the skin on her neck from the chemotherapy, which people sometimes mistake as a hickey. After the surgery to remove the second mass, she was told she was likely infertile. Nine years later, however, she found out she was pregnant, and now says her three-year-old is proof that miracles exist! ◊

◊

TERATOMA

38 YEARS OLD | BREDA, NETHERLANDS

◊

I n her early thirties, this patient noticed a bump on her belly. At first, she thought her abdomen was distended because she was always constipated. When she pressed on it, it was firm, and she assumed it was from stool in her bowel (Figure 1).

She was feeling fatigued, so she went to her doctor for a workup. Her doctor pressed on her belly and determined her abdominal extension was not due to constipation: it was possibly a mass. To confirm this, an MRI was ordered, and a mass was discovered on her ovary.

A few weeks later, this patient was scheduled for surgery to have the mass removed. Her doctor felt confident that the mass was a benign cyst. In some cases, if an ovarian cyst is small, a less-invasive surgery can be done to remove the cyst through small holes with the assistance of a camera in a procedure called a laparoscopy. Due to the large size of the mass, the decision was made to make an open incision in her abdomen to remove it.

When the mass was removed, it weighed over three pounds (Figure 2). It was examined

Figure 1

◊

in pathology and diagnosed as a teratoma.

A teratoma is a cystic tumor that grows in the ovary. Teratomas are fairly common and are usually benign. Even though there is a low risk of a teratoma being cancerous, it is still important to remove them since they can grow quite large and cut off the blood supply to the ovary. This condition is known as ovarian torsion.

Teratomas arise from cells in the ovary called germ cells. Germ cells are reproductive cells found in both male and females. These are the cells that are responsible for making a human, so they have the capability to produce human parts, like muscle tissue, brain, even hair.

"Teratoma" comes from the Greek word teraton, meaning "monster," but in no way is a teratoma alive. Although this tumor is made up of pieces of a human, it is not a human because no sperm is required for it to grow.

When her cyst was opened in the pathology lab, it was filled with a thick, oily, waxy malodorous fluid that resembles peanut butter mixed with hair. Under the microscope, it was determined that all the components of this cyst were benign. This type or teratoma is also referred to as a dermoid cyst.

In this case, surgery was the cure. Having open abdominal surgery and an ovary removed can sometimes decrease fertility. That is not a concern, however, because this patient has no plans to have children.

Ironically, her mother had surgery a few years prior for an ovarian teratoma. Teratomas are typically not hereditary, but there have been rare, reported cases of them in families. ◊

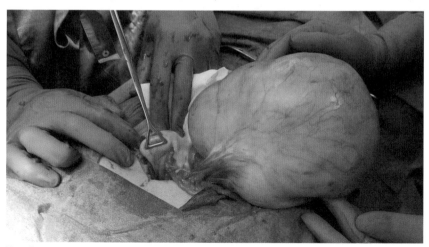

Figure 2

TORSION

32 YEARS OLD | CHEVERLY, MARYLAND, UNITED STATES

few years ago, this patient started having episodes of abdominal pain. The pain would come for a few days, leave, then return every few weeks.

The first time she experienced this, she went to urgent care since the pain felt different and more intense than menstrual cramps. She was diagnosed with constipation.

The next time it happened, she went to her primary doctor, who told her it was due to a combination of stress, a bad diet, and a lack of exercise. She was told to take a probiotic.

The third time, she went back to urgent care and was told she was having a reaction to food she ate.

Not satisfied with the treatment she was receiving, and still in a severe amount of pain, she went to a different urgent care. This office took her symptoms more seriously. She was sent to the emergency room, where she was given a CT scan and an ultrasound. A large seven-inch cyst was found on her ovary; however, a more serious condition was also identified, called ovarian torsion.

Ovarian torsion is a surgical emergency. The ovaries are attached to blood vessels that bring oxygenated blood to the ovary and deoxygenated blood back to the blood supply. If these blood vessels get compressed, it can cut off oxygen to the ovary

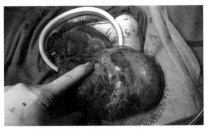

Figure 1

and the ovary can die. Because women only have two ovaries, the loss of one can decrease fertility in some circumstances.

Ovarian cysts are common. As a cyst is growing, it can cause the ovary to become unbalanced, and the ovary can start to twist, cutting off its own blood supply. If ovarian torsion is discovered in a timely fashion, the ovary can be untwisted and saved. Unfortunately, in this case, it was too late. During her surgery, the cyst was removed, along with her dead ovary and fallopian tube (Figure 1).

This patient does not currently have any children. She was informed, however, that fertility should not be an issue in the future, although open abdominal surgery and the loss of one ovary can slightly increase the risk of infertility in some cases. The cyst which was about the size of a grapefruit and was benign. Since her surgery, she has had no other issues. ◊

PANCREAS

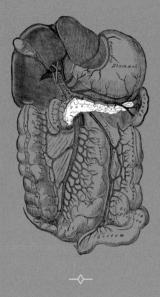

—◇—

The pancreas is a gland located deep in the back of the abdomen.
Although food does not pass through the pancreas, it has a key role
in digestion. After we eat, the pancreas secretes juices through a duct
into the small bowel to break down our food. It also works by secreting
hormones into the bloodstream to regulate the sugar in our blood.
We can live without a pancreas, but we would need medication to
supplement the functions of the pancreas for the rest of our life.
Since the pancreas is tucked deep in the abdomen, oftentimes it is not
realized there is pathology until it is advanced.

WHIPPLE

◇

Last year, this patient was working from home during the pandemic when he started to feel ill one morning. He was lightheaded and had abdominal pain. By the afternoon, his abdominal pain was more intense, and he also started having diarrhea. He called into a health line concerned he may be having symptoms of COVID-19. They were not overly concerned and recommended testing in a few days if his symptoms persisted.

As the night went on, he started having more diarrhea, only this time there was blood present in his stool. He called the health line again and was told to go right to the emergency room. In the emergency room, his blood was taken, and his hemoglobin was low: only 8 g/dL, while a normal male hemoglobin level is from 13.5 to 17.5 g/dL.

Hemoglobin is a protein that is present in the red blood cells and is responsible for bringing oxygen to all our organs throughout the body. One cause of low hemoglobin is when a patient is bleeding. The hemoglobin can become low over a period of weeks from a slow bleed or can drop rapidly in a short period of time with a more significant bleed. If the hemoglobin level drops too low (usually lower than 5 g/dL), it can lead to heart failure and death.

The emergency room doctor thought, based on his symptoms, that this patient was having an upper gastrointestinal tract bleed. He was prepped for an endoscopy the next day, which is when a camera is placed down the throat to examine the upper gastrointestinal tract.

By the next day, it was apparent he was having a very serious bleed. His hemoglobin dropped to dangerously low levels (5 g/dL). Since his hemoglobin was so low, he was given a blood transfusion. This is when a patient is given blood to temporarily replace the blood that they are losing or not producing on their own.

A blood transfusion is only a short-term fix. If the patient continues to bleed, their hemoglobin will continue to drop. That is why it is important to identify the source of the bleed and stop it.

When the endoscopy was performed, his doctor found the cause of his bleed. An ulcerated tumor was identified in the first part of the small intestine, called the duodenum. Although they found the source of the bleeding, they were not able to control it during the endoscopy. He had to go to another hospital via ambulance for treatment.

At the second hospital, an interventional radiologist (a radiologist who does minimally

◇

invasive procedures assisted by imaging) was able to control the bleeding by entering his body through the femoral artery. From there, they were able to travel up the vascular system and place a coil to stop the bleeding.

Although his bleeding was under control, the patient still had to receive three additional blood transfusions over the course of the next few days. They were not able to address treating the tumor surgically until his hemoglobin was back within normal range, which took a couple of months.

During that time, he had more scans and endoscopes to get a better look at the tumor. The surgeon was hopeful she would be able to easily remove the tumor. When she opened the patient up, however, she, unfortunately, realized the tumor was much more extensive than she thought. It was invading the head of the pancreas.

The duodenum is the first part of the small intestine. It is attached to the stomach, where it curves to make the letter C. The head of the pancreas is attached to the duodenum and sits in that letter C. If a patient has a tumor in this area of the duodenum, the pancreas must come along for the ride with its removal. The same can be said if a patient has a tumor in the head of the pancreas; the duodenum must be removed with it. The two are anatomically attached.

The surgeon was hoping she could remove the tumor without having to do a more extensive surgery. When she realized the tumor was invading the pancreas, she had to do a much more extensive surgical procedure called a pancreaticoduodenectomy, or a Whipple procedure (Figure 1). This surgery is very complex because it involves the removal of a highly condensed area of anatomy. In this surgery, the duodenum (small bowel), pancreas head, bile ducts, and gallbladder are all removed at once. This procedure is most commonly performed in patients who have cancer originating in the head of the pancreas. In less common cases like this, it is performed to remove a duodenal tumor.

When the pancreas and duodenum were examined in pathology, the tumor was diagnosed as a gastrointestinal stromal tumor, or GIST. GISTs are less-common tumors that can grow anywhere in the GI tract. Their behavior is not always predictable. They can be benign, but they also have the potential to behave like a malignant tumor and can spread. Fortunately, most GIST tumors found in the duodenum are considered low risk.

After his Whipple procedure, he spent ten days in the hospital recovering. In the year after his procedure, he has experienced a few episodes of pancreatitis (inflammation of the pancreas) and gets fatigued easily. Overall, he is doing well and is back to eating anything he wants. ◊

Opposite page: Figure I

◊

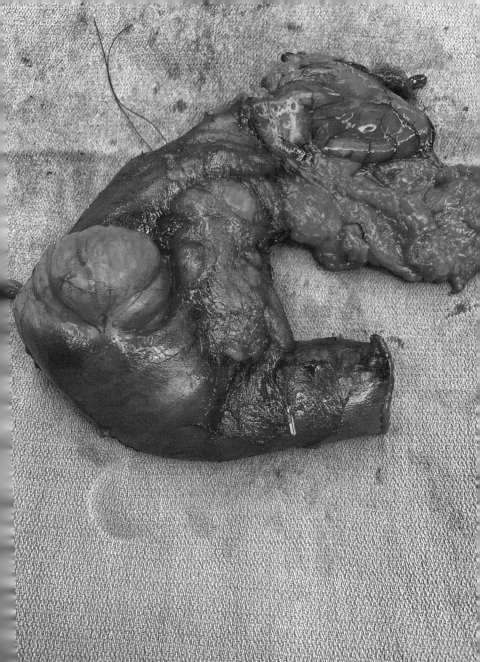

PLACENTA

The placenta is one of the coolest organs because it is temporary! It forms during pregnancy and is discarded after birth (unless you keep it and have it on display in your house, like I do). During pregnancy, when a fertilized egg implants in the uterus, a placenta also starts growing with it. The placenta is the lifeline between the mom and her growing fetus. Since the growing fetus can't eat or breathe on its own, all the fetus's nutrients and oxygen are passed through the placenta. Millions of babies are born around the world each year, and millions of placentas have some degree of pathology. Placenta pathology can range from little to no problems for the growing fetus to fetal death.

VELAMENTOUS CORD INSERTION

30 YEARS OLD | BELLEVILLE, ILLINOIS, UNITED STATES

Worldwide, about a quarter of a million babies are born every day, and with each baby comes a placenta. Placentas vary in size, shape, and color; however, a variation in the anatomy and structure of the placenta can mean the difference between life and death.

This patient went to her obstetrician for her standard twenty-week anatomy ultrasound scan. Around this period in the pregnancy is typically the best to visualize the baby's anatomy and to make sure the pregnancy looks healthy. During this scan, the placenta is also examined.

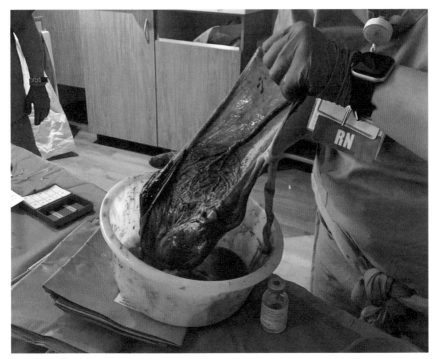

Figure 1

Abnormalities with the placenta can have devastating effects on both the mother's and baby's lives.

During her scan, she was relieved to hear that her baby's anatomy looked normal. She was not expecting to hear that there was a problem with her placenta: The umbilical cord only had one artery.

The umbilical cord of the placenta is the lifeline between the mother and her baby. The cord is normally made up of three blood vessels which facilitate blood and nutrient flow back and forth between mother and baby. The three blood vessels in the cord include two umbilical arteries and one umbilical vein. When the umbilical cord is cut in cross-sections, the vessels look like a smiley face (the two arteries look like eyes, the vein looks like a mouth).

A single umbilical artery is a rare defect of the umbilical cord, only happening in 1 percent of all pregnancies. In most of these births, there will be no noticeable difference in the baby. In some cases, however, the babies can be born with low birth weights and birth defects, including heart and kidney conditions.

This mother continued the remainder of her pregnancy with no complications and delivered a healthy 8.2-pound baby girl at thirty-nine weeks' gestation.

To her (and her doctor's) surprise, the placenta had another defect that was not detected in the ultrasound: a life-threatening abnormality called a velamentous cord insertion.

The three umbilical cord blood vessels are very important and very delicate. Normally, the blood vessels of the cord are covered by a thick, insulating gel called Wharton's jelly. This gel helps protect the blood vessels from getting kinked or torn. In the case of a velamentous cord insertion, the umbilical vessels are naked and have no Wharton's jelly to protect them. The vessels trace along the fetal membranes (Figure 1), which make up the amniotic sac the baby lives in throughout pregnancy. At any time, the baby can compress its own blood supply by pushing on one of these exposed blood vessels. These exposed vessels are also more prone to injury. A tear can cause a massive bleed, which can be life-threatening for both mother and baby.

This mother worked as an EMT and was on her feet all day for the entire thirty-nine weeks of her pregnancy, completely unaware of the ticking time bomb inside her. She is extremely lucky that both she and her baby made it through the pregnancy and delivery without any complications from these rare placental abnormalities. ◊

◊

QUADRICEPS

There are about six hundred muscles in the human body, and the quadriceps make up four of them. There are three types of muscle throughout the body: smooth, cardiac, and skeletal. Smooth and cardiac muscles can be found in our organs and blood vessels. These are muscles that make our organs work; however, we do not have any control over them. We can't tell our hearts to beat! We do have control, however, over the third type of muscle in our body, which is skeletal. The quadricep muscles are a group of four skeletal muscles in the front thigh responsible for lifting the lower leg. The quadriceps are essential for walking, running, and standing. Pathology of one or more of the quadriceps can have a serious impact on mobility.

TENDON RUPTURE

59 YEARS OLD | GLASGOW, SCOTLAND, UNITED KINGDOM

◊

One day, this patient was standing talking to his friends when he heard a sudden pop and felt pain in his right leg. He knew exactly what was happening as it had happened before in his left leg. After the popping noise, he looked down and saw he had a large gap between his thigh muscle and his kneecap (Figure 1). His knee also swelled up, and he was not able to walk. This patient's quadriceps muscle was torn again.

Our bones give us structure and the ability to stand upright. Attached to the bones are skeletal muscles which are responsible for moving our body. The skeletal muscles are attached to the bones by thick cords called tendons.

The front muscles of the thigh are responsible for straightening the leg. This is a muscle group consisting of four muscles that form the "quads," or quadriceps muscles. They all attach to a tendon called the quadriceps tendon, which attaches to the kneecap. If this tendon is torn, the patient will not be able to straighten their leg.

Two days after the injury, doctors performed surgery to repair the torn tendon, consisting of drilling two holes in the patella bone (kneecap) to reattach it.

A quadriceps tendon rupture is rare and usually happens during a traumatic

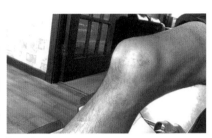

Figure 1

event like a motor vehicle accident or a fall. This injury occurred while the patient was at rest, making it extremely rare. Sometimes, underlying diseases such as chronic steroid use and renal failure can cause this type of rupture. This patient, however, does not have any of these risk factors. Throughout his life, he was very active and exercised frequently. His doctors feel that lifelong strenuous exercise contributed to his tendon tear.

Aside from having both of his quadriceps tendons rupture, his Achilles tendon (the tendon that connects the calf muscle to back of heel) also ruptured while at rest.

After having both of his quadriceps muscles snapped and repaired, he is still able to walk; however, he requires assistance at times. He is not able to get off the toilet without holding on to something, and he cannot stand for long periods at a time. ◊

◊

RESPIRATORY

The respiratory system starts by breathing in oxygen through the mouth, which is taken into the lungs via the trachea (windpipe). It travels from the trachea through the bronchial tree, where it lands in tiny air sacs called alveoli. Here, oxygen exchange occurs. Cells in the alveoli take the oxygen from the air we breathe and transport it to our blood. From there, the heart pumps the oxygenated blood throughout the entire body to deliver oxygen to all our organs. After the oxygen is used up, the blood goes back to the lungs, where it drops off the waste (carbon dioxide) and picks up more oxygen. The carbon dioxide goes back up through the bronchial tree, up the trachea, and is exhaled through the mouth. Pathology of the lungs is serious and can greatly impact a patient's quality of life. Two functioning lungs are ideal, but it is possible to live with only one lung.

CYSTIC FIBROSIS / LUNG TRANSPLANT

29 YEARS OLD | TORRANCE, CALIFORNIA, UNITED STATES

◊

When this patient was born, she was seemingly healthy. During the first four weeks of her life, however, she wasn't gaining any weight. Several tests were performed by her pediatrician, and she was diagnosed with a condition called cystic fibrosis.

Cystic fibrosis is a rare, inherited disorder that causes chronic disease in the lungs, pancreas, and other organs. A child born with this disorder can only get it if they inherit a defective gene mutation from each parent.

When two parents with this mutation have children, there is a 25 percent chance they will have a child with cystic fibrosis, a 50 percent chance the child will not have cystic fibrosis but will carry the gene, and a 25 percent chance the child will not have it or not carry the gene.

Her parents both have the gene mutation, and one of their children has cystic fibrosis. They also have two sons, both of whom do not have cystic fibrosis or carry the gene for cystic fibrosis. This diagnosis was surprising to her parents because there is no family history of cystic fibrosis and because they were completely unaware they were carriers of this gene mutation.

Many of the organs in our body have fluids called mucous that help them function properly. This mucous is normally thin and moves freely through the passageways. In cystic fibrosis, the protein that normally helps this fluid to stay thin and free flowing is not produced properly due to the inherited, mutated gene. Due to the lack of this protein, the thin fluid becomes thick and sticky. Over time, this thick and sticky mucous plugs up the passageways, causing inflammation, chronic infections, and scarring. Eventually the organs will become so damaged that they can no longer function, and the patient will die unless they receive a life-saving transplant.

Early diagnosis of cystic fibrosis is key. If it is diagnosed and treated before the organs become damaged, the patients have a better prognosis. In the US, all fifty states now test all newborn infants for cystic fibrosis, along with other diseases. This mandatory testing of newborns was not around at the time of this patient's birth, but luckily, her pediatrician recognized her symptoms and got her tested. Her testing consisted of a sweat test and a genetic test. People with cystic fibrosis often sweat more. Their sweat contains more levels of chloride and has a salty taste. The sweat

◊

can be tested for high chloride levels which is used in conjunction with genetic blood testing to give a patient a diagnosis of cystic fibrosis.

After her diagnosis, she started attending a clinic every three months to monitor her progression with the disease. These quarterly appointments consisted of the testing of her lung function by her pulmonologist and meetings with social workers and nutritionists. This was to ensure she had a good support system and was eating properly. Patients with cystic fibrosis must be on a special high-calorie, high-fat diet because of the lack of absorption in the body.

As time went on, her lung function declined. As a teenager, she was hospitalized frequently with lung infections. When she turned twenty-two years old, her pulmonologist discussed the possibility of a lung transplant.

A lung transplant is when one or two lungs from a deceased donor are transplanted into a person who has end-stage lung disease. Patients with cystic fibrosis who have a lung transplant often have a significant increase in their quality of life. A lung transplant is not a cure for cystic fibrosis. The donor lungs have the DNA of the donor, so they will not become diseased, but cystic fibrosis patients still have the mutated gene in their body that will continue to damage other of their organs, like the pancreas.

When she started the testing process to be a candidate for a lung transplant, she had to fly across the country to see her specialist. She was eventually placed on a lung transplant list and decided to move across the country while she was waiting for her new lungs. While on the list, she had appointments with her team of physicians every two months. Her lungs were continuing to fail, and her body was resisting the medications. She was placed on oxygen.

She was on the transplant list for two years because she was waiting for lungs that would fit her small frame. She also has a rare blood type. When she got the call, she had to report to the hospital immediately. She called her parents, and her mother took an emergency flight across the country. She made it to the hospital just in time to see her daughter getting wheeled to the operating room. Her diseased lungs were removed (Figure 1) and her new lungs were transplanted successfully.

Her donor lungs came from a thirty-seven-year-old female. The rest of the donor's information was kept confidential. After her transplant, the patient wrote a letter to the donor family expressing thanks, but she never heard back. She understands the decision to donate a loved one's organs after they die is extremely difficult, especially if the death was unexpected. The best

day for this patient and her family was the worst day for the donor and her family.

Living with cystic fibrosis and being a lung transplant recipient never held her back. She is now in a clinical PhD program writing her dissertation on the psychological implications for lung transplant patients with an end goal to work in an outpatient transplant clinic aiding in the mental health of patients.

There is still no cure for cystic fibrosis. Many years ago, people diagnosed with cystic fibrosis had a very short lifespan and would not live into adulthood. Now, with early diagnosis, monitoring, new treatments and lung transplantation, these patients can live well into old age. ◊

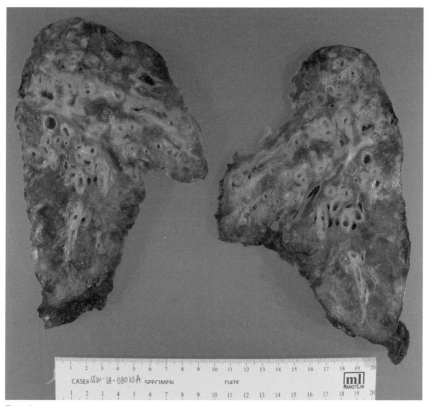

Figure 1

SALIVARY GLAND

Humans have three major salivary glands; parotid (close to the ear), submandibular (under the chin), and sublingual (under the tongue) that produce the saliva in our mouth. These glands produce up to a liter of fluid a day! As our teeth chew on food, the salivary glands release fluid that have enzymes to aid in the digestive process. The salivary glands do not just aid in digestion. Saliva is also responsible for helping us taste our food and assists in healing wounds in our mouth. Pathology of the salivary glands can be both painful and affect a patient's quality of life.

SIALOLITHIASIS

27 YEARS OLD | SAVANNAH, GEORGIA, UNITED STATES

This patient was able to do a fun party trick called "gleeking." Gleeking is a slang term used to describe squirting saliva out of the salivary ducts on command.

We have three major salivary glands in our mouth. These glands make saliva, which has enzymes that help break down food as we chew.

A few years ago, over the course of six months, the patient had a gradual increase in yellow discharge from under her tongue after gleeking. She mentioned the changes to her dentist, who referred her to an ENT (a doctor who specializes in ears, nose, and throat).

The ENT was able to palpate a small hard nodule (Figure 1) right next to her sub-mandibular gland under her tongue. She was diagnosed with a salivary gland stone.

When we eat, the saliva in the salivary glands is stimulated and exits the glands via ducts that exit under the tongue. Certain foods—such as ones that are sour—can cause more saliva to be released.

Sometimes components of the saliva can accumulate and form a stone. When the salivary glands are stimulated after eating, the stone can get stuck, which can cause pain and swelling. If the stone is stuck over time, it can cause an infection to form in the salivary gland.

The ENT put her on a diet high in sour foods to increase saliva production. She was also told to use hot compresses and to lightly massage the gland in the hope of dislodging the stone without surgery.

Within three days, she had severe pain and swelling under her tongue, which increased any time she ate or drank. She was also having difficulty sleeping. Unable to deal with the pain, she went to the emergency room. The swelling and pain

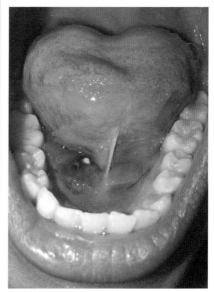

Figure 1

increased so much on the right side of her face that she had a difficult time speaking without producing tears. She was given intravenous morphine for the pain and antibiotics for the infection that had developed.

A CT scan showed a half-inch-sized salivary duct stone. While waiting for the IV antibiotics to finish being administered, she lifted her tongue to show her father the swelling and the tip of the stone broke through the duct (Figure 2), which oozed an abundant amount of pus into her mouth. Every time she lifted her tongue, more and more pus flowed. When the doctor was called in, she gently removed the rest of the stone from the patient's mouth. It was placed in a cup and given to her as a souvenir (Figure 3).

Since this incident she has not had recurrent symptoms.

At the time of her hospitalization, she was in a physician assistant program. While training, she was able to recognize the symptoms of a patient she was caring for in the emergency room who was suffering from a blocked salivary duct stone, based on her own personal experience.

Salivary duct stones can occur in patients who have a decrease of saliva, which can be due to dehydration or from the use of certain medications. She attributes her salivary duct stone to a decrease in daily water intake, an increase in coffee consumption, and daily vitamin C powder packets during her time in PA training. ◊

Figure 3

◊

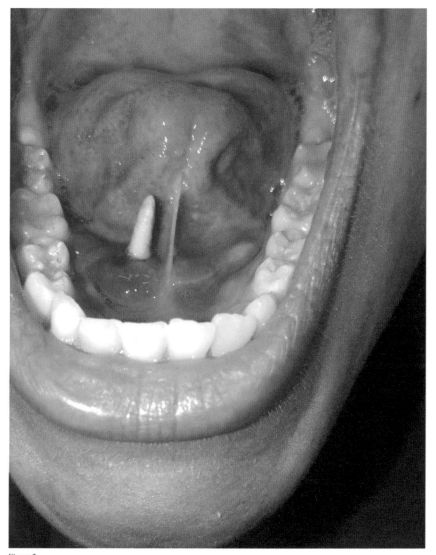

Figure 2

SKIN

Our skin is the largest organ of our body, and it is our first line of protection from the outside world. Skin protects our muscles, bones, and internal organs from infections and trauma. It also can recognize heat and cold and regulate our body temperature. Although skin is very strong and durable, it is also very prone to pathology since it is exposed to the elements. Not all pathology, however, is due to our environment. It can also occur before we are even born.

GIANT CONGENITAL MELANOCYTIC NEVUS

2 YEARS OLD | SAVANNAH, MISSOURI, UNITED STATES

After years of miscarriages and infertility, this patient's parents were so happy to be expecting a healthy child. Her mother was so excited to hold her new baby that she did not even notice what her husband described as a "large birthmark on the baby's buttock and leg." The mother recalls being exhausted from a long night of labor and giving birth that she did not think much about the mention of her newborn's birthmark. She did recall, however, she felt as if the vibe in the room had changed after the baby was born.

Within a few hours of birth, the baby was brought to the nursery and examined by a pediatrician. Luckily, the doctor recognized this condition immediately and diagnosed the abnormal skin patch as a giant congenital melanocytic nevus. She was referred to a pediatric dermatologist.

A giant congenital melanocytic nevus is an abnormal, noncancerous patch of dark skin that contains cells called melanocytes. Melanocytes are cells normally present in our skin that produce pigment and are responsible for our skin color. This condition occurs because of a mutation (change) in a gene after a baby is conceived.

The patch of skin was diagnosed as "giant" because it was over 19.6 inches at the time of birth. When she was born, her nevus was completely hairless and very black. As she has grown, however, it has gotten lighter in color and hairy. Over time, she continues to develop smaller, pigmented satellite lesions. Today, she has more than fifty, which the child refers to as her "polka dots."

Sometimes, this condition is seen with another called neurocutaneous melanosis,

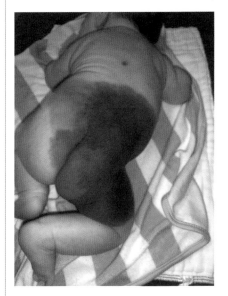

making it a medical concern to those who have it. Neurocutaneous melanosis is when these pigment cells cover the brain and spinal cord, leading to neurological problems. At three months old, she was given an MRI under anesthesia to see if she had any of these lesions. Fortunately, she did not.

Overall, there are some health concerns in patients with a giant congenital melanocytic nevus. This area of skin is made up of different cells than the rest of the body. These lesions tend to be flatter than the rest of the skin because fat does not grow under them. Due to this, there is an increased chance of melanoma (skin cancer) in these patients, and they must be monitored because the skin does not sweat or regulate temperature normally.

This patient must avoid excessive sun exposure and overheating. Additionally, the nevus skin is very fragile and tears easily, so they need to prevent her from falling.

In some cases, surgery is performed to remove these lesions, but it is only done for cosmetic reasons. Unfortunately, due to its large size, she would need several surgeries to remove it. These surgeries could leave her with scarring and mobility issues, so her parents have decided to wait until she is old enough to decide for herself whether she wants surgery.

Currently, her parents have decided to hold off on any procedures so their child can have as normal a childhood as possible. If these lesions are found on the brain or spinal cord, there is nothing that can be done to treat it. Since there is no treatment, the parents feel it is not necessary to put her through anesthesia. She is expected to live a normal life with a giant congenital melanocytic nevus. ◊

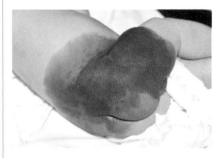

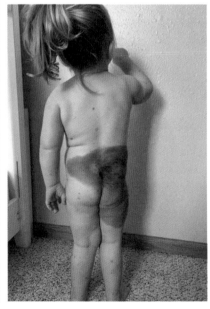

M E L A N O M A

30 YEARS OLD | OMAHA, NEBRASKA, UNITED STATES

◊

For years, this patient had a freckle on her left toe (Figure 1) that she noticed was starting to change, becoming darker. Due to this change, she decided to visit a dermatologist, who agreed it looked suspicious and took a scrape biopsy.

This type of biopsy typically involves a dermatologist scraping or shaving a thin layer off the top of the freckle so that it can be looked at under the microscope. Within a week, the dermatologist diagnosed her with melanoma, a type of skin cancer.

Melanoma is a cancer that originates from the cells in our skin (melanocytes) that produce pigment and are responsible for our skin color. Fortunately, melanoma is not as common as other skin cancers; however, it is more aggressive and more deadly. Since this type of skin cancer can spread quickly and easily, it's best for this to be diagnosed at an early stage. This is why it is important to address any changes in moles or freckles immediately.

Ninety percent of melanomas are thought to be caused by exposure to UV light. The risk is increased significantly if the patient uses a tanning bed. In this case, this patient used a tanning bed prior to vacations or special events.

Genetics also play a role. If a person has a family history of melanoma, they are more likely to develop it. Melanoma does not discriminate. People that are fair and burn easily are more likely to get melanoma than darker-skinned people; however, melanoma can be diagnosed in all races. It can also be diagnosed in all ages, including children.

After her diagnosis, she was scheduled for a procedure called Slow Mohs. A classic

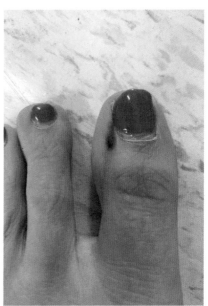

Figure 1

◊

Mohs procedure is a specialized procedure that allows the surgeon to map the cancer and remove the least amount of tissue possible. This is especially important in areas of the body where it is either difficult to remove a large area surrounding the tumor based on the patient's anatomy, or if the removal of the tumor will leave disfiguring scars.

A classic Mohs procedure is done in stages during one visit. This procedure is usually done on patients with less aggressive types of skin cancer like a basal cell carcinoma. A modified version of this surgery, called a Slow Mohs, is recommended in cases of melanoma. Since melanoma is much more aggressive and serious than other skin cancers, the tissue needs to be examined with more precision.

During the Slow Mohs procedure, the patient was awake and given a local anesthetic. A layer of the tissue with the cancerous lesion was removed and looked at by a pathologist within a couple days.

When the rim around the tumor is clear of cancer cells, the surgery is complete. If it is not clear, however, the surgeon will go back after a couple of days and go deeper and deeper until all the cancer is removed.

In this case, multiple layers of her skin were removed until the surgeon approached the bone in her toe (Figure 2). After removing all the cancer, the surgeon was able to save some of the patient's toe-nail, but more importantly, she did not have to have her toe amputated.

The entire tumor was examined in pathology, and she was given a diagnosis of stage 0 melanoma, or melanoma in situ. Cancer is given a stage based on multiple factors, including how far it has spread. A cancer stage helps with not only a patient's treatment plan, but their prognosis as well.

Melanoma in situ refers to the cancer cells being confined to the upper layers of the skin. It is stage 0 because the cancer cells have not broken through that layer to access the underlying blood vessels and lymphatics. Once the cancer cells have access to these layers, they can move around the body and spread. If a melanoma in situ is left untreated, there is a high probability it would advance to a more aggressive cancer.

A Slow Mohs procedure has a high success rate, especially when the stage of cancer is low. Fortunately for this patient, she has an excellent prognosis because of a successful surgery combined with a low stage of cancer.

Most commonly, Melanoma occurs on the skin of the legs, back, top of the head, etc., with UV light exposure being one of the highest risk factors. Melanoma, however, can also occur in unusual places that do not have much exposure to sunlight, like under the fingernails, the eyes, and even the genitals. ◊

Opposite page: Figure 2

◊

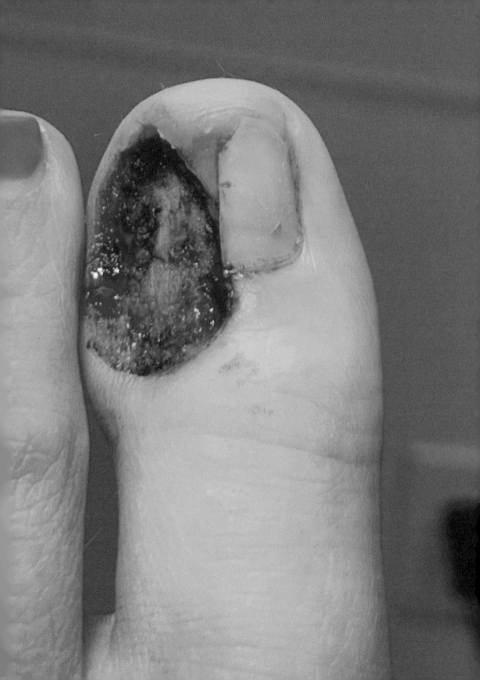

39 YEARS OLD | SUDBURY, ONTARIO, CANADA

bout ten years ago, this patient noticed a small bump in her gluteal crease (butt crack). At first, it seemed like nothing. The bump was a minor nuisance, with occasional itching. She brought it to her doctor's attention at her yearly physical and was told it was nothing, likely an ingrown hair or a pimple.

Over the next couple of months, the bump started to grow and became extremely itchy. She was not able to easily scratch it due to the bump becoming more like a mole protruding from the skin.

She showed her doctor again and asked if the mole could be removed. At this point, the intense itching was starting to affect her quality of life. She was told that it could be removed; however, it would be something she would have to pay for out of pocket because it was considered cosmetic.

This patient lived with the mole for a while, but it became increasingly symptomatic due to constant irritation. The severe itching, redness, and bleeding increased to the point that she finally demanded to have it removed and was able to get an appointment with a surgeon. When the surgeon looked at the mole, he made a note that it looked "angry," but she was not scheduled for surgery for another month.

When she finally had the surgery to remove the mole, she was so relieved to be rid of her symptoms that she did not think about anything else. It never occurred to her that the mole removed during her surgery could be anything else until her two-week follow-up appointment. She went to the appointment by herself thinking she would be in and out. Once there, the surgeon delivered the news that the mole they removed was not in fact a mole, but cancer. At the time of her diagnosis, she was only thirty-one years old.

When a person is diagnosed with cancer, they are given further testing to see if cancer has spread throughout their body. This is how the stage of cancer is determined. The stage a person is given helps determine a patient's treatment plan, along with their prognosis.

Her surgeon was able to get her in the hospital the following morning for further testing, which determined the cancer had spread to the inguinal lymph nodes in her right groin. She was diagnosed with stage 3C melanoma.

The surprise and shock after being diagnosed with cancer quickly turned to anger because of the delay in her diagnosis. The earlier a patient is diagnosed with melanoma, the better their prognosis is. The

Figure 1

Figure 2

delay in diagnosis could mean the difference between life and death for patients.

The cause of this patient's melanoma in such an unusual location is unknown. She has a history of repeated sun exposure, with multiple sun burns throughout her life, some of which were severe. She also has a history of UV light exposure from tan-

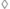

ning beds, which she visited about twenty times. Indoor tanning beds have been proven to cause skin cancer. Exposure to tanning beds before the age of thirty increases a patient's chance of developing melanoma by 75 percent.

A few months after having the cancerous mole removed, the patient had another surgery called a wide excision. This is when the surgeon removes a larger area of skin and tissue surrounding the cancerous mole. They also removed her right inguinal lymph nodes.

Lymphatics are small ducts that help with fluid distribution around the body. After she had all the inguinal lymph nodes removed from her right groin, she experienced chronic leg swelling, which is a known side effect. Over the next year, she was given a drug treatment called interferon. Interferon is used to stimulate a patient's immune system so it will attack the cancer cells.

Within a few months after finishing the interferon treatment, she felt a lump in her left groin. The cancer had come back in her left inguinal lymph nodes. They were surgically removed, and she was also given nineteen rounds of radiation, a cancer treatment that uses beams of intense energy to kill cancer.

After that treatment, she lived with no evidence of melanoma for a few years, until she noticed what she thought was a varicose vein on the back of her left thigh. At first she thought nothing of it, and neither did her doctors, until over forty blue-and-purple bruise-like lesions started popping up under her skin throughout her midsection. One of the lesions was biopsied, and it was determined that the cancer had spread throughout her skin. This finding bumped her up to a diagnosis of stage 4 melanoma, which carries a poor prognosis, with only 15-20 percent of patients living past five years. This was four years ago.

She was started on additional medical therapies which helped some; however, metastatic melanoma nodules continue popping up all over her body, especially concentrated in the buttocks and vulva (Figure 1). Over the course of the past four years, she has had several small surgeries to remove some of the cancerous lesions (Figure 2) that were causing her pain. She has been told, however, that she is no longer responding to treatments and there is nothing more they can do for her.

Throughout her diagnosis and treatment, the patient has documented her journey on social media, trying to promote patient awareness and advocacy. She is trying to remain positive but struggles because she is young and not ready to die. She hopes that by sharing her story, more patients will have the courage to fight for their bodies when they feel something isn't right. Melanoma is one of the leading causes of cancer death in females of this age group. ◊

RADIATION DERMATITIS

50 YEARS OLD | REGINA, SASKATCHEWAN, CANADA

hree years ago, this patient was brushing her hair in the mirror after a shower when she happened to notice a very slight indentation (dimpling) of the skin on her left breast. She recalled a breast cancer awareness post she saw online describing some changes patients see with breast cancer. At first she dismissed the indentation, but she kept thinking about the awareness post and decided to talk to her doctor about it.

Her doctor examined her and did not feel a lump, but just to be safe sent her for a mammogram.

A mammogram followed by an ultrasound was done, and the radiologist identified a small mass and ordered a biopsy. The biopsy confirmed she had invasive ductal carcinoma (breast cancer).

She had a left breast lumpectomy and five axillary lymph nodes removed, which are located in the armpit. A lumpectomy is when a surgeon removes only the tumor, not the breast. The tumor and an area of normal tissue surrounding it is removed to preserve the patient's breast.

One of the five lymph nodes had microscopic evidence that the cancer spread. She

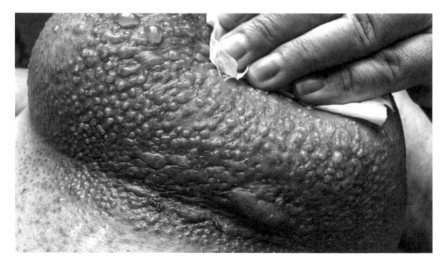

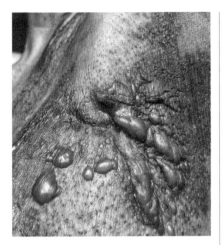

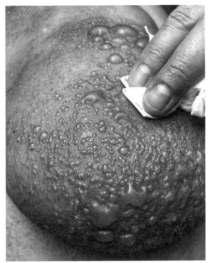

did not need chemotherapy, but it was recommended she have radiation to the area.

Radiation therapy is when a high-energy beam is targeted at the site of cancer; in this case, the left breast. Radiation is very effective in killing cancer cells, but unfortunately, in the process it also kills healthy cells, which can lead to skin irritation. Some patients can experience serious, less-common side effects, including scarring, severe burns, and a development of a second cancer later in life.

Almost immediately after receiving radiation, her skin looked sunburned. As she continued treatments, her skin started to get more and more irritated. Around her sixteenth treatment, her skin started to blister. By the eighteenth treatment, she was in so much pain her doctors discontinued the radiation.

In most cases, when the radiation therapy is discontinued, the skin will heal on its own. Her skin has healed remarkably well, and she has full mobility. She continues to work with a physical therapist (a type of therapist that specializes in helping patients regain mobility and strength) to address problems caused by swelling and scar tissue that developed from the radiation.

Without a family history of breast cancer, breast cancer-screening mammograms are not done in her country until fifty years of age. In this case, this patient's doctor, her radiologist, and her surgeon could not feel this tumor. She credits the breast cancer awareness post for educating her about skin dimpling and for saving her life. ◊

TEETH

Teeth are an essential part of our health. Aside from giving us our signature smile, they are the first part of our digestive system. Teeth are coated by a substance called enamel, which is the hardest substance that can be found in the human body. Humans are born with all their baby and adult teeth. When a baby is born, twenty baby teeth (primary teeth) are just below the gumline, and at least thirty-two adult teeth are waiting right there to take their place.

NATAL TEETH

7 MONTHS OLD | BERLIN, GERMANY

◇

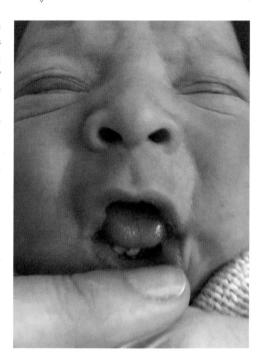

This mother was shocked when she looked into her baby's mouth and saw he was born with teeth! The pediatrician had only seen this condition in textbooks. The teeth were very loose, and the pediatrician feared the baby would inhale the teeth, so the family was referred to a pediatric dentist.

After examining the teeth, the pediatric dentist told the baby's mother that her son had natal teeth, a very rare condition. Natal teeth are not real baby/primary teeth. They are teeth that are present when a baby is born that are not fully developed and have a weak root.

The pediatric dentist was able to pull the teeth out with her fingers. The baby is not expected to have any potential problems associated with this condition. ◇

◇

THROAT

◇

The throat is part of both the respiratory and digestive systems. Our throats are a multifunctional pathway responsible for eating, drinking, breathing, and speaking. The back of the throat houses our tonsils and adenoids, which are part of the immune system. The tonsils act as a filter to catch the debris, bacteria, and viruses we breathe in. Unfortunately, that line of defense does not always protect us from infection. Pathology in the throat can occur before we are even born or can be acquired throughout our life.

GONORRHEA

18 YEARS OLD | SIOUX FALLS, SOUTH DAKOTA, UNITED STATES

◊

One day, this patient noticed a bump in the back of her throat (Figure 1) and didn't think much of it. A few days later, she went to an appointment at her gynecologist's office to get birth control.

As routine protocol, her doctor tested her for sexually transmitted infections (STI) before prescribing her birth control. While she was there, she thought she would also have her doctor look at the bump in the back of her throat. The doctor swabbed her throat as a precaution and sent it to the microbiology lab (a lab that specializes in microorganisms like bacteria, fungi, etc.) along with her other STI testing.

When her STI test results came back, her doctor told her the bump in her throat was caused by gonorrhea that she contracted through oral sex.

Gonorrhea is a sexually transmitted infection caused by a bacteria called *Neisseria gonorrhoeae*. This bacterium is spread through unprotected vaginal, anal, and oral sex.

The bacteria that cause gonorrhea are usually easy to treat with antibiotics once it is diagnosed. If untreated, however, it can cause serious problems in both males and females, including sterility. The inflammation from a gonorrhea infection can cause scarring of the reproductive system, which can make it difficult for a sperm or egg to travel through properly. Gonorrhea can also be passed to a fetus through the birth canal and cause serious defects, including blindness in the infant.

The bacteria that cause gonorrhea can also spread to other parts of the body, including the joints, which can cause painful arthritis.

In this case, her gonorrhea was caught early, she was treated, and her infection cleared up. She is not expected to have any further complications.

Gonorrhea is less likely to be transmitted with proper condom use, but the only way to completely avoid a sexually transmitted infection is by not having sex. ◊

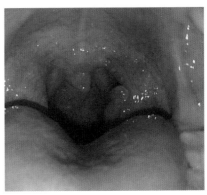

Figure 1

◊

THYMUS

The thymus is a very large, prominent gland seen in the chest of babies and children responsible for producing T cells. T cells, or T lymphocytes are an essential cell of the immune system that protects the body from foreign invaders like bacteria, viruses, and cancer cells. After puberty, the thymus is done making T cells and begins to shrink. Eventually, the entire gland will be replaced by fat. The thymus is not immune from pathology because it starts to shrink in adulthood. Pathology of the thymus can cause serious, systemic symptoms that greatly affect a patient's quality of life.

MYASTHENIA GRAVIS

40 YEARS OLD | RIYADH, SAUDI ARABIA

◊

About two years ago, this patient began experiencing worrisome symptoms including drooping of her eyelids, episodes of choking, and weakness throughout her body.

She had a consultation with neurologists (doctors who specialize in conditions involving the nervous system) who did a special test on her eyelids called an ice pack test. Based on the results of that test, which were positive, she was admitted to the neuro ICU to rule out a condition called myasthenia gravis.

Muscle movement starts when an impulse is sent down a nerve to the nerve ending. There, it stimulates the release of a chemical that transmits messages between the nerves and the muscles. This chemical then activates the muscle to move. Myasthenia gravis is an autoimmune disease that creates autoantibodies that attack this connection between the nerves and the muscles. The muscles can not contract properly and become rapidly fatigued.

An ice pack test is given because it is a specific, non-invasive test that can distinguish myasthenia gravis from other neurological conditions. If a patient presents with droopy eyelids, the neurologist can apply ice to the eyelids for 2 minutes. If a patient has myasthenia gravis, the drooping symptoms will disappear. When the muscle fibers are cooled, the body is not able to block the connection between the nerves and muscles.

In the ICU she had other tests confirming her myasthenia gravis diagnosis. She was given medications which only slightly improved her symptoms. Since up to 75% of patients with myasthenia gravis have some kind of abnormality with their thymus gland (either an increased number of cells or a tumor), it was suggested she have her thymus gland surgically removed (thymectomy) (Figure 1). ◊

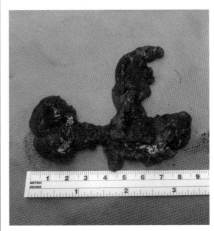

Figure 1

◊

THYROID

The thyroid is a tiny-yet-important gland that wraps around the front of the windpipe. Its job is to secrete hormones essentially regulating every function of the body. Due to this, there are many symptoms when it malfunctions. We do not need a thyroid gland to live if medication is given to supplement its function. Pathology of the thyroid can cause systemic symptoms, as well as local symptoms based on the anatomical location in the neck.

GOITER

28 YEARS OLD | MCKEE, KENTUCKY, UNITED STATES

◊

bout six years ago, this patient thought she was having an asthma attack and went to the hospital. She was given a chest X-ray to see if the cause of her symptoms could be identified. It was then she was told she had an enlarged thyroid, or a goiter.

A thyroid goiter is a general term to describe an enlarged thyroid gland. The thyroid gland can become enlarged for multiple reasons. Sometimes the enlargement of the gland causes an alteration in production of the thyroid hormone, which can cause a patient to have a variety of symptoms throughout their body. Other times, the goiter can get so big that it can compress local structures.

As the years went on, her goiter started causing her more and more symptoms, including weight gain, hair loss, fatigue, and anxiety. Despite her thyroid being enlarged, her blood results showed that her thyroid gland was functioning normally. She was given an ultrasound that showed the gland was enlarged. It was biopsied and looked completely normal under the microscope. Since testing showed her thyroid to be normal, she was not offered treatment.

The severity of her symptoms increased. She was having difficulty breathing and began frequently choking on her food. Then an alarming symptom occurred: She started randomly passing out. It was then she switched endocrinologists (doctors specializing in glands and hormones). That is when the severity of her condition was discovered.

She was given another ultrasound. Her thyroid had grown significantly, and it was

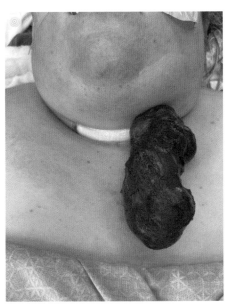

Figure 2

◊

not able to be entirely examined with an ultrasound. A CT scan was performed to get a better view of what was going on. Doctors were shocked at what they saw. The thyroid gland had grown so large on the left side it was partially encasing her trachea (windpipe) and was compressing on her aorta (Figure 1). Her oxygen supply was being cut off.

Surgeons decided that they were first going to try to remove the larger half of the thyroid gland. If the entire thyroid gland is removed during surgery, a patient will need to be on thyroid medication for the rest of their life. Doctors do not want to remove a patient's entire gland unless it is necessary to save a patient's life.

The surgery was successful (Figure 2). The left half of her thyroid was examined in pathology and was benign (Figure 3). She did not have to have the remainder of her thyroid gland removed.

Although her breathing improved dramatically after surgery, she felt worse than before surgery. Post-surgery, her thyroid levels were coming back abnormal for the first time. She had no energy and was very sluggish and tired.

Her doctors suspect the larger lobe was so large and working so hard that it suppressed her remaining smaller lobe. She was placed on thyroid medication with the hope that one day her other lobe will begin functioning properly again and she can go off the medication. Since her thyroid hormones have been regulated with the medications, she feels significantly better. ◊

Figure 1

Opposite page: Figure 3

◊

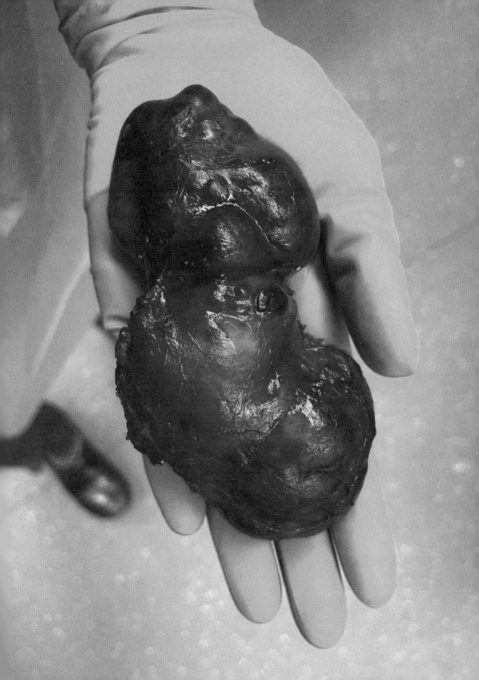

TONGUE

The tongue is made up of a group of strong muscles which work independently of the skeletal system, unlike our other skeletal muscles. Since eating is essential to our survival as humans, our tongues are covered in thousands of taste buds. These serve as a line of protection, ensuring we are eating food that is healthy and not harmful to us. Since the tongue is an essential part of the digestive tract and necessary for speaking, pathology can greatly impact a patient's quality of life.

FISSURED TONGUE

30 YEARS OLD | SYDNEY, NEW SOUTH WALES, AUSTRALIA

◇

As a small child, this patient noticed that her tongue looked different than all the other kids in her school. Her tongue's unusual appearance is a condition known as a fissured tongue.

The surface of the tongue is normally flat and rough, but about 5-10 percent of the population have deep grooves in their tongues called fissures.

Fissured tongues can be seen in patients with syndromes (for example, Down syndrome), but in most cases, the cause of this condition is unknown. Fissures in the tongue are considered benign. Since a significant amount of the population has a fissured tongue, some scientists suggest that it may be a normal anatomic variation.

Despite the condition being benign, some patients experience symptoms associated with their fissured tongue. Patients can have pain and inflammation from food getting stuck in the fissures. This patient, however, experi-ences pain from certain foods—specifically lemons, tomatoes, or anything acidic.

There is no treatment for a fissured tongue, and its recommended patients pay extra attention to brushing the grooves in the tongue to remove food that may irritate it.

Although the cause for a fissured tongue is unknown, it is very common to see them among families. This patient did not pass on this trait to her children. ◇

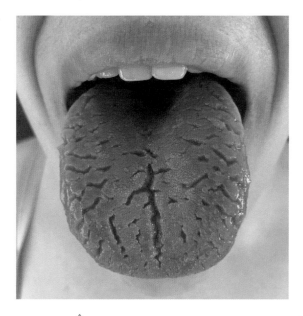

◇

TRAUMA

7 YEARS OLD | REGINA, SASKATCHEWAN, CANADA

◊

Figure 1

Figure 2

One day, this patient's mother asked her children to put away their laundry. They decided to have fun and play a game of tag, running around with their clean underwear on their heads. During the game, this patient, who was six years old at the time, fell down the steps, and in the process, bit through his tongue (Figure 1).

The wound looked deep and was bleeding significantly, so his mother took him to the hospital. At the hospital, she was told there was no treatment and that it would heal quickly. She was surprised there was no treatment given how disgusting the wound looked. She was amazed, however, to witness it fully heal in less than a week (Figure 2).

Wounds in the mouth heal faster than other tissues since the lining is very vascular. There are more blood vessels, which causes the mouth to bleed so badly when injured. The constant flow of oxygenated blood helps wounds heal fast. In addition, saliva also has antibacterial and healing properties. It is not surprising this deep wound healed so quickly without treatment. ◊

◊

PYOGENIC GRANULOMA

29 YEARS OLD | PRINCE GEORGE, BRITISH COLUMBIA, CANADA

◊

I n this patient's third trimester of her first pregnancy, she noticed a bump on her tongue. She showed her doctor and was diagnosed with a common benign tumor seen in pregnancy called a pyogenic granuloma.

A pyogenic granuloma is a fast-growing vascular tumor that can occur on the skin or mucous membranes in both male and female patients of any age. These tumors are benign and have no potential to become cancer; however, they can be stubborn to treat.

The hormones of pregnancy have been directly related to the development of oral pyogenic granulomas. When these tumors grow in the mouth during pregnancy, they are referred to as a granuloma gravidarum.

Her doctors were hesitant to remove the mass until the patient's pregnancy was over for fear the hormones would make it grow back. Unfortunately, over the course of the next few weeks, the mass grew significantly in size and started to affect her daily life.

Pyogenic granulomas are very vascular, which means they bleed easily with very little trauma. Something as simple as eating caused her tumor to bleed constantly. Toward the end of the pregnancy, she was only able to eat smoothies, which she had to carefully put in her mouth with a spoon.

Her ENT doctor (a doctor who specializes in ear, nose, and throat pathology) recommended the mass be surgically removed within a few weeks of giving birth, because the excessive hormones of pregnancy and breastfeeding would increase the chances of the tumor growing back.

Within two months of giving birth, the mass was surgically removed and healed well. She has not experienced any further complications. ◊

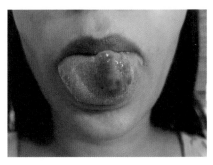

◊

UTERUS

—◇—

The uterus is a small, hollow organ of the female reproductive system that is anatomically designed to house a pregnancy. The wall of the uterus is made of smooth muscle, which we are not able to control. This allows the uterus to expand very large to accommodate a growing fetus, then shrink back down to regular size. Every month, the uterine lining (endometrium) builds up to create the perfect environment for implantation of a fertilized egg (when an egg and sperm meet). If a pregnancy does not occur, the uterus contracts to expel the lining through the vagina. This is called the menstrual cycle. Pathology of the uterus can start before we are born or can develop during life. Either way, this little organ can cause huge problems throughout a patient's life.

FIBROIDS

42 YEARS OLD | CHICAGO, ILLINOIS, UNITED STATES

◊

Around four years ago, this patient was at a routine gynecologist appointment, and her doctor felt a hard lump right above her pubic bone. She was sent for an ultrasound and diagnosed with fibroids.

Fibroids, or leiomyomas, are very common benign tumors of the uterus. The tumors arise from the cells in the uterine muscle wall. Depending on their size and location, the symptoms from these tumors can range from mild to severe. In some cases, fibroid tumors can be small and cause minimal problems. In other cases, the tumors can grow large and cause significant pain, bleeding, and problems conceiving.

This patient's doctor told her the fibroids were nothing to worry about, which did not sit well with her. Over the course of the next year, the lump in her pelvis grew larger and larger. She also noticed she was bleeding heavier during her periods and would also bleed after sex. She finally decided to get a second opinion. Her new doctor sent her for an ultrasound to determine the size of the fibroids. She was told she would need a hysterectomy.

A hysterectomy is a surgery in which the uterus is removed. This surgery can be a blessing for some, but in other cases, it can be devastating, especially if a patient wants to have children.

Figure 1

Fortunately, when her surgeon evaluated the anatomic location of the fibroids, the tumors were able to be removed while preserving her uterus. This allows her to have the option of future pregnancies if desired. In total, ten fibroid tumors were removed from her uterus (Figure 1).

The fibroids were sent to pathology and examined, because in rare cases, leiomyomas can be malignant (cancerous).

In this case, the fibroids were benign. After surgery, her periods are still heavy, but she no longer has bleeding after sex. She was told if she does have a pregnancy, a Cesarean section would have to be scheduled to avoid potential complications associated with her surgery. ◊

◊

UTERINE DIDELPHYS

45 YEARS OLD | MACON, GEORGIA, UNITED STATES

◇

A t seventeen years old, this patient still had not completely gone through puberty. Her body had made some changes, but she never got her menstrual period. Her parents brought her to the doctor, and after multiple tests, it was determined that she had low estrogen levels.

Estrogen is a hormone that is produced by the ovaries and is the main hormone responsible for the menstrual cycle. It is unknown why her ovaries were not producing enough estrogen; however, she was given hormone replacement therapy to bring on her menstrual cycle, which was successful.

After she started menstruating, her periods soon became painful, with intense cramping and bleeding. By the age of twenty-four, she went to the gynecologist for her first pelvic exam to address her symptoms. She was told at that time that she had a vaginal septum. The gynecologist suggested getting an ultrasound and prescribed her oral contraceptives (known as birth control pills) to control the bleeding and cramping.

A vaginal septum is a condition when the female genital tract does not develop properly in the fetus. The result is a vagina that is partially or completely split in two. This condition can lead to an obstruction of blood coming out of the uterus during menstrua-

tion, which can cause severe cramping. This condition can also make sex uncomfortable.

At that time, she decided not to get the ultrasound until she was ready to have children. She continued taking the birth control pills for years, which kept her intense cramping and bleeding under control. Eventually, at forty-one years old, the bleeding and cramping returned.

She went to the gynecologist again to get her symptoms evaluated and was told the only other option to control heavy bleeding and cramping was a procedure called ablation, or a hysterectomy.

A hysterectomy is a surgical procedure which removes the uterus. While this surgery does cure uterine cramping and bleeding, it is a major surgery and can come with complications. A less invasive procedure called a uterine ablation is sometimes offered as an alternative. During this procedure, a tool is inserted into the vagina and the uterine lining is essentially burned. This procedure does not involve cutting, and there is less downtime. In some cases, this uterine ablation eliminates or lessens a patient's symptoms.

Before a decision was made, her doctor ordered an ultrasound to see if there were any obvious causes for the bleeding and cramping. Surprisingly, the cause of her

◇

bleeding and cramping was obvious: she had two uteri, a condition known as uterine didelphys (Figure 1).

When a female fetus is developing, the female genital tract starts as two tubes. Typically, as the fetus develops, the tubes join to form one uterus, one cervix, and one vagina. If those tubes do not join properly, there can be a range of anatomical abnormalities of the female genital tract. This can result in a double uterus, known as uterine didelphys. Some patients with a double uterus may also have a double cervix and a double vagina.

Figure 1

Patients born with uterine didelphys still may be able to have children depending on the severity of the defect, but there is still a higher risk of miscarriage. This anatomical defect can cause severe symptoms in a patient's life, especially with pain and bleeding. Menstrual bleeding can be a challenge for some of these patients. Having two uteri means having two menstrual periods. Blood can come out of both sides of the uterus, which means bleeding from both sides of the vagina. This makes using something like tampons a challenge. A tampon in one side of the vagina will not stop the bleeding on the other side of the vagina.

The treatment for uterine didelphys is either managing the symptoms with medications or to surgically remove the uterus. Since the medications were no longer working, and she was not planning on having children at this point, she opted for a hysterectomy.

Her double uterus was successfully removed and cured her symptoms. She is not expected to have any further complications related to her uterine didelphys.

Her doctors believe her uterine didelphys was the cause of her lifelong gynecological symptoms. At twenty-four years old, this patient was diagnosed as having a vaginal septum, partially splitting her vagina into two. At the time of that discovery, her doctor suggested further investigation with an ultrasound, which she declined. If that ultrasound had been performed, she may have avoided years of suffering. ◊

◊

VAGINA

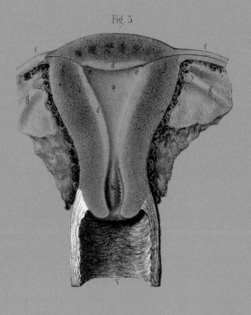

Fig. 3

The vagina is a muscular tube within the body which runs from the vulva to the uterus. This tube is part of the female genital tract and was anatomically designed for sexual intercourse. It also acts as a passageway for childbirth and expelled menstrual blood. Pathology of the vagina can be painful and affect the quality of a patient's life, as well as their sex life.

EPISIOTOMY / INFECTION

31 YEARS OLD | SPRINGVILLE, UTAH, UNITED STATES

For over thirty grueling hours, this patient was in labor, attempting to give birth at home. Since her labor was not progressing, her midwife, who is a healthcare specialist who specializes in labor and childbirth, decided to continue the delivery at the hospital. At the hospital, the labor continued for another eight hours, and after two hours of pushing, the doctor decided to perform an episiotomy.

Figure 1

An episiotomy is an incision that is made in the area of skin between the vaginal opening and the anus. This incision helps make the vaginal opening bigger so the baby can pass through easier.

If an episiotomy is not done, there is a chance the patient can tear, which is known as a vaginal laceration. In the past, it was thought that giving a patient an episiotomy gave them a better outcome. Now, however, research suggests patients have more complications with an episiotomy, especially infections. Still, the procedure is performed at times, especially when there are complications with the delivery.

The episiotomy was not entirely successful, leaving this patient with significant tearing in her vagina.

There are four grades of severity when it comes to vaginal tears, with a fourth-degree tear being the most severe. A fourth-degree tear is a laceration from the vaginal opening to rectum. She was diagnosed with a second-degree/borderline third-degree tear, which involved her vaginal opening, skin and muscle of the perineum, and part of the anal sphincter.

Her incision and tear were sutured closed after childbirth. At that time, her labia and perineum were severely swollen, and she was not able to see her vulva or vagina clearly. Within a few days of giving birth, as the swelling went down, she noticed that her sutures had loosened and were coming apart (Figure 1). She also noticed a foul-smelling red-and-white discharge.

She went to her obstetrician, a doctor who specializes in labor and delivery, five days after giving birth and was told her episiotomy/lacerated wound was infected (Figure 2). The doctor was unsure why the sutures fell apart, but they decided not to re-suture the wound. Instead, they left the sutures in place and told her they would eventually dissolve. She was given oral antibiotics and was told that it may heal back together on its own.

The antibiotics helped to clear the infection; however, the wound was still widely spaced apart, and the sutures were not dissolving. About two weeks later, her midwife finally removed the sutures.

It has been thirteen months and she still has a significant amount of scar tissue. Her vaginal opening is now significantly larger than pre-pregnancy, which has left her with complications including painful sex, periods of intense itching, and very loud, uncontrollable vaginal flatulence. ◊

Opposite page: Figure 2

VULVA

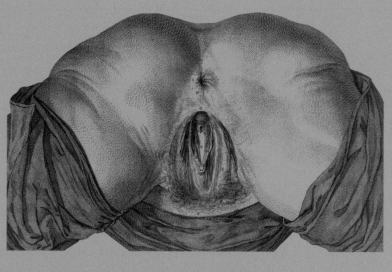

The vulva is the external portion of the female genital tract and has many anatomic parts, including openings for both the urethra (pee hole) and vagina. These openings are surrounded and protected by folds of skin called the labia. Directly above the urethral opening is the clitoris, which has more nerve endings than any other part of the body—even more than the penis! Patients can be born with pathology of the vulva or acquire it throughout their life. Pathology can cause patients physical pain, as well as be a source of embarrassment for some.

VULVAR INTRAEPITHELIAL NEOPLASIA

32 YEARS OLD | SOUTHAMPTON, HAMPSHIRE, UNITED KINGDOM

About two years ago, this patient noticed a brown, smooth mark on her labia. She did not think much of it but decided to show her doctor, who referred her to a gynecologist. The gynecologist thought it may be a mole or a varicose vein but took a biopsy to be sure.

Both she and her doctor were surprised with the biopsy results. The innocent-looking mark on her vulva turned out to be a much larger issue. It was a VIN, or vulvar intraepithelial neoplasia.

VIN is a precancerous skin lesion that occurs in the skin of the vulva. In some cases, these lesions can go away on their own; however, it is still important to treat it. If the cells continue to change over time, the lesion can develop into cancer.

The development of VIN has been linked to an infection with the HPV (human papillomavirus). Additional factors like cigarette smoking and immunosuppression have also been linked to these lesions.

This patient has an autoimmune disease called rheumatoid arthritis. Having an autoimmune disease does not make a person immunosuppressed, but the medications given to treat these disorders slow down the immune system and can cause a person's immune system not to work as well. Her doctors suspect this is why she developed VIN.

Her gynecologist recommended surgically removing the lesion. Unfortunately, within minutes of receiving anesthesia for the surgery, the patient went into anaphylactic shock (a severe, life-threatening allergic reaction to the medications) which landed her in the hospital's intensive care unit for days. She was too weak for surgery, so it had to be postponed for months.

Eventually, she was rebooked for surgery. The excision of her VIN lesion was successful. Her surgeon removed the lesion, along with a rim of healthy tissue to make sure all the precancerous tissue was removed. When the lesion was looked at in pathology, it was diagnosed as VIN3, which is a high-grade lesion with a closer progression to cancer. Since she caught this lesion at the precancerous stage and had it successfully removed, she is not expected to have any complications if she continues with her follow-up appointments. ◊

WOMB

—◇—

The womb is defined as the organ in the lower body of a female mammal where offspring are conceived and in which they gestate before birth, the uterus. The pregnant (gravid) uterus goes through a series of significant changes over the course of a pregnancy that is typically forty weeks of gestation. Many pregnancies do not go as planned, and problems can happen along the way. Some pathology during a pregnancy has little impact, while some can be life-threatening for both the unborn fetus and the mother.

HEMORRHAGIC SHOCK

30 YEARS OLD | CORBY, NORTHAMPTONSHIRE, UNITED KINGDOM

◇

During this patient's fourth pregnancy, she had light bleeding that started at eleven weeks' gestation. She was sent for an ultrasound and told the fetus did not have a heartbeat. It appeared the fetus stopped growing at around six weeks of pregnancy. She was diagnosed with a missed abortion, or a miscarriage.

A missed abortion is defined as a pregnancy that naturally ends before twenty weeks' gestation; however, the pregnancy tissue has not been expelled from the uterus.

She was given the option to pass the fetus naturally or with assistance from medication. Medication can be inserted in the vagina to start contractions of the uterus to expel the pregnancy tissue. She was devastated by the news of her miscarriage, so she decided to pass the pregnancy naturally. In most cases, the pregnancy tissue will eventually pass on its own.

◇

Two days after learning she was having a miscarriage, she was at her house when she started having intense contractions every three minutes, followed by severe bleeding. Blood was pouring out of her body at a rapid rate. She knew something was wrong and decided to take of photo of her massive blood loss. Shortly after the photo was taken, she passed out.

She was rushed to the hospital, where she was given IV fluids. Doctors pulled large clots of blood out of her vagina, but the bleeding would not stop. That is when they decided to give her a surgical procedure called manual vacuum aspiration (MVA). This procedure uses suction to remove extra tissue from the uterus that was not expelled during a miscarriage. She also had to have two blood transfusions to supplement her blood loss.

Her doctors described her condition as hemorrhagic shock and estimated she lost over 40 percent of her total blood volume. Hemorrhagic shock is a condition where the organs are not receiving enough oxygen due to a massive loss of blood. This is a serious, life-threatening emergency that will result in death if not treated quickly.

This patient went from being a vibrant, healthy, and strong thirty-year-old woman to being weak, tired, and frail. She gets easily confused, has poor memory, and experiences frequent migraines. Her massive blood loss left her anemic, which is a condition wherein the blood does not have enough healthy red blood cells to provide oxygen to the body. Her doctors estimate it could take weeks to months for her body to regenerate and for the patient to start feeling back to her old self. ◊

AMNIOTIC BAND SYNDROME

50 YEARS OLD | BRIGHAM CITY, UTAH, UNITED STATES

Immediately after birth, this patient's mother noticed her baby son's lip and his fingers looked different. After visits with several doctors, he was finally diagnosed with a condition known as amniotic band syndrome.

During pregnancy, the fetus lives inside the amniotic sac of the placenta. Within that sac, the fetus is surrounded by fluid called amniotic fluid. The sac consists of two layers: an inner layer and an outer layer. The inner layer is called the amnion. In some cases, the amnion can become damaged, causing part of the membrane to tear off like a string. This is called an amniotic band. This band can then wrap around a part of the baby, cutting off the circulation. In some cases, the damage done by these bands is minimal. When these bands cause damage throughout the body, this condition is referred to as amniotic band syndrome.

In some cases, the damage from these bands can be so severe it can lead to seri-

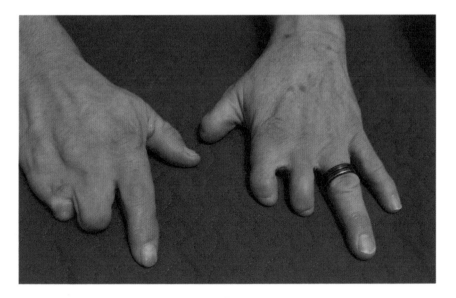

ous complications including amputations and damage to the face such as cleft lip/palate. In rare instances, these bands can compress the umbilical cord, resulting in fetal death.

Amniotic band syndrome was not detected during the mother's pregnancy over fifty years ago. Even today, this condition is difficult to diagnose with ultrasound. In some cases, amniotic bands can be seen on ultrasound, but oftentimes, they are not identified until after a child is born.

After his diagnosis, this patient's mother took him to multiple specialists, and it was suggested that the affected fingers be amputated. His mother fought hard against the amputation, and ultimately, that has proven to be the best decision for his adult life.

This patient has been able to live and work with amniotic band syndrome throughout his entire life, but he does face some challenges. His biggest struggle is something that most of us take for granted: wearing gloves. Since he is not able to purchase standard work gloves to fit the anatomy of his hands, he has to custom-make gloves. He starts by purchasing leather gloves, then cutting off the fingers that correspond to his missing digits and resewing them. ◊

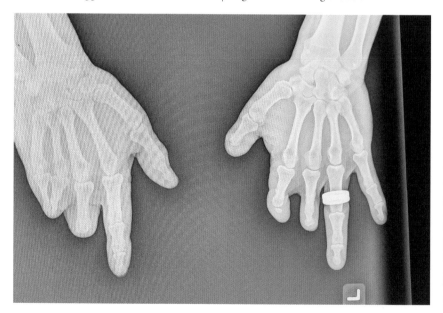

X & Y CHROMOSOMES

X Y

—◇—

Chromosomes are structures of DNA in our cells that make every one of us unique. A karyotype is an individual's collection of chromosomes. The typical karyotype for most humans is a total of forty-six chromosomes, or twenty-three pairs. Twenty-three chromosomes come from the father, and twenty-three chromosomes come from the mother. A chromosome from each parent creates a pair, for a total of twenty-two pairs of chromosomes. These pairs of chromosomes are the same in most humans. It is the twenty-third pair which separates humans into two categories in most cases, male and female. When a fetus is born female, it has two X chromosomes. When a baby is born male, it has one X chromosome and one Y chromosome. These are referred to as sex chromosomes because they determine what biological sex a child will be at birth. Sometimes babies are not born with enough chromosomes, and sometimes they are born with too many. In fact, one in every 150 babies is born with a chromosomal abnormality. Depending on what chromosome(s) are added or deleted, depends on the severity of symptoms a child will be born with. Some of these symptoms will be mild, while others will be so severe they are incompatible with life.

—◇—

KLINEFELTER SYNDROME

9 YEARS OLD | MIAMI, FLORIDA, UNITED STATES

◇

When this child was around two years old, his parents noticed their son had a developmental delay. They brought their concerns to their son's doctors, who agreed he was delayed, but could not say why. The doctors seemed to have no interest in doing further testing to find the cause. The parents were not satisfied with that and started doing research on their own. His parents were the ones who pushed for additional testing and asked for more bloodwork for certain conditions. Finally, when he was eight years old, he was given a formal diagnosis of 48,XXYY, a variant of Klinefelter syndrome, a chromosomal condition seen in males who are born with an extra X and Y chromosome.

48,XXYY is not an inherited condition but rather a random event that occurs with one of the sex cells: the egg or the sperm (usually the sperm). In most cases when a child with 48,XXYY is conceived, the sperm has too many chromosomes. When this sperm cell with too many chromosomes meets with an egg and starts dividing to form the fetus, the result is that the fetus has too many chromosomes. Typically, a human has forty-six chromosomes, but because these patients have an extra X and an extra Y chromosome, they have forty-eight chromosomes.

This syndrome can cause multiple medical and behavioral problems. While he has a normal life expectancy, this patient will have some challenges.

48,XXYY Klinefelter syndrome disrupts male sexual development. These patients have very low testosterone production and small testicles that do not develop properly.

Testosterone is a hormone that is responsible for developing male secondary sex characteristics. Typically, during puberty, the male testicles grow. Testosterone increases and causes changes in the body, including an increase in body hair and muscle tone, deepening of the voice, and sperm production.

Since there is a lack of testosterone at puberty, patients with 48,XXYY tend to have less body hair, low muscle tone, and an increase in breast size (known as gynecomastia). There is also no sperm production, so these patients are infertile.

48,XXYY patients tend to be taller than the average male. They can experience other medical issues in addition to the effects of low testosterone, including allergies, dental problems, heart defects, and problems with the vascular system.

These patients also have a lower IQ, with learning disabilities and behavior problems.

◇

Due to his condition, the patient needs speech therapy and is in a special classroom for children with learning disabilities. He is also being treated for attention deficit hyperactivity disorder, or ADHD, which is characterized by hyperactivity and an inability to stay focused.

Since he is only nine years old and has not started puberty yet, the true effects of this variant of Klinefelter syndrome are not entirely known at this time. His parents describe him as a sweet young boy who gets along best with younger children, and he especially connects to other children with learning disabilities. ◊

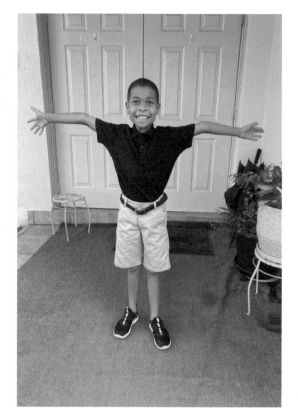

ZYGOMATIC

◇

The zygomatic bone, also known as the cheekbone, is a bone of the skull which forms a portion of the lower orbit (eye socket). This bone is prone to pathology because it is the most prominent bone of the face.

◇

FRACTURE

15 YEARS OLD | ATLANTIC CITY, NEW JERSEY, UNITED STATES

◊

For years, this patient has been bullied for being gay. At twelve years old, he was being teased on the school bus by an older child. As he was exiting the school bus, the older child grabbed the straps of the patient's backpack and threw him on the ground. He proceeded to stomp on his head with a heavy pair of work boots until the patient fell unconscious. Luckily, the school bus driver was present and was able to break up the assault.

Subsequently, this patient was brought to the hospital with a very swollen, painful face and given a CT scan. He was diagnosed with a concussion.

A concussion is a serious traumatic head injury. When a patient experiences head trauma, the brain can bounce within the skull, causing it to become damaged. Concussions are not usually considered life-threatening head injuries; however, the trauma can damage brain cells and can cause lifelong complications. This is especially seen in cases where patients experience another concussion in their life. Therefore, it is import that these patients avoid high-risk activities. In this case, it was recommended this patient quit playing football.

Aside from the traumatic brain injury, he was also diagnosed with a fracture of the zygomatic bone. The zygomatic bones, also known as the cheek bones, are most susceptible to injury when there is trauma to the head or face because they are the most prominent bones of the skull.

No treatment was provided for his injuries. He was told to rest, and he eventually healed without any complications.

Charges were pressed against the bully, and it was discovered that this was not his first offense. Since the bully was still a minor at the time of the assault, he received a restraining order and was sentenced to probation, community service, and a counseling program. ◊

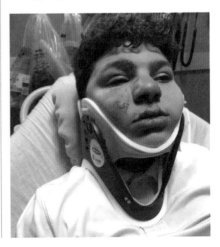

◊

INDEX

◇

◇

◇

ACKNOWLEDGMENTS

◇

My success throughout the years can only be attributed to the joint efforts of my family, starting with my parents, Beth and Lou, siblings Annie and Louie, niece Deanna, and my adoptive grandparents, Joan and Joe Farley, who were a godsend. Without their help, I would have never been able to get through all the hardships of growing up as a single teen mom and the vigorous schedule I had through my bachelors and master's education.

My husband, Gabriel, is my protector and confidant. He is a constant source of strength, loyalty, motivation, reason, ideas, and unconditional love. I am proud to say I am his wife (except when he grows his creepy mustache).

My now-twenty-seven-year-old daughter Maria's persistence and organizational skills are how this book came to fruition. Although she works for me, everyone in the family knows she is the boss. Her strength and love have gotten me through so many tough times, which has only made us stronger. I look forward to the future of our family and our business.

My eight-year-old daughter, Lillian, told me to thank her in my book for all her great ideas and to mention that she is my favorite daughter. Lillian shows an interest in disease and is very inquisitive about my profession.

My seven-year-old daughter, Lucia, also told me to mention she is my favorite daughter. Lucia is a comedic genius and keeps me laughing, especially when I am having a stressful day.

Much love to the Qualtieris; my favorite father and mother-in-law, R&R; Aunt CamCam and crew; and Jablonskis. RIP, Nanny and Pop. ◇

PROFESSIONAL ACKNOWLEDGMENTS

◇

So many people have helped me throughout my career, but I would like to point out a few people who had the most significant impact on my story.

Dr. John "Blue Steel" Farber is responsible for fueling my love of pathology. If I had to pick one person who was most influential over my career, it would be him. We only worked together for a few years, but his passion for pathology was infectious. I utilized that time well by sucking all the information out of his brain. On Dr. Farber's seventieth birthday, I had "Blue Steel" tattooed on my hands. Dr. Farber will forever be my role model.

Professor Rita Connelly introduced me to science, microscopy, and the medical laboratory. When I entered her class in 1999, I was a lost teenager. She helped me find my life's purpose. I owe my love for education to her.

My Autopsy Mentors:

Joey DiRienzi labeled me as the messiest PA student he ever had, probably because I got blood on the ceiling in his morgue. While his cleaning skills failed to make an impression on me, his autopsy skills did. I am still complimented on my dissections at autopsy, and I owe it all to him. I have not been his student for years, but every year on my birthday, the first greeting of the day is from him. We will forever have a special relationship.

Igor Tsimberg pushed me out of my comfort zone and did not let me give any excuses when it came to my strength and abilities as

◇

a young female doing the physically vigorous job of an autopsy. Because of Igor, I became a master of the bone saw and can take out a brain with my eyes closed! And yes, there is really a PA who works in the morgue named Igor.

Frank Penick was not only my autopsy mentor and partner, but also a great friend and role model. He is a strong example of the success that comes with resiliency. I will forever treasure his lessons and the times we spent together cutting bodies and listening to Stevie Wonder.

Dr. Gary J. Collins is one of the coolest people I have ever met. He is upbeat, positive, and fun. I was especially impressed and envious of his presence when I attended his lectures. I will never forget the day Dr. Collins told me he thought I was ready to cut an autopsy by myself. I opened the body bag, and the person was green, bloated, and covered in maggots. I was nervous, but he walked me through it and built my confidence. If you had a chance to ask him about working with Nicole Angemi, he wouldn't know my name. He only calls me Marisa Tomei.

Thanks to these fellow authors and friends who have given me countless hours of support and guidance through my first book.

Dr. Lindsay Fitzharris

Dr. Paul Koudounaris

A special shout out to Dr. Peter McCue. Thank you for trying to destroy me. Your weakness gave me strength.

Thank you to my publisher, Abrams Books, especially Rodolphe Lachat and Regan Mies, for taking a chance on this book and supporting my artistic vision.

I also want to thank my friends, whom I ignored for two years while writing this book, especially Annette, Krisper, Laura, Andrea, Other Maria, CW, Rita, and Lynn. Thank you for supporting and understanding my insanity. Love you guys.

Jen Garde for being so dedicated to my business and our friendship. I would be lost without her support.

A special thanks to Ken Penn for my author portrait. 11/11.

RIP, Jessie Miele. You were the first non-medical person who was excited and interested to hear all about my autopsies. I know you would have this book prominently on display with your other weird stuff. I miss your cackle.

This book would not be possible without the contributions from all of the patients featured in this book. Thank you for trusting me to tell your stories and allowing me to share your personal experiences with pathology to the world. For more anatomy stories, visit www.theduramater.com.

NICOLE ANGEMI'S

ANATOMY BOOK

ISBN: 978-1-4197-5475-3
LCCN: 2020944165

© 2022 Nicole Angemi
Printed and bound in Italy
10 9 8 7 6 5 4 3

Texts: Nicole Angemi
Cernunnos logo design: Mark Ryden
Book design: Benjamin Brard

Abrams books are available at special discounts
when purchased in quantity for premiums and
promotions as well as fundraising or educational
use. Special editions can also be created to
specification. For details, contact specialsales@
abramsbooks.com or the address below.

Abrams® is a registered trademark
of Harry N. Abrams, Inc.

ABRAMS The Art of Books
195 Broadway, New York, NY 10007
abramsbooks.com

X Y

Fig. 10.